THE
POST-IMPRESSIONISTS

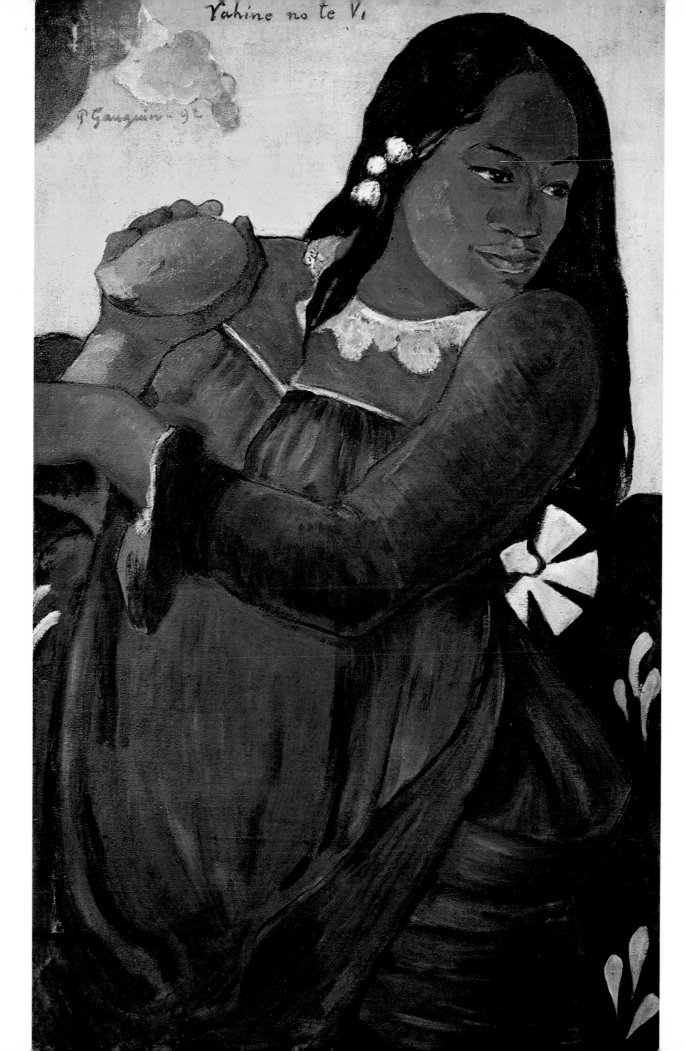

To Francis,
With all my love
Jessica x

THE POST-IMPRESSIONISTS

RICHARD SHONE

First published in 1979 by
Octopus Books Limited, 59 Grosvenor Street, London W1

© John Calmann & Cooper Limited, 1979
This book was designed and produced by John Calmann & Cooper Limited

Filmset by Composing Operations Limited, Tunbridge Wells, Kent
Printed in Great Britain by Morrison and Gibb Limited, Edinburgh

1. (*Frontispiece*) Paul Gauguin, *Woman with Mango*, 1892. Oil on canvas, 28¼ × 17½ in (71.8 × 44.5 cm). Baltimore, Baltimore Museum of Art.

Contents

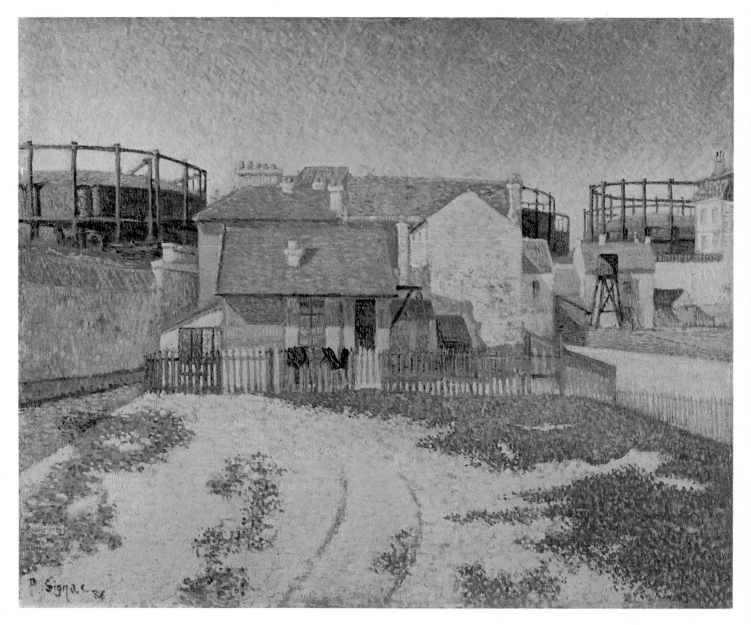

2. Paul Signac, *Gas Tanks at Clichy*, 1886. Oil on canvas, 25½ × 32 in (64.8 × 81.3 cm). Melbourne, National Gallery of Victoria.

3. Georges Seurat, *Le Cirque*, 1891. Oil on canvas, 72½ × 60 in (185.5 × 152.5 cm). Paris, Louvre.

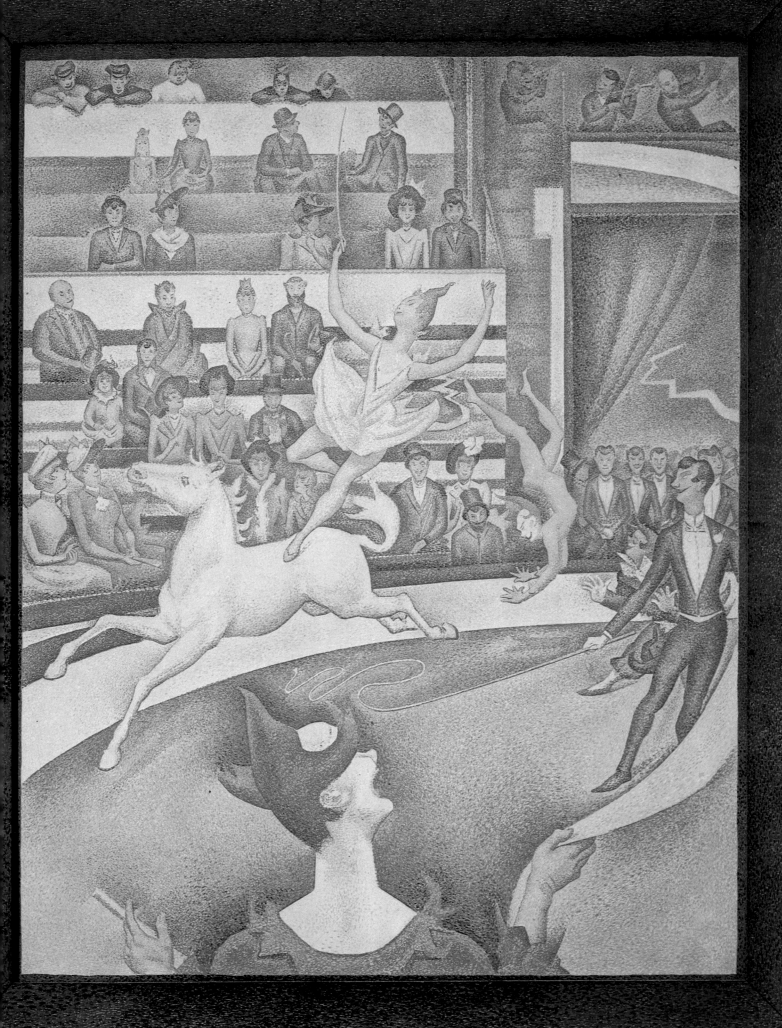

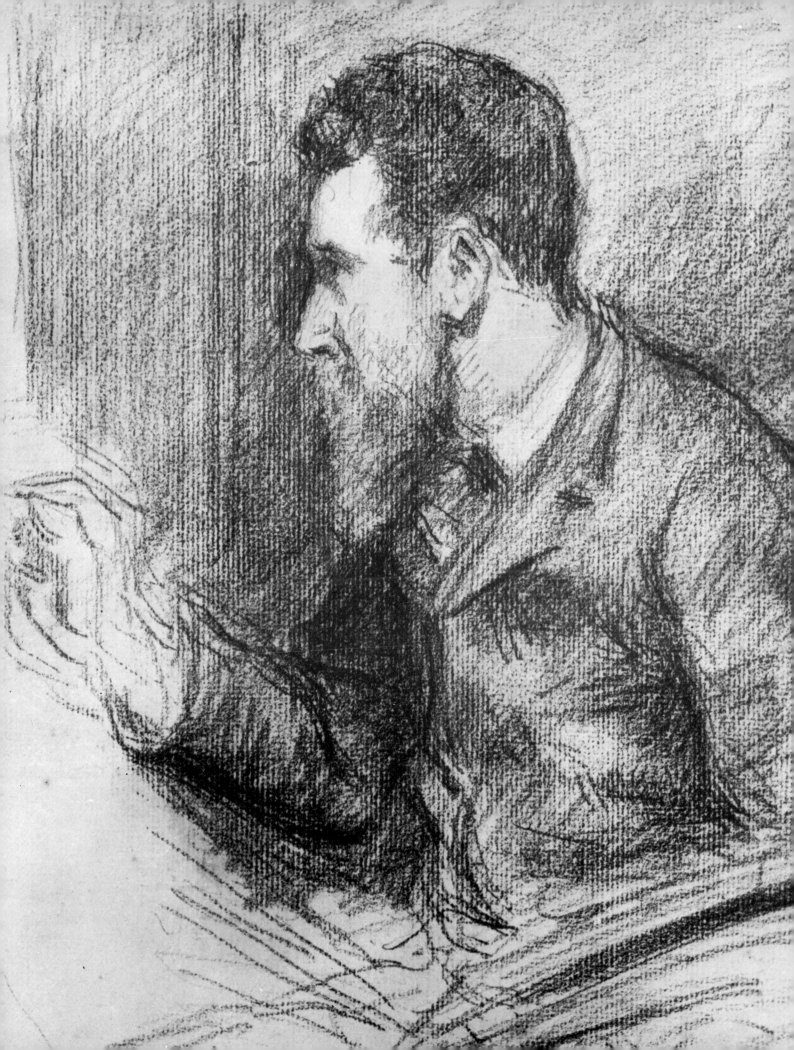

1
Introduction

4. Maximilien Luce, *Portrait of Georges Seurat,* 1890. Charcoal on paper, 11¾ × 9 in (29.8 × 22.9 cm). New York, Collection Arthur G. Altschul.
Maximilien Luce painted portraits of nearly all his friends and colleagues in the Neo-Impressionist circle. He met Seurat in 1887 and became a warm admirer. After Seurat's death, Luce was entrusted (with Signac and Fénéon) with sorting out and cataloguing the contents of Seurat's studio.

The term Post-Impressionist was first used by the English writer Roger Fry in 1910 when he organized an exhibition in London called 'Manet and the Post-Impressionists'. For the first time, it introduced a wide range of modern French painting to a bewildered British public. The painters most fully represented were Cézanne, Gauguin and van Gogh, all of whom were dead but still comparatively unknown. Among younger painters shown were Matisse, Rouault, Picasso, Derain and Vlaminck. The exhibition shook the quiet English art world. Roger Fry, a respected connoisseur and writer on Italian painting, found himself at the centre of an unprecedented row. The public came to laugh, the newspapers published caricatures and lampoons and the battle over Post-Impressionism began. The work of Cézanne and van Gogh outraged all notions of what good painting should be; it attacked vested interests, trampled on conventional ideas of beauty and upset accepted methods of representation. The words 'anarchist', 'degenerate' and 'madmen' peppered the columns of serious newspapers. 'Nothing I could say,' Fry later wrote, 'would induce people to look carefully enough at these pictures to see how closely they followed tradition. . . .' (R. Fry, *Vision and Design,* 1920).

A second exhibition in 1912 showed pictures by French, English and Russian painters variously influenced by the older Post-Impressionists. Although Fry still stressed their links with tradition, the younger artists were seen to be pressing forward in their search for new forms, questioning all the received ideas of what constituted a work of art. By that date Fauvism was virtually over and Cubism several years old; non-representational painting was already underway in the work, for example, of Wassily Kandinsky and Franz Kupka. All such developments owed much to the impact of Post-Impressionism, with its renewed concern for the formal possibilities of painting, its emphasis on the autonomy of the picture, its invariably heightened colour detached from mere description, and its expression of unfamiliar or previously unexplored emotions. Within an exceptionally fertile period

5. (*Above left*) Spencer Gore, *Gauguins and connoisseurs at the Stafford Gallery*, c. 1911. Oil on canvas, 33 × 28¼ in (83.8 × 71.75 cm). Theydon Bois, Collection Sir William Keswick. Paintings by Cézanne and Gauguin were exhibited by the Stafford Gallery, London, in November 1911. Gauguin's *Manoa Tapapau* and *The Vision of the Sermon* hang on either side of *Christ in the Garden*. Among the visitors are Augustus John (with hat and beard, foreground) and Wilson Steer (with cane, centre).

6. (*Above right*) Vanessa Bell, *A room at the Second Post-Impressionist Exhibition*, 1912. Oil on panel, 20 × 24 in (50.8 × 60.9 cm). Paris, Musée d'Art Moderne. The room of Matisses at the Grafton Galleries, London, in 1912 painted *in situ* by one of the English participants of the Second Post-Impressionist Exhibition. Matisse's 1905 *Le Luxe* (Copenhagen) hangs on the left of the door.

7. Paul Gauguin, *Self-portrait with Yellow Christ*, c. 1889. Oil on canvas, 15 × 18⅛ in (38 × 46.5 cm). Paris, Collection the Denis Family. Almost certainly painted at the end of 1889 in Brittany, Gauguin's self-portrait is shown against two further images of himself. In *The Yellow Christ*, Christ's features resemble Gauguin's own. The ceramic pot to his left, showing a schematized self-portrait, was made by Gauguin earlier in the year.

in the arts the leading Post-Impressionists were outstanding, and their influence on their immediate contemporaries was no less invigorating than on their great successors.

It will become clear that my definition of Post-Impressionism for the purposes of this book is perhaps narrower in scope than is customary. It includes specifically those painters who reacted against the Impressionism of the 1870s and early 1880s in France, the main figures being Seurat, Gauguin, van Gogh and Cézanne. All had their followers, giving rise to various movements within Post-Impressionism. Early on, Seurat attracted an energetic following: Signac, Cross and Luce were among the more prominent Pointillists. It is as well to mention here something which often gives rise to confusion. Pointillism describes the methodical application of paint in dots or small dabs of colour clearly evident to the eye, a method invented by Seurat. But the word is often incorrectly used to describe the grander aspects of Seurat's painting; Neo-Impressionism is a more inclusive and preferable term. Neo-Impressionist theory promoted the breaking down, or division (hence 'Divisionism', another alternative term) of the depicted object into the primary colours, their complementaries and their derivative tones when white is added. Green, the local colour of grass, would be made up of blue and yellow; a purple dress, of red and blue. Grass in sunlight would be predominantly yellow and in shadow predominantly blue. The colour of a dress would be modified according to its position in shadow or sunlight. When areas of complementary colour are adjacent (red/green, yellow/violet, blue/orange) their intensity is strongest as they meet and thus the yellow becomes strongest at its edge and even spills over into the violet, and vice-versa. In practice the theory was considerably altered by individual preferences and temperaments, and Seurat far transcends it in the originality of his colour combinations and variety of handling.

Gauguin and his followers in Brittany constituted another group intent on reforming Impressionism and introducing a wider variety of subject-matter through pure colour and emphatic line; their movement was given the loose generic name, Synthetism. Van Gogh was familiar with Neo-Impressionism (through Seurat and Signac) and the Synthetism of Gauguin and such painters as Anquetin and Bernard; Cézanne, on the other hand, developed in a more isolated position, uninfluenced by either movement, yet sharing some of their more general characteristics. In the last decade of the century the Nabi painters, a further group, absorbed various influences, particularly that of Gauguin, but now seem closer to the Impressionist generation.

It is vital to remember that there were other forms of painting evolving simultaneously with Post-Impressionism, most notably the Symbolist movement with Moreau, Redon, Lévy-Dhurmer and Jean Delville. To many people the most surprising omission here may be a lack of any

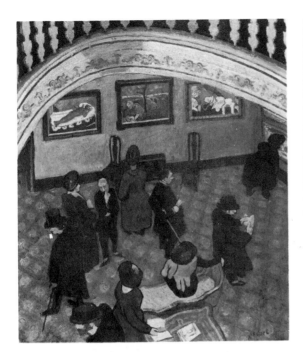

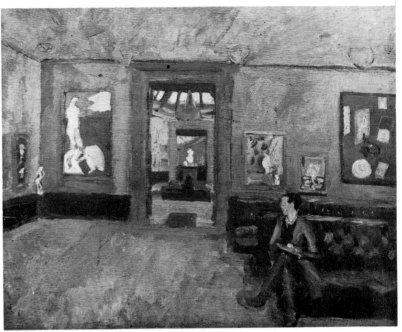

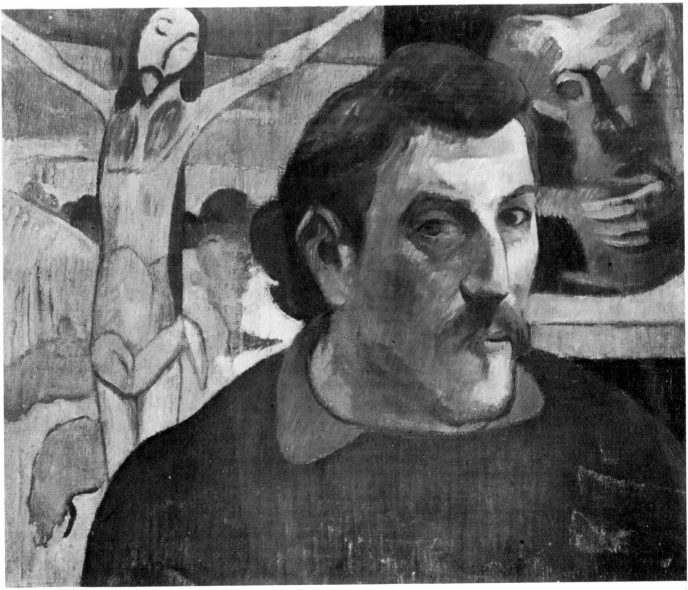

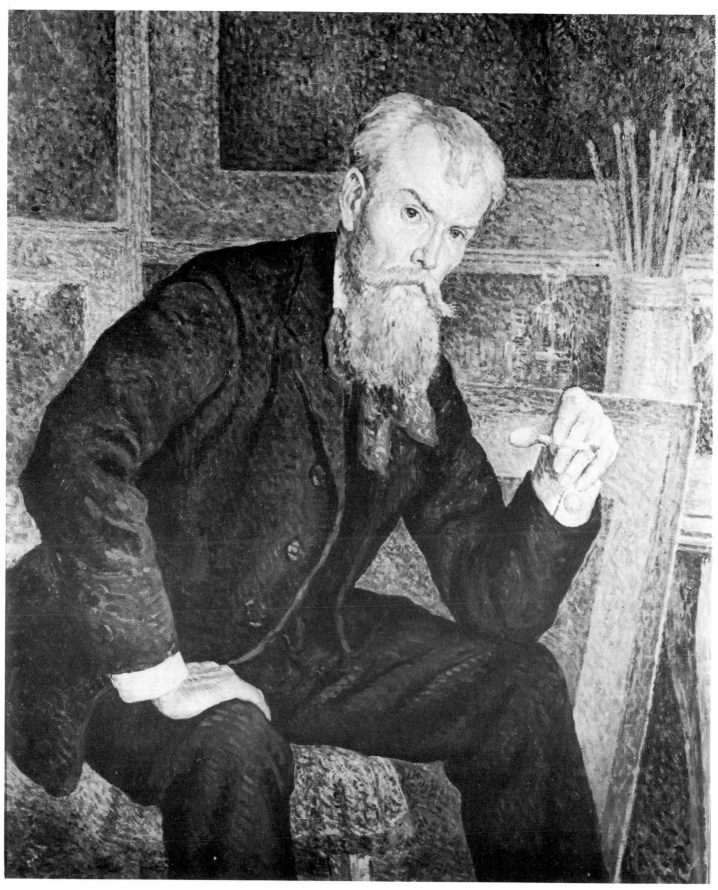

8. Maximilien Luce, *Portrait of Henri-Edmond Cross*, 1898. Oil on canvas. 39¼ × 31¾ in (100 × 81 cm). Paris, Musée d'Art Moderne.

lengthy discussion of Toulouse-Lautrec. Born in 1864, he was younger than the main Post-Impressionists, a year younger than Emile Bernard and not much older than several of the Nabi painters who were among his friends. But much of his art was derived from older painters such as Daumier and Guys, Manet and Degas. He did not share to the same degree any of the characteristics of Post-Impressionism mentioned above, although the evident humanity of his portrayal of contemporary men and women gives him a place beside van Gogh. His influence as a painter was much more limited; as a poster designer it was spectacular. Irony, humour, sharp psychological portraiture and acid line are not, however, chiefly characteristic of the Post-Impressionists and, on a formal level, Lautrec was less adventurous than they. His omission here (although he is represented among the illustrations) is by no means intended as a detraction; perhaps it even emphasizes his special position in late nineteenth-century painting.

We can rarely point to a single overwhelming cause for the way in which one movement follows another in painting. To disentangle one from the complex factors involved leaves the rest in a state of incompletion. Why does one style become especially dominant at a given moment, an expression of its time and place? Explanations involve a variety of considerations, from the larger issues of contemporary intellectual currents and pressing social conditions to the particulars of personality, local reaction and the influence of picture on picture. Some movements seem to be a smooth development from the art of the previous period; in others conscious rebellion sets the pace. Within movements, differences between adherents are usually more glaring than similarities. Vague general theory is often the only common denominator and the group name, or stylistic label, becomes simply an historical peg. Major painters associated with a movement are often ill-served by its definition. The individuality of lesser painters is swamped out of recognition (yet, curiously, it is often in their works that a movement's characteristics can be most clearly formulated). Artists have at all times formed groups, but a movement in painting may also be represented by several individuals pursuing similar aims even though they are more or less unknown to each other.

The Impressionists publicly emerged as a group in 1874. When we look at certain landscapes of about that time by Monet, Pissarro and Sisley, there is no doubt in our minds that these artists held certain aims in common, painted in similar methods and shared similar subjects. If we look at a group of Post-Impressionist paintings from, for example, fifteen years later, our response might not be so clear. But of one thing we would be certain, that they differed considerably from the Impressionists – in technique, in composition, in their internal rhythms and, very often, in the subjects depicted. Other sorts of painting during these years changed too, but a 'Salon picture' of 1874

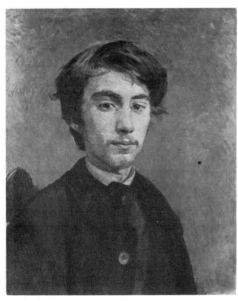

9. (*Top*) Maximilien Luce, *Portrait of Signac*. Black and blue chalk on white paper, 8 × 7 in (20.3 × 17.8 cm). Formerly Collection Benjamin Sonnenberg.

10. Henri de Toulouse-Lautrec, *Portrait of Emile Bernard*, 1885. Oil on canvas, 21¼ × 17½ in (54 × 44.5 cm). London, Tate Gallery.
Toulouse-Lautrec was twenty-one and Bernard seventeen at the time this portrait was executed, when both painters were students at the Atelier Cormon.

GROUPE IMPRESSIONNISTE ET SYNTHÉTISTE

CAFÉ DES ARTS

VOLPINI, Directeur

EXPOSITION UNIVERSELLE

Champ-de-Mars, en face le Pavillon de la Presse

EXPOSITION DE PEINTURES

DE

Paul Gauguin	Émile Schuffenecker	Émile Bernard
Charles Laval	Louis Anquetin	Louis Roy
Léon Fauché	Daniel	Nemo

Paris. Imp. E. WATELET, 55, Boulevard Edgar Quinet.

Affiche pour l'intérieur

11. Volpini's Café des Arts was situated on the Champ de Mars in Paris where the 1889 Universal Exhibition took place. Gauguin and his associates, excluded from the official exhibition, showed in the café with considerable success in terms of attendance and publicity.

would differ hardly at all from one of a few years later. It might have a veneer of being up to date, with perhaps a touch of Impressionist brushwork, but the Impressionists and Post-Impressionists appeared quite distinct from the 'accepted' artists of the day.

The gradual divergence of official art, as represented in France by the annual Salon – a vast exhibition of all kinds of painting which had to be acceptable to the official selectors – and the Ecole des Beaux-Arts, from those painters whose work was rejected or condemned, has in the past perhaps been too dramatically stressed. Manet, for example, had more pictures accepted by the Salon than refused, and the Impressionist generation, in the face of seemingly hopeless odds, continued their annual submissions. This debate between official and unofficial art came to a head with the Post-Impressionists. Although Seurat and Gauguin, for example, were at first accepted by the Salon, their subsequent work proved inadmissible and they preferred (as did the Impressionists eventually) to form their own exhibiting societies. The one-man exhibition or the group show at dealers' galleries or in hired

rooms was a relatively new departure in artistic life. In 1884 the Société des Artistes Indépendants eventually came into being, notable for its exhibition that year of Seurat's *Une Baignade, Asnières,* which had earlier been refused by the Salon.

The independent groups and societies which sprang up from then onwards in Paris were symptomatic of the artists' increasing isolation within the art world and their separation from the general public. It gave rise too to a comparatively new breed – that of the supposedly cultured person devoted to the arts, but who could not stand the painting of the day. Never before had there been such a gap between the so-called person of taste and the painters whose work mattered, who were the real guardians of tradition. The amateurs and *cognoscenti* of the eighteenth century were infinitely more receptive to the merits of their contemporaries and could act as patrons from a sense of real appreciation. Such people grew scarce in the mid-nineteenth century. To deplore Pissarro but admire his mentor Corot may seem to expose a lack of understanding of either painter. This attitude to new painting has continued ever since. But, of course, there were also a number of perceptive men and women who were unswayed by the opinions of the majority or of those in authority, free from aesthetic snobbery and the corset of social status. Their appreciation led to purchases and some of them should be mentioned here, people who frequently came to the rescue of the unconventional painters of the day – the publisher Georges Charpentier and his wife (Renoir's particular patrons); Eugène Murer, a hotelier of Rouen; Jean-Baptiste Faure, a singer with the Paris Opéra who bought Manet's *Le Déjeuner sur l'Herbe* and financed Sisley on a painting trip to England; Dr de Bellio; Dr Gachet of Auvers-sur-Oise; Victor Chocquet, a clerk at the Customs and fervent admirer of Renoir and Cézanne; and Count Armand Doria and the financier Count Camondo. We should not forget Manet's generosity to Monet, Degas's purchase of Gauguin, Mary Cassatt's efforts in America on behalf of her colleagues nor Gustave Caillebotte's great collection of Impressionist pictures left to the Louvre. Gauguin sold a considerable amount of work, van Gogh and Seurat hardly any; Seurat had independent means, as did Cézanne, Signac, Denis, Bernard and Vuillard. In general the Post-Impressionists came from middle-class backgrounds and were able to rely on family income.

The Post-Impressionists began painting under the influence of the Impressionists; the aesthetic and personal relations between the two groups were as diverse as those found within each group itself. The younger men took over quite naturally the Impressionists' new discoveries in composition (nourished by Japanese art and by photography), their subjects (more particularly themes from urban life) and their use of unadulterated colour in which neutral tints were abandoned in favour of close-woven textures of primary colours and their

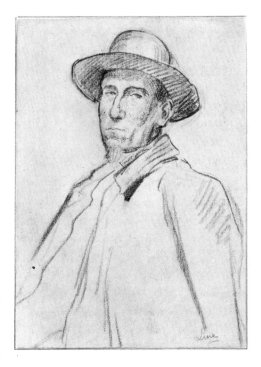

12. Maximilien Luce, *Portrait of Félix Fénéon.* Crayon, 10½ × 7½ in (26.7 × 19 cm). London, Courtesy of Sotheby Parke Bernet. Félix Fénéon (1861–1944) was one of the first writers to defend the Post-Impressionists, particularly Seurat and the Neo-Impressionists (a term he invented). He remained an influential art critic.

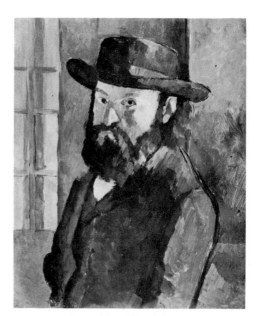

13. Paul Cézanne, *Self-Portrait*, c. 1879–82. Oil on canvas, 24 × 20 in (61 × 51 cm). Bern, Kunstmuseum.

complementaries. Linear perspective, dominant in European painting since the fifteenth century, was often replaced by a subtle gradation of atmospheric colour. Spontaneity of vision was matched by a freedom in handling and varieties of brushstroke within the same canvas. But with light as the motivating force behind the surface organization of a picture, forms tended to dissolve and crumble and the expression of volume became paper thin. To capture the *délicieuse finesse de fugitives nuances* ('exquisite finesse of fugitive nuances'), in Huysmans' words, was at first sufficient and commensurate with the Impressionists' early passionate and lyrical response to the landscape.

Between about 1880 and 1885 several of the Impressionists recognized some of the shortcomings of their vision and manner. 'I had come to the end of Impressionism,' Renoir told his dealer Vollard, 'and had arrived at a situation in which I did not know how to paint and draw. In a word, I was at an impasse.' (A. Vollard, *Renoir, An Intimate Record*). Pissarro was dissatisfied with his technique. Monet wrote to his dealer Durand-Ruel that he had 'come to the point of wondering whether I am going crazy or whether what I do is neither better nor worse than before, but the fact is simply that I have more difficulty now in doing what I formerly did with ease.' (Quoted in J. Rewald, *History of Impressionism*). All began to pursue different methods, going back to much earlier phases and themes in their own work or to the study of older painters (such as Ingres in Renoir's case) or younger ones (such as Seurat in Pissarro's). During this difficult time for the older generation younger painters became sure that Impressionism was no longer the style best suited to their vision of the world. It was too materialistic, too much rooted in everyday life – or rather there were other subjects and other more obviously 'imaginative' interpretations of daily life. Until the early 1880s the Impressionists concentrated on the world about them in all its impermanence and transitoriness. To use Cézanne's distinction, there was a danger of too much eye and not enough mind.

It would of course be a gross mis-statement to accuse Monet or Renoir of having no mind. But there was a tendency to repetition, to weak composition, to insufficient 'meaning'. We can see this particularly in a painter like Sisley who, in trying to maintain the qualities of his early landscapes, introduced inimical colours and gratuitously varied brushwork; his work of the 1880s looks hot and exhausted and no amount of powder and paint disguises the passing of his youthful lyricism. A return to more constructive and solid design in the early 1890s led to a period of recovery.

It was this woolliness, this superficiality which the Post-Impressionists wished to avoid and rectify; it became not simply a matter of imposing new concepts upon Impressionist methods but of evolving a radically new approach of their own. Certainly Seurat was never an Impressionist – his early drawings, his written notes and the

whole tenor of his early research point to a quite different sort of painter. But in his work he could not ignore Impressionist discoveries; they had to be incorporated within his own conception of painting. We see him doing this most clearly in his small oil panel studies for *Une Baignade*. In his choice of subject matter he was in line with the Realist development from Courbet and Manet to the most characteristic motifs of the Impressionists, even going to the very places where his elders pitched their easels – to the banks of the Seine, the 'café-concerts' and the coast of the English Channel. But nowhere do we find the scintillating atmosphere of Manet's late café scenes or the sensuous *joie de vivre* of Renoir's *Moulin de la Galette* and river boating parties. In Seurat's paintings all pleasure seems limited and temporal. There is a world of difference between Monet's dashing views of northern harbours and resorts and Seurat's serene and tranquil vision of the coast. Men and women bend their backs to work in fields where Renoir's girls had strayed to fill straw-hats with summer flowers.

Van Gogh was perhaps even further away from the Impressionists, the direction and feeling of his work both in Holland and later in Provence being essentially different. Only in his Paris period are the similarities noticeable; but even so the fundamental impulse behind his work remained consistent. Gauguin, older than either Seurat or van Gogh, was a true child of Impressionism, quarrying among them all in a search to focus his vision – sometimes his handling of paint comes close to Sisley; his Breton drawings remind us of the delicacy and unusual viewpoint of Degas; and then it seems that the example of Cézanne suddenly obliterates everyone else. But always, lurking in the background, is the figure of Camille Pissarro.

He was the oldest of all the Impressionists, the 'humble and colossal Pissarro' as Cézanne called him; it was in him that the two generations found a meeting place. He singled out Cézanne very early on; he encouraged Gauguin, befriended van Gogh; he saw in Degas an incomparable master. In mid-career he absorbed the principles of Pointillism from Seurat and Signac, turning his back on the 'romantic' Impressionism of Monet. It was a courageous move for a man with a large family, and a painter to whom the public was becoming just a little more accustomed. Domestically it was fatal; his wife accused him of deliberately pushing his family into financial suicide. Old friends mocked him; Renoir greeted him with 'Bonjour, Seurat' and Monet was soon exasperated with scientific explanations. But Signac expressed his and his friends' admiration: 'How much misery and trouble your courageous conduct will bring you! For us, the young, it is a great good fortune and a truly great support to be able to battle under your command.' (Signac to Pissarro, May 1887). And in his last years, bridging the generations, we find him giving advice to the young Henri Matisse.

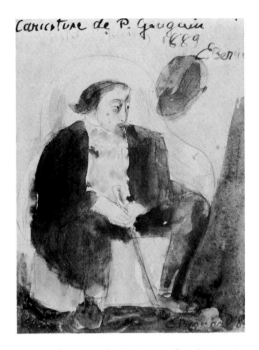

14. Emile Bernard, *Caricature of Paul Gauguin*, 1889. Pencil and watercolour, 7½ × 6 in (19 × 15 cm). London, Courtesy of Sotheby Parke Bernet.

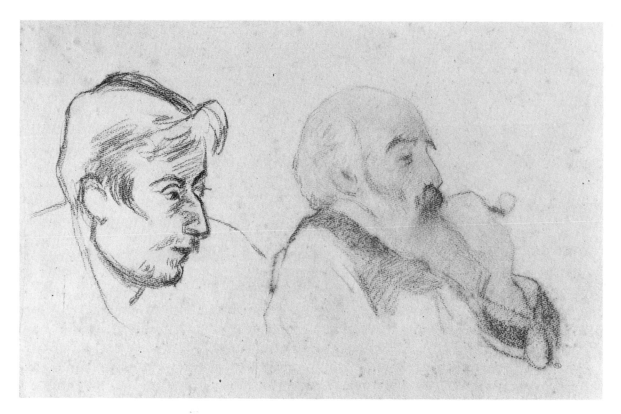

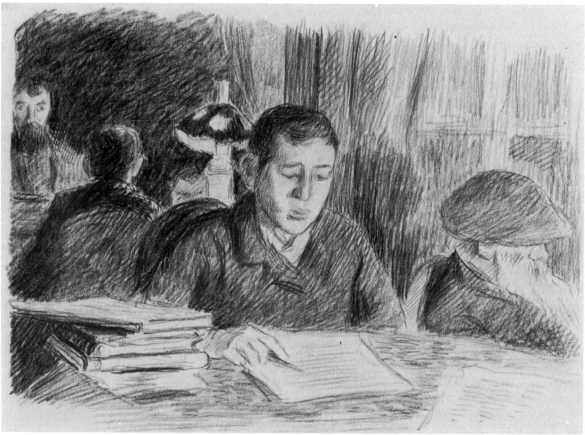

He was the elder statesman of the Post-Impressionist period to whom all seemed to come for guidance, encouragement and personal sympathy. His theoretical cast of mind and radical political views endeared him to the younger painters. The simplicity of treatment and directness of feeling in his studies of peasant life (uncommon among his fellow Impressionists) were appreciated by Seurat and van Gogh and prefigure a recurrent theme of the painters working in Brittany in the later 1880s. Unlike Monet and Renoir, he never withdrew from the artistic and political life of his time. When he was not busy finding things out for himself in Paris, he was kept in touch with new developments by his painter son Lucien. But it must not be presumed that he was a whole-hearted admirer of the Post-Impressionist generation; as we shall see, within a few years he renounced Pointillism, and he deplored the mystical in art as much as in daily life, complaining of 'the bustling of religious symbolists, religious socialists, idealist art, occultism, Buddhism, etc., etc.' He saw his early protégé Gauguin as one of the chief culprits of this mystical revival. But with a painting in front of him judgements and prejudices were suspended and his comments on contemporary French and English art are acutely perceptive.

The various responses to Impressionism by the younger generation are recounted in more detail in individual chapters, beginning with some of Seurat's followers who seem closest to the previous movement. It should be stressed that no matter how different their actual work appears, the Post-Impressionists retained an immense admiration for the achievements of the older painters, looked to them for support and were sustained by their example in their own struggles. But the very nature of their reaction against Impressionism, their drive to extend the boundaries of art towards greater freedom made their isolation from society more acute and the public's hostility more ferocious. The appeal of Brittany, for example, is partly explained by its isolated position away from the progressive mainstream of late nineteenth-century France; it was a refuge for painters who felt that they had little place in the society of their time. Monet, Renoir and Sisley were impeccable family men following the prevailing bourgeois way of life. Most of the painters discussed in this book were similarly inclined. Seurat, as far as is known, led an ordered industrious life, even concealing his mistress and child from his family and friends, as any good bourgeois might have done. The tumultuous and vivid lives of van Gogh and Gauguin were exceptions, but it is well to remember how much van Gogh hated the rattling Bohemian life of Paris and how deeply hurt Gauguin was by the enforced separation from his family. Nevertheless, the opposition encountered by the Post-Impressionists and the often appalling insecurity of their positions should be kept in mind. There has been a noticeable move to underplay them in recent studies, an understandable reaction to much romantic interpretive criticism and spurious psycho-

15. *Portraits of Paul Gauguin (left) and Camille Pissarro (right) by each other.* c. 1883. Pencil, 12⅜ × 19⅜ in (31.4 × 49.2 cm). Paris, Louvre, Cabinet des Dessins.

16. Lucien Pissarro, *Camille and Félix Pissarro at home,* c. 1884–6. Black chalk, 6 × 8½ in (15.3 × 21.4 cm). Oxford, Asmolean Museum.

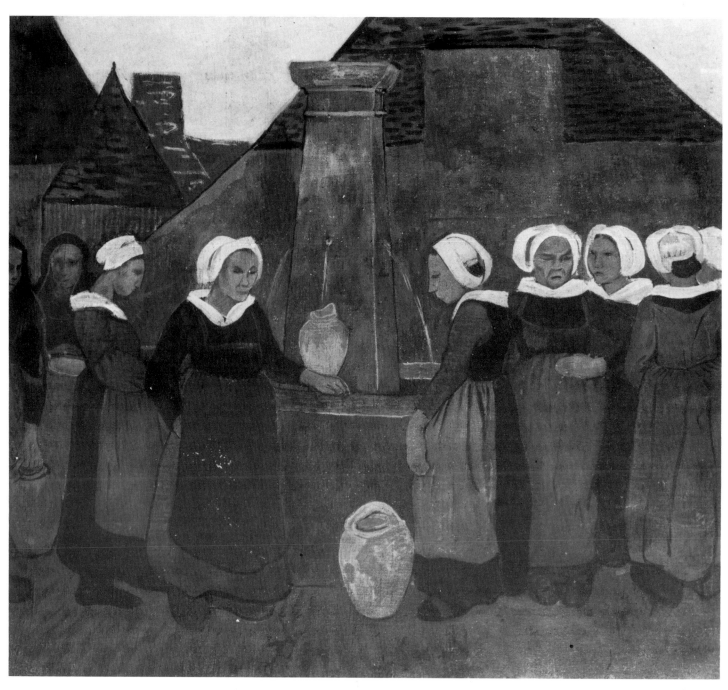

17. Paul Sérusier, *Breton women at the fountain, Châteauneuf de Faou,* 1893. Oil on canvas, 23¼ × 28 in (59.1 × 71 cm). London, Courtesy of Sotheby Parke Bernet.
With its ancient cultural and religious traditions, local costume and unspoilt landscape, Brittany inspired generations of painters from Boudin and Daubigny to Gauguin and Matisse. Sérusier called it his 'true homeland' and remained there until his death.

analysis. Although such considerations have little bearing on the quality of a particular picture they do say a good deal, of course, about certain choices of subject and circumstances of production.

Anyone familiar with the work of the Impressionists will have little trouble, looking at the reproductions in this book, in tracing the similarities and differences between the two movements. But it should be remembered that the Post-Impressionist dissatisfaction with Impressionism was not simply a reaction against technical procedures, a way of reforming composition and handling. New kinds of subject matter

demanded such changes. A return to the self and all the complexities of its dreams, reflections and symbols needed a new language for their reinstatement. 'Before his easel,' wrote Gauguin, 'the artist is slave neither to the past, the present, nature nor even to his neighbour. Himself, always himself.' (Gauguin, *Avant et Après,* pub. 1923). Where an Impressionist landscape bathes us in sensuous and uncomplicated feelings, a landscape by van Gogh introduces to us considerations which had not arisen before in front of a cornfield and a few dark cypresses. The immense popularity of Renoir or Monet depends on pleasurable associations. The equal popularity of pictures by van Gogh and Gauguin is a different phenomenon and although pleasure is naturally a prominent ingredient, such pictures offer something less easily defined. It is the pleasure of the unexpected, the introduction of the strange, the highly personal, of colour that ignites rather than re-assures, of unfamiliar associations. And there are moments when the sight of van Gogh's night-sky or a cheap bowl of flowers come as a relief from endless Impressionist afternoons or the peonies of Manet and when Cézanne's shattered rocks and pines seem like a restorative after the lush and healthy landscapes of the Ile-de-France.

We must think of the Post-Impressionists not just as newcomers in the field of painting, but as men who extended our knowledge and who, consciously or unconsciously, reflected increasingly complex ways of thinking. Through their thorough investigation of the properties of painting and the expression of emotions new to art such painters as Seurat and Gauguin in their rigorous audacity are forebears of some of the artists of our own time. One of their most striking qualities is the simplicity of their imagery. They suggest profoundly exciting emotions through subjects which would have previously been thought too flimsy or even banal to carry such weight of feeling. Two boring men sit opposite each other immobile at a game of cards, an empty quayside confronts an unruffled sea, a bunch of half-wilted sunflowers is stuck in a plain earthenware pot. What a far cry they are from writhing Depositions, the coronation of emperors, portraits that are flamboyant, noble or picturesque and landscapes rich in human incident under complicated skies.

Yet the often simple imagery of the Post-Impressionists is deceptive; it veils levels of experience and feeling expressed through highly calculated procedures. In their greatest works there seems to be a sense of tragedy – of melancholy, gravity, a distilled solemnity of occasion. It is this which marks a return to one of the fundamental preoccupations of European painting. Essential as they are, discussions of the formal qualities and manipulation of the surface in, for example, a Seurat or a Cézanne can only be regarded in the light of their overall purpose. Only when we feel as though we are satiated with all the intricacies of their practice does the full importance of their work become apparent.

2
Seurat and Neo-Impressionism

In May 1884, when he was twenty-four, Seurat exhibited the first masterpiece of his short painting life and one of the pre-eminent paintings of the nineteenth century in which imagery and technique are fused in a miraculous design. This was the large *Une Baignade, Asnières* (plate 25). Several Parisians, mainly boys, relax on the bank of the Seine – bathing, boating or simply lying in the sun, gazing over to the Ile de la Grande Jatte. Factories and their chimneys, veiled in summer haze, provide a background to these circumscribed pleasures. The mood is sober, the activities are restrained; to feel a certain warmth on pale urban skin is enough. It is a scene of absolute calm presided over by the monumental figure of the boy dangling his legs in the water, immutable at the centre of a composition of faultless diagonals. Small details add counterpoint to the broad melody of the painting – the shoe tabs, the beribboned straw-hat, the alert small dog and the figures boating in the middle distance. Although long familiarity with this picture never diminishes the potency of its subject, it is subsumed by the perfection of the overall harmony, the continual transaction between line and line, colour and colour, the disposition of light and dark accents.

In the year in which Seurat exhibited this work students not much younger than himself were bidden at the Ecole des Beaux-Arts (where he had been a student) to try for the coveted Prix de Rome with a picture of the following subject:

After Lucretia has killed herself, Brutus extracts the dagger which she used and, holding it, swears to pursue Tarquinius and his race and to endure no longer kings in Rome. Near the dead woman will be represented Collatinus and Luciolus her husband, her father, and Valerius Publicola, all repeating Brutus's vow.

Ennobling and morally elevating paintings were still expected to be the outcome of a student's training; usually mythical or historical in inspiration, they frequently combined landscape and nude or semi-nude figures (the toga being indispensable stage property for the conservative and ambitious student). In most academies the fossilized Neo-Classical

18. Georges Seurat, *Portrait of Edmond Aman-Jean*, c. 1883. Conté crayon, 24½ × 18¾ in (62.2 × 47.6 cm). New York, Metropolitan Museum of Art (Stephen C. Clark Bequest, 1961).
Seurat and the painter Aman-Jean (1859–1936) had met as students at the Ecole des Beaux-Arts and remained friends. This portrait was Seurat's first exhibited work, hung at the official Salon of 1883.

19. Georges Seurat, *The Gleaner,* c. 1883.
Crayon, 12⅝ × 9½ in (32 × 24.1 cm).
London, British Museum.
This drawing should be compared with van
Gogh's treatment of a similar theme (plate 23).
Both works suggest the influence of Millet.

20. (*Opposite above*) Georges Seurat, *Port at
Gravelines (le chenal de Gravelines: Petit Fort-
Philippe*), 1890. Oil on canvas, 28¾ × 36½ in
(73 × 92.7 cm).
Indianapolis, Museum of Art (Gift of
Mrs James W. Fesler in memory of Daniel
W. and Elizabeth C. Marmon).

21. (*Opposite below left*) Georges Seurat,
Study for Le Chahut, 1889. Oil on panel,
8½ × 6½ in (21.5 × 16.5 cm). London,
Courtauld Institute Galleries.

22. (*Opposite below right*) Georges Seurat,
Seated Model, 1887. Oil on board, 9½ × 6 in
(24 × 15.2 cm). Paris, Louvre.

tradition of David persisted and, as a conscientious student at the
Beaux-Arts, Seurat had gone through the mill of drawing from antique
casts, copying and the life-room. His master Henri Lehmann had been
a pupil of Ingres and we can see the influence of that artist in some of
Seurat's early drawings. There is no record of Seurat having rebelled
against the straightjacket of such teaching methods, no episodes
comparable to those found in the early careers of Monet and Manet. It
appears that he was content to continue drawing and to make his own
independent discoveries among the old masters – either in the Louvre or
from engravings and art-books. He copied Dürer and Holbein,

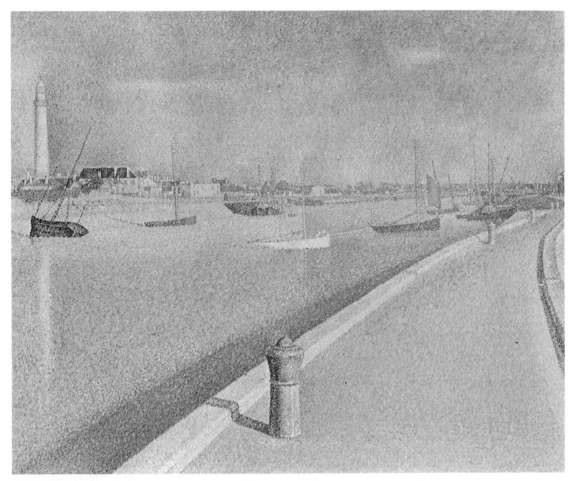

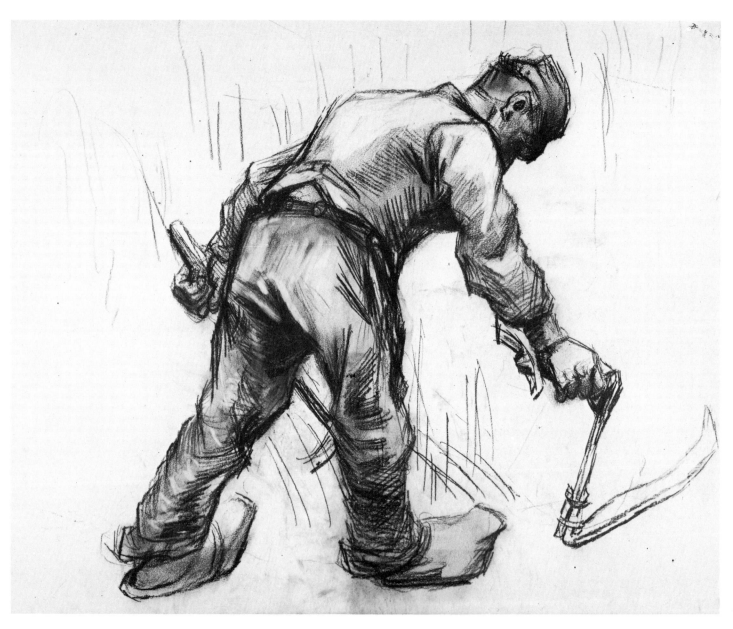

23. Vincent van Gogh, *Peasant Reaping*, 1885. Charcoal on paper, 16¼ × 20 in (41 × 51 cm). Amsterdam, National Museum Vincent van Gogh.

Raphael, Poussin, Michelangelo and Titian, as well as casts from the Parthenon and Hellenistic sculpture. Piero della Francesca, that painter invariably evoked in connection with Seurat, was represented at the Beaux-Arts by two copies placed in the chapel. They would certainly have been known to him, but no drawings from them – if indeed there were any – have come to light. Piero was not much appreciated at that time but it is difficult to look at the boy wearing the straw-hat in *Une Baignade* without thinking of the sleeping soldier, head in hands, in Piero's *Resurrection*.

Not all academic teaching, however, was as stilted as that found among some teachers at the Beaux-Arts. The annual Salon was by no means crammed with heroic nudes and Roman matriarchs – there were genre scenes similar to those found in the work of Manet and Renoir

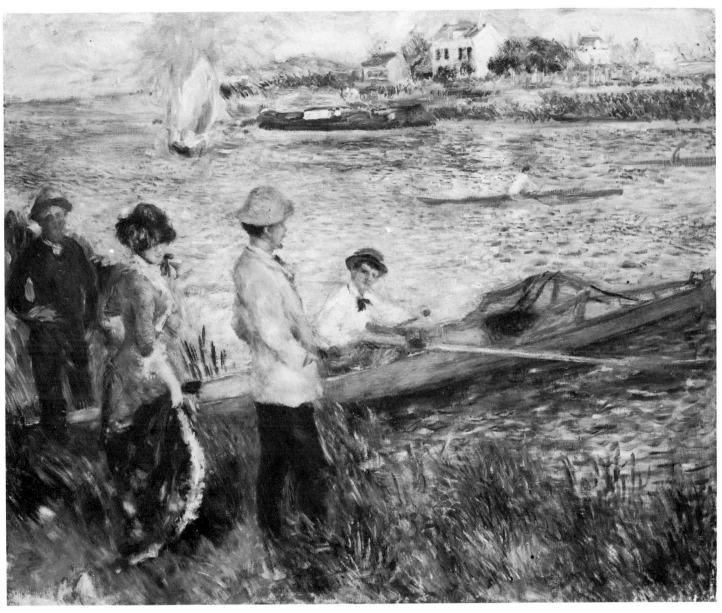

24. Pierre-Auguste Renoir, *Oarsmen at Chatou*, 1879. Oil on canvas, 32 × 39½ in (81.3 × 100 cm). Washington, National Gallery of Art (Gift of Sam A. Lewisohn, 1951). Seurat's early sketches for *Une Baignade* show the influence of Impressionist brushwork although his interpretation of river-side recreation is in a markedly different spirit from Renoir's.

although the treatment was different. There was an established body of critical opinion calling for a new modernity in painting, for an end of 'taking refuge in legend, of looking through the registers of the imagination. . . . The universe which we have before us is the very one which the painter must depict and translate.' This was the critic Jules Castagnary's exhortation of 1867 and since then the whole glorious episode of Impressionism had taken place. When Seurat began to paint in about 1881, he quite naturally adopted recent Realist subjects – peasants at work, the raw suburbs of expanding Paris, modest Barbizon landscapes and people bathing by the Seine. Seurat knew the Impressionists' work from his visit to their fourth exhibition in 1879; he was particularly taken by the Renoirs that he saw at Durand–Ruel's gallery. The early oil sketches for *Une Baignade* have something of the painterly

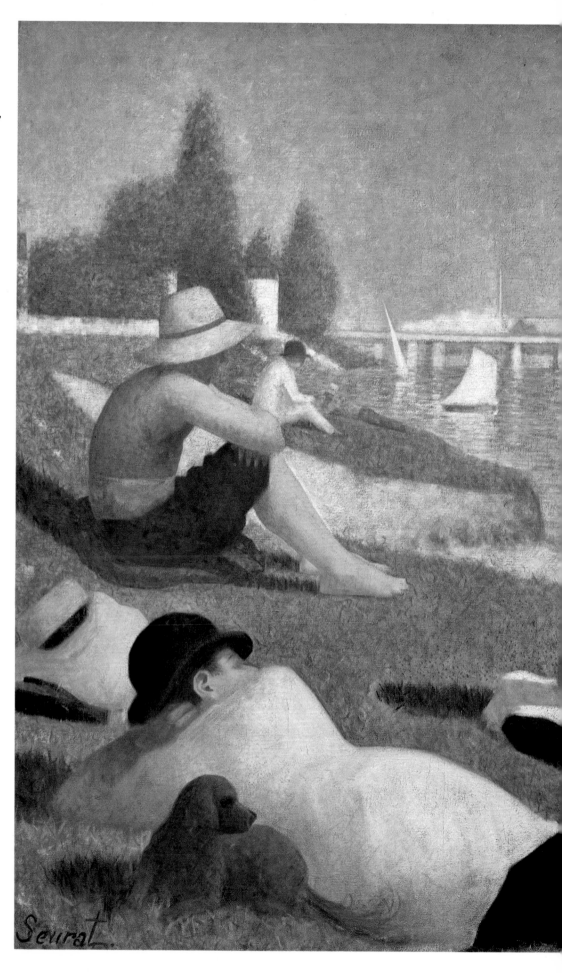

25. Georges Seurat, *Une Baignade, Asnières*. 1883–4. Oil on canvas, 79 × 118½ in (201 × 298 cm). London, National Gallery.

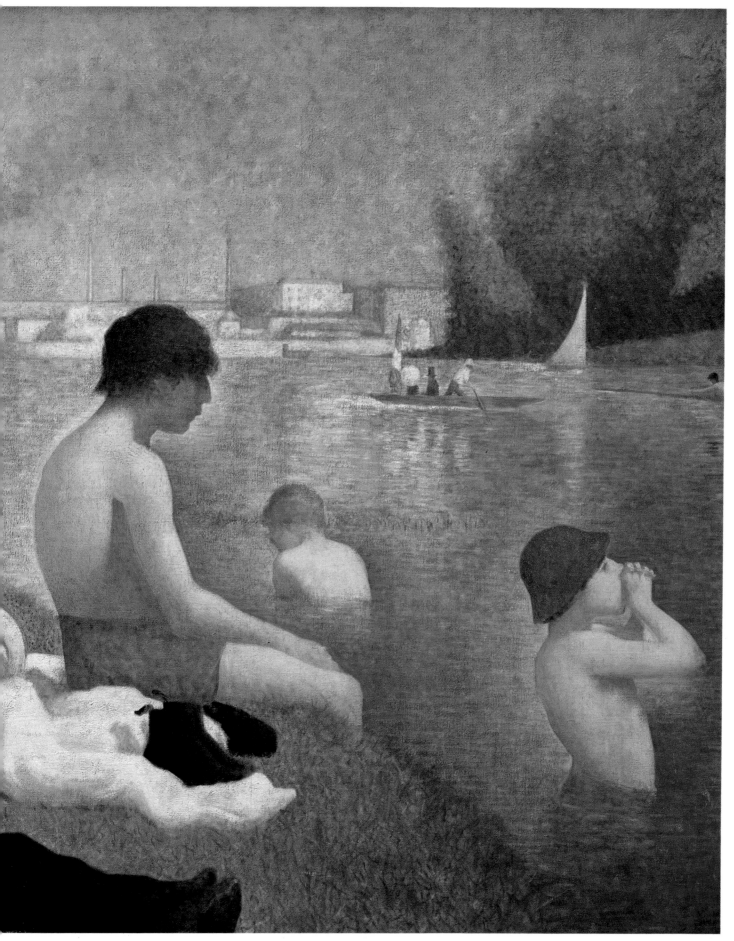

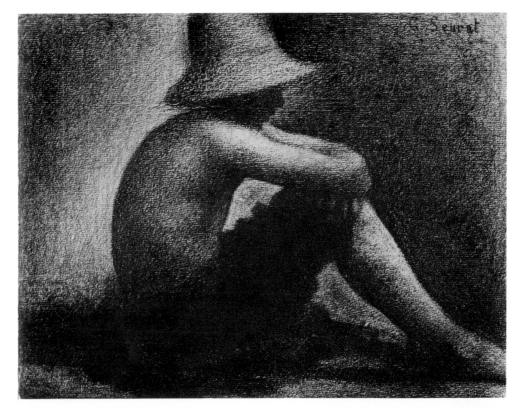

26. Georges Seurat, *Seated boy with straw hat,* c. 1883. Conté crayon drawing, 9½ × 11⅞ in (24.13 × 30 cm). New Haven, Connecticut, Yale University Art Gallery (Everett V. Meeks Fund).

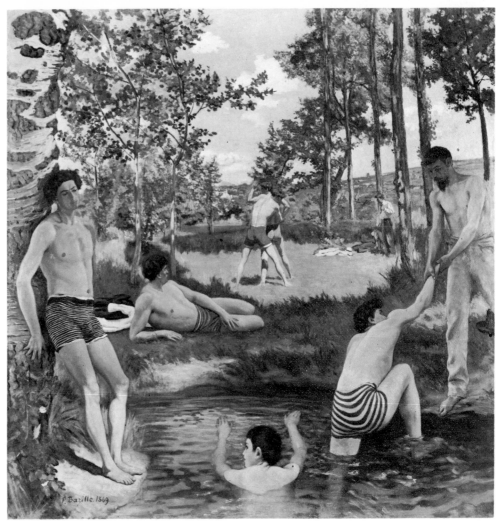

27. Frédéric Bazille, *Summer scene,* 1869. Oil on canvas, 62¼ × 62½ in (158.1 × 158.7 cm). Cambridge, Mass., Fogg Art Museum, Harvard University, (Gift of M. and Mme. F. Meynier de Salinelles).
Cézanne's groups of male bathers (plate 111) celebrate the pleasures of his youth in Provence and his memories of classical literature. With Bazille (the only other painter of the Impressionist generation to treat the theme) we are nearer Seurat's depiction of contemporary life.

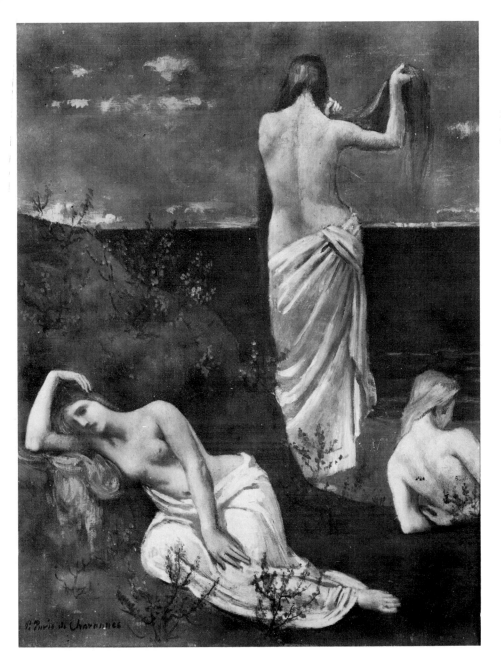

28. Pierre Puvis de Chavannes, *Young Girls by the sea,* 1879. Oil on canvas. Paris, Louvre, Cabinet des Dessins.

vitality and brisk drawing of a work like Renoir's *Boating Party at Chatou* (1879), as well as a similarity of theme. But where Renoir is pleasure-loving, gaily celebrating elegant clothes and a first-class boat, Seurat's social implications are inescapable. To Renoir, the only one among the Impressionists from a working-class background, it would have been inconceivable to hint even at the sort of criticism implied by *Une Baignade* by Seurat, the son of a well-to-do family and the possessor of a private income.

The point is important in considering the ideas of several of the Post-Impressionists, particularly the followers of Seurat. They were more prepared than the older generation to bring their beliefs to bear on their work. Even Pissarro, who at one point felt that it would be safer to leave France because of his well-known anarchist sympathies, rarely strays in his painting into political territory. Seurat and some of his

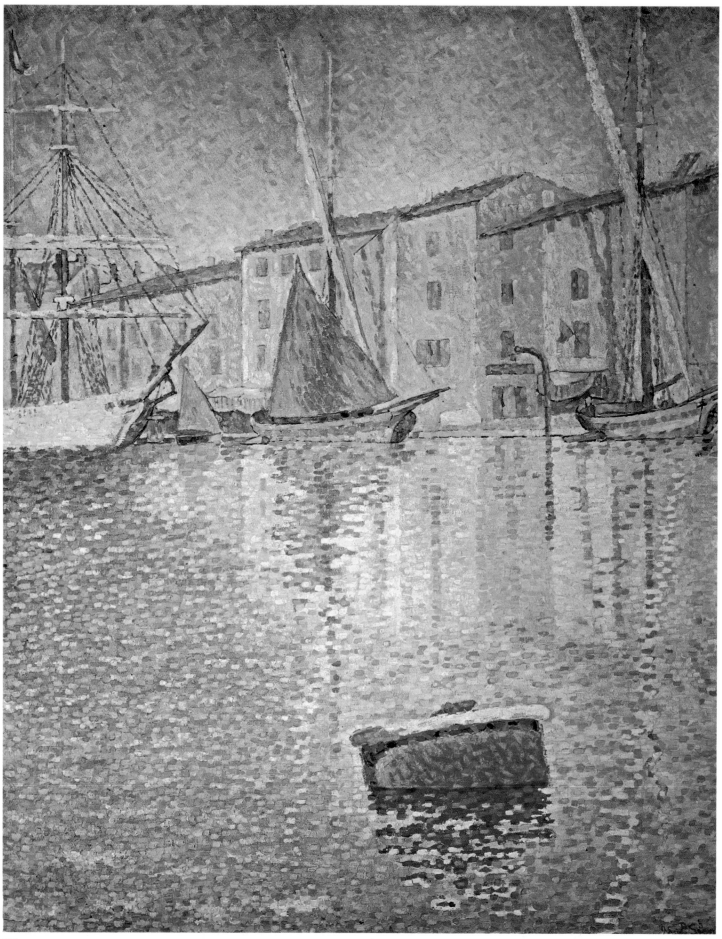

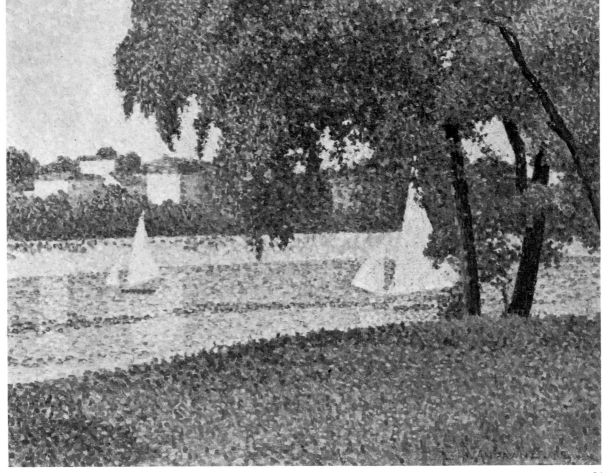

30. (*Above right*) Paul Signac, *The Bridge at Asnières,* 1888. Oil on canvas. London, Private Collection.

31. (*Right*) Charles Angrand, *The Seine at Courbevoie,* 1888. Oil on canvas, 19½ × 25 in (49.5 × 63.5 cm). London, Private Collection.

29. (*Left*) Paul Signac, *The Red Buoy.* Oil on canvas. Paris, Louvre.

32. Georges Seurat, *The Canal, Gravelines, looking towards the sea*, 1890. Oil on canvas, 28¾ × 36½ in (73 × 93 cm). Otterlo, Rijksmuseum Kröller-Müller.

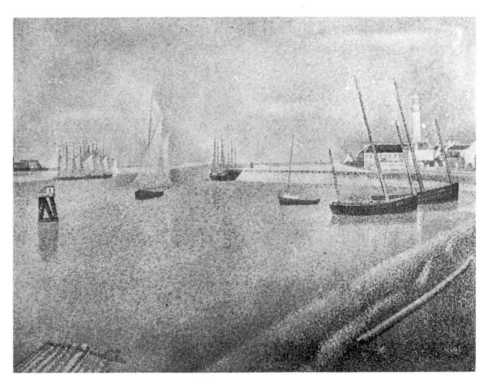

close friends shared anarchist and reforming views; although these are not made directly evident in Seurat's paintings, they can be sensed in the choice of subject and in the technical and compositional methods that he developed from *Une Baignade* to his death.

Close associates such as Paul Signac and Maximilien Luce were vociferous critics of the world from which they frequently chose their themes. The Pointillist application of paint developed by Seurat and propagated by Signac and others was only the skin to a body of theory inspired by concepts of liberty and equality available through the grasp of certain practical rules. To put the analysis of light on a firm scientific basis was almost an act of political philanthropy in itself: such methods would become available to anyone. An undeniable proof of this aspect of the Pointillist movement is found in the number of adherents attracted to it who shared visions of social justice and faith in scientific progress: the Pissarros, father and son; Louis Hayet and Léo Gausson are examples.

Une Baignade, of course, is not a Pointillist work in spite of Pointillist additions made to it by Seurat in 1887 (on the boy's red cap for example). But it contains certain ideas which became major pre-occupations of the artist in the great works which followed – *La Grande Jatte, Les Poseuses, Parade, Le Chahut* and *Le Cirque*. It is worth examining the stages by which Seurat arrived at a manner of painting which struck several receptive contemporaries so resoundingly and made converts so rapidly and yet is in many ways a logical development of much that had gone before – from Delacroix through Manet to the Impressionists.

A description of Seurat might serve as a preface to such an outline. He was tall, good-looking, soberly dressed, restrained in his speech until the excitement of a particular idea brought animation to his voice and face. He had always been extraordinarily studious and had read and annotated theoretical and scientific works from his days at the Beaux-Arts. 'He believed in the importance of theories, in the absolute value of methods and in the future of revolutions,' wrote the Symbolist critic Teodor de Wyzewa. He was friendly with many of the progressive writers and painters of his time and enjoyed intellectual discussion. He was also totally dedicated to his work and so sure in his method and so thorough in his preparation before beginning a large work that he often painted into the night by artificial light. His secrecy has become famous and many details of his private life are elusive. It was not until a week before he died that his mother and friends learned of the existence of his mistress Madeleine Knoblock (see *La Poudreuse,* plate 33) and his one-year-old son. He would talk persuasively about his work but rarely wrote anything down – unlike his contemporaries van Gogh, Gauguin or Signac – and what statements we have are terse and telegrammatic.

As we survey the ten years or so of his working life – he died in 1891 aged thirty-one – we see a pattern emerge of concentrated energy, an almost step-by-step plan of attack, hardly deviating in his re-examination of the properties of painting. Compared to Seurat, several of his contemporaries seem haphazard, turning this way and that to find the nourishment that was vital to the continuity of their activities. Seurat's profound self-confidence in reconciling the demands of painting with the peculiarities of his temperament ensured that he never made a false step nor started down some unprofitable road. It is this inner conviction of the importance of what he was doing, combined with a rare and lovely sensibility, which put him far above his many competent followers. He approached the unknown along the path of what he knew already to be absolute certainties.

Those certainties were not gained at the Beaux-Arts for, as Signac later observed: 'He was preserved from the dismal influence of that school by his intelligence, his strength of will, his lucid and methodical turn of mind, his uncontaminated taste and his painterly eye. Constantly in and out of the museums, prizing our libraries for their stocks of art-books and engravings, he drew from the study of the classical masters just the strength that he needed to stand out against the lessons of the school. In the course of these independent studies, he noticed that in Rubens, as in Raphael, and in Michelangelo, as in Delacroix, line and chiaroscuro and colour and composition were subject to analogous laws: rhythm, proportion and contrast.' (Signac, *La Revue Blanche,* 1899).

Through his teacher Lehmann Seurat was at one remove from Ingres, but his independence took him early on to a study of Delacroix. He annotated his writings, sought out his works in dealers' shops and

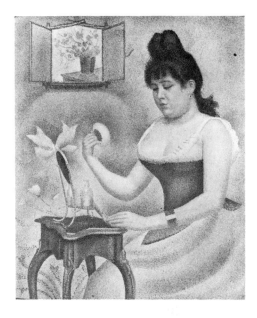

33. Georges Seurat, *La Poudreuse,* 1890. Oil on canvas, 37½ × 31¼ in (95.3 × 79.4 cm). London, Courtauld Institute Galleries. A portrait of Seurat's mistress and the mother of his child, Madeleine Knoblock.

34. (*Opposite above*) Lucien Pissarro, *Au Café Concert*, c. 1886–8. Crayon, 6⅜ × 8⅜ in (16.2 × 21.3 cm). Private Collection.

35. (*Opposite left*) Georges Seurat, *At the 'Concert Européen'*, c. 1887–8. Conté crayon, sheet 12¼ × 9⅜ in (31.1 × 23.8 cm). New York, Museum of Modern Art (Lillie P. Bliss Collection).

36. (*Opposite right*) Georges Seurat, *Clowns and Pony*, c. 1882–3. Conté Crayon drawing, 9½ × 12½ in (24.1 × 31.7 cm). Washington, The Phillips Collection.

held that artist's character in high regard. He studied colour theory as found in Eugène Chevreul and Charles Blanc and reinterpreted his findings in the light of Ogden Rood, the American physicist whose *Modern Chromatics* appeared in France in 1881. Not until a little later did he begin to paint systematically, for he was almost entirely preoccupied with black and white, beginning that long series of drawings (mainly of figures but also of rural and urban scenes) which Signac described as 'the most beautiful painter's drawings in existence'. One, a portrait of his friend Edmond Aman-Jean, marked his début at the Salon of 1883 (plate 18). In a drawing such as the study of a seated boy for *Une Baignade* (plate 26) we see the form reduced to its essentials through the most delicate gradation of values from the rich black of the crayon to the white of the paper. Yet the figure itself retains its identity in counterpoint to the dream-like chiaroscuro. By 1882–3 Seurat was also painting small panels of landscapes and working people in the country east of Paris where his father lived, in and around Barbizon and in the city suburbs. Jean-François Millet seems to have provided some of the subject matter and the paintings also show kinship with the work of the Barbizon school and with Pissarro. An increasing interest in Impressionism was finally reflected in the oil studies begun in 1883 which went towards the making of *Une Baignade*, regarded by some writers as manifestly anti-Impressionist in its aims. The preparatory sketches are often reminiscent of Monet and Renoir, but none of the Impressionist generation had attempted the particular subject of *Une Baignade* before; Bazille's *Summer Scene* (plate 27) comes near to it but has a rather lifeless air. And Cézanne's male bathers of 1875–6 are conceived in quite a different spirit.

The work of Pierre Puvis de Chavannes (1824–98) has also been suggested as an influence; he was the one painter Seurat knew well outside the Impressionist circle and his own contemporaries. With Aman-Jean, Seurat was a frequent visitor to Puvis's studio in 1879 and 1881–2. It is not difficult for us to understand the admiration expressed by Seurat, Gauguin and van Gogh for Puvis's decorative frescoes. Painters often have an enviable capacity to concentrate on a particular feature which interests them in a work and to disregard the rest. When we look at those fusty and rheumatic figures grouped on seashores or in clearings among trees, we cannot doubt that it was not the subjects that attracted them, nor the pallid colour of many such scenes. Puvis had a monumental sense of form and his figures are often simplified to meet the exigencies of a large overall design. In his emphasis on contour and in the subtle relationships established between figure, ground and sky he shares obvious affinities with Gauguin and Seurat. His passion for early Italian frescoes, for Greek sculpture and Egyptian art, which was reflected in his own work, drew sympathetic assent from the younger painters dissatisfied with Impressionism. These archaic quali-

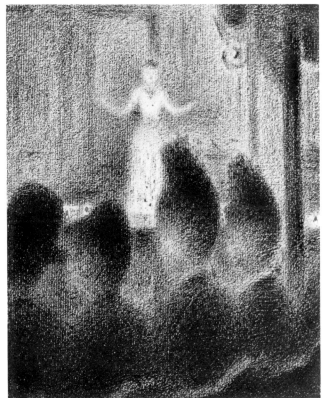

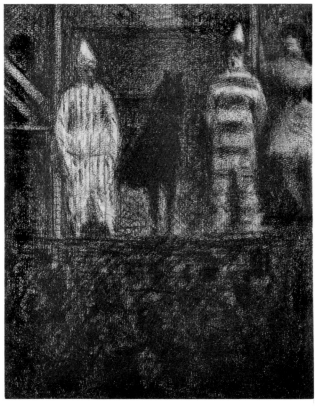

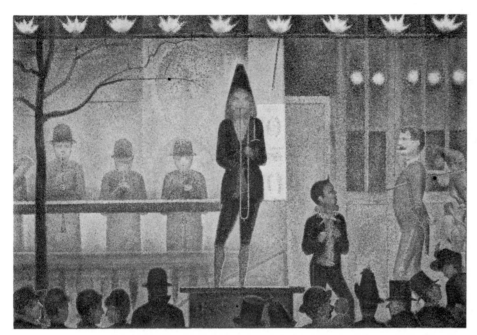

37. (*Above left*) Georges Seurat, *La Parade,* 1887–8. Oil on canvas, 39¾ × 59⅛ in (99.7 × 150.2 cm). New York, Metropolitan Museum of Art (Stephen C. Clark Bequest, 1960).

38. (*Above right*) Georges Seurat, *Le Chahut,* 1888–9. Oil on canvas, 67⅛ × 55¼ in (170.5 × 140.3 cm). Otterlo, Rijksmuseum Kröller-Müller.

39. (*Opposite above*) Georges Seurat, *Sunday afternoon on the Island of Grande Jatte,* 1884–6. Oil on canvas, 81 × 120⅜ in (205.7 × 305.7 cm). Chicago, Art Institute of Chicago (Helen Birch Bartlett Memorial Collection).

40. (*Opposite below*) Georges Seurat, *Les Poseuses,* 1886–8. Oil on canvas, 79 × 98⅞ in (200.7 × 251.1 cm). Merion, Penn., Barnes Foundation.
The inclusion of other works of art in paintings by late nineteenth century artists is seen here at its most evocative and mysterious – in the similarity of images (hat, parasol, seated figure) and the contrast of indoor and outdoor and naked and clothed which the presence of *La Grande Jatte* affords.

ties caused him to be underrated by the public for many years. The English painter Charles Ricketts noted the strangeness of the appearance in the Salon of 1884 of Puvis's *The Sacred Grove,* a work affectionately parodied by Lautrec and admired by van Gogh: '. . . it produced the effect of some Greek fragment lost in an upholstered drawing room with the velvet poufs and pink lamp-shades then in vogue.' (C. Ricketts, *Pages on Art,* 1913).

No sooner was *Une Baignade* finished than Seurat began work on another large painting, *La Grande Jatte* (plate 39). It was similar in subject matter – figures out-of-doors in summer – but in the complex composition, systematic handling of colour and the development of a controlling pictorial light; in contrast to the varied reflections of natural light which we see in Monet or Sisley, he moved even further away from the Impressionists. The geometrical rigidity of the posture and spacing of the forty or so figures, the elaborate planning of detail and the use of multiple perspective contribute to the painting's grand immobility and its almost disquieting air of 'unreality'. At the same time Seurat is so sensitive to the nuances of values, the modulation of contour and enlivening detail, that a perfect balance is maintained between abstraction and the exigencies of his subject in all its Sunday banality. The Pointillist technique employed (although not, it should be noted, with complete consistency) rids the work of that freedom and spontaneity of gesture so central to Impressionist practice. It allows the most subtle tonal changes through the vibration of juxtaposed touches of colour and, through the slight variations in size of those touches, plays an important architectural role.

Une Baignade had included earth colours and was painted in small brush-strokes which evoke surface appearances – short criss-cross strokes for

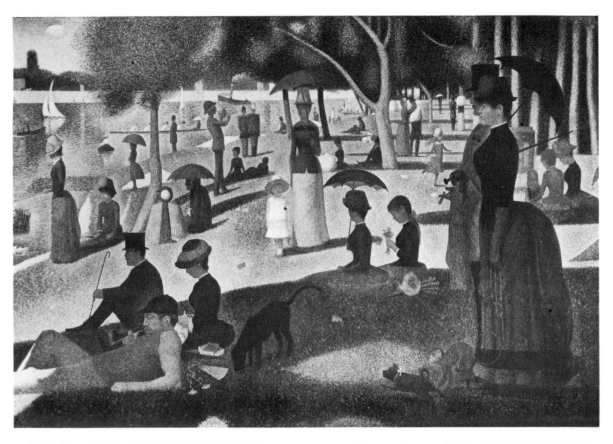

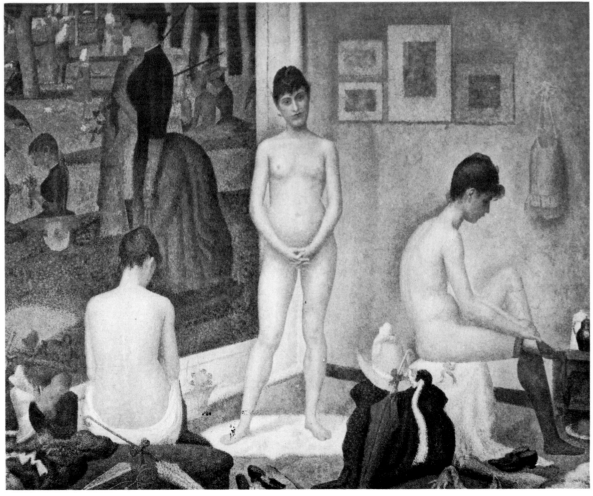

41. Paul Signac, *Breakfast*, 1886–7. Oil on canvas, 35 × 45¼ in (89 × 115 cm). Otterlo, Rijksmuseum Kröller-Müller.
This and *The Milliners* – two interior scenes – are unusual in Signac's work which is mainly devoted to ships, coastlines and harbours (Signac was a fervent yachtsman). Both are subjects treated frequently by some of the Nabi painters, especially Vuillard and Vallotton.

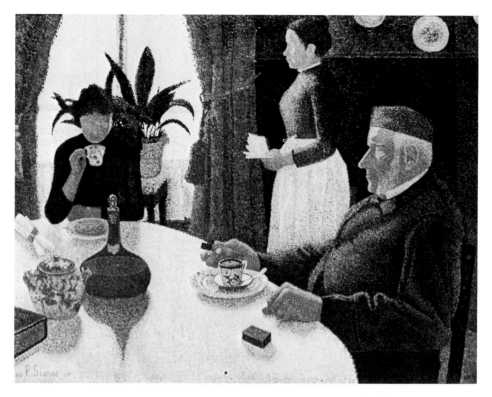

42. (*Opposite*) Paul Signac, *The Milliners*, 1885. Oil on canvas, 39⅜ × 31⅞ in (100 × 81 cm). Zurich, Bührle Foundation.
Signac's first great Neo-Impressionist work which hung in the same room as Seurat's *La Grande Jatte* in the Eighth (and last) Impressionist Exhibition of May 1886.

the grass, and longer horizontal ones on the lightly ruffled water. In *La Grande Jatte* the dot reigns supreme and Seurat's palette is composed of the colours of the spectrum and the tints that result when those are mixed with white. The expressive qualities of line and colour – their physiological effect – were explored in Seurat's later works with his customary rigour. Contemporary scientific writings again aided his almost fanatical dedication to the formulation of an aesthetic that was self-contained, free from messy improvisation and which, through the conscious application of rules, could produce a masterpiece from the most unpromising subject. From *Les Poseuses* (plate 40) onwards Seurat's large studio paintings – *Parade, Le Chahut, Le Cirque* – are indoor Parisian subjects with artificial lighting. Outdoor subjects were relegated to the summer months when Seurat stayed at Grandcamp, Honfleur and Port-en-Bessin on the Channel coast where he produced remarkable seascapes and harbour views – from the complex sea-front architecture of Port-en-Bessin (1888) to the great open spaces of his last pictures of Gravelines.

Since his student-days Seurat had realized the expressive potential of certain combinations of colours and directions of lines. Reading Blanc on Delacroix had perhaps planted the seeds of a preoccupation that became prominent only in his last works. A book by a young contemporary, Charles Henry, set out such ideas as demonstrable facts and with innumerable examples. Seurat read the book, *Introduction à une Esthétique Scientifique,* when it appeared in 1885 and met Henry the

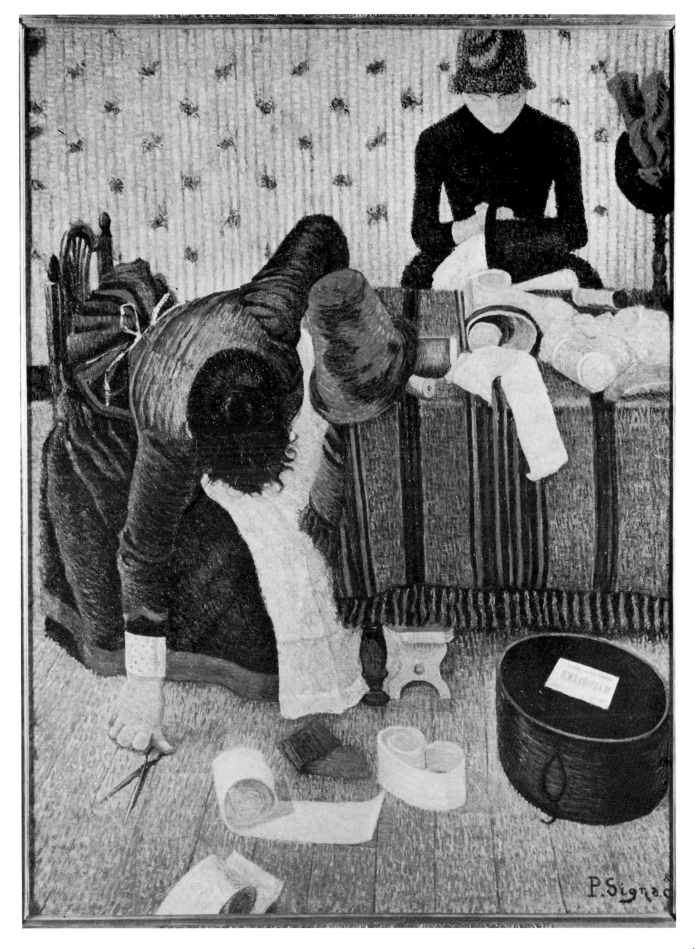

following year. In a letter written to the writer Maurice Beaubourg (28 August 1890) Seurat states with characteristic economy this particular part of his aesthetic:

Cheerfulness, in terms of value, means a luminous dominant tone; in terms of colour, a warm dominant tone; in terms of line, lines above the horizontal, thus:

Calm, in terms of value, means equilibrium between dark and light; in terms of colour, equilibrium between warm and cold; in terms of line, the horizontal.

Sadness, in terms of value, means a dark dominant tone; in terms of colour, a cold dominant tone; in terms of line, downward movement, thus:

If we look at Seurat's *La Parade* (plate 37) the complex geometry of his later style is immediately apparent. But how ironically he uses his symbol of linear cheerfulness in the row of gaslights at the picture's top, illuminating this scene of desolate urban pleasure with its imperious master of ceremonies, ghoulish trombone player and desiccated tree. As one writer observed, 'the spectators would have as readily flocked

43. (*Opposite above left*) Camille Pissarro, *View from the artist's window at Eragny*, 1888. Oil on canvas, 25⅝ × 31⅞ in (65 × 81 cm). Oxford, Ashmolean Museum.
This and the following plate belong to Pissarro's Pointillist phase, although neither are as resolutely dotted as some other works. In this one, an Eragny landscape, Pissarro employs commas and dashes of paint in contrast to the more methodical application seen in contemporary work by Seurat and Signac.

44. (*Opposite above right*) Camille Pissarro, *Woman in a field*, 1887. Oil on canvas, 21 × 25½ in (53.3 × 65 cm). Paris, Louvre.

45. (*Opposite below*) Henri-Edmond Cross, *The Coast near Antibes*, 1892. Oil on canvas, 25¼ × 37 in (65 × 94 cm). New York, Collection Mr and Mrs John Hay Whitney.

46. Paul Signac, *Cap Lombard, Cassis*, 1889. Oil on canvas, 25¾ × 31¾ in (66 × 81 cm). The Hague, Gemeentemuseum.
Signac, Cross and van Rysselberghe among the Neo-Impressionists all lived on or near the Mediterranean coast, preferring its brilliant light to the more veiled and softer atmosphere of the northern French coast over which Seurat reigned supreme.

47. Henri-Edmond Cross, *Femme en Violet,
(Automne)*, 1896. Oil on canvas, 24 × 21½ in
(61 × 55 cm). London, Courtesy of
Sotheby Parke Bernet.

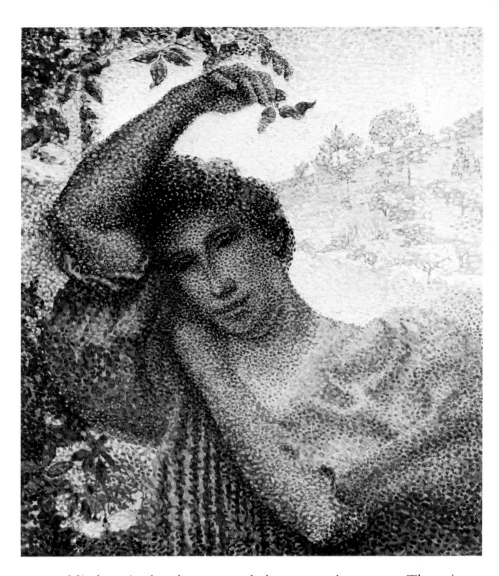

to a public hanging' as have attended *cette parade sauvage*. There is an inescapable melancholy in so much of Seurat's work, something disquieting even when his subject has been composed from potentially vivacious material. The most famous example of this is in *Le Chahut* with its extraordinarily compressed space and rank colouring. In spite of its programmatic scheme of upward-flying lines and attention to analogous phrasing (such as the hair-line of the bassplayer with the light fittings, the flautist's fingers with the dancers' shoes), the painting leaves a forlorn impression only partly accounted for by the transitory nature of pleasure as seen throughout Seurat's work. *Le Cirque,* although exhibited in Seurat's lifetime, was left unfinished, which perhaps explains its somewhat unrewarding colour. But here Seurat's pictorial science is working at an intense level, particularly in the feather-light equestrienne and springing acrobat. Details throughout once more show Seurat's predilection for recurring emblems – the lapels and tailored shoulders of the spectators in the second tier, the horse's mane, the coat-tails of the ringmaster and the wing-collars of the stuffed shirts behind him. Seurat shared with Toulouse-Lautrec a liking for sinuous Art Nouveau rhythms (compare *Le Chahut* with Lautrec's *Le Divan Japonais* [plate 174]) and they both admired the

48. (*Above*) Henri-Edmond Cross, *The Artist's garden at St Clair,* c. 1908. Watercolour, 10½ × 14 in (26.6 × 35.5 cm). New York, Metropolitan Museum of Art (Harris Brisbane Dick Fund, 1948).

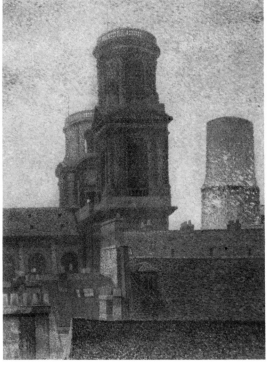

49. Albert Dubois-Pillet, *The Towers of St Sulpice,* c. 1888–9. Oil on canvas, 12½ × 9¼ in (32 × 23.75 cm). London, Courtesy of Christie's.

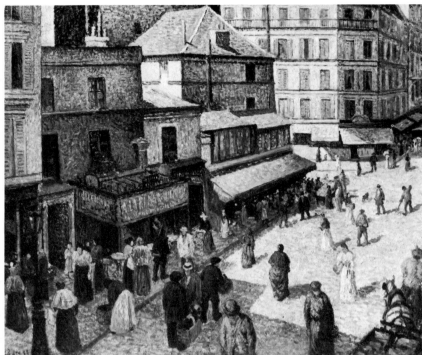

50. (*Above*) Charles Angrand, *Head of a child*, 1898. Charcoal, 24 × 18 in (61 × 45.7 cm). London, Courtesy of Sotheby Parke Bernet.

51. (*Above right*) Maximilien Luce, *La Rue Mouffetard, Paris*, 1896. Oil on canvas, 25½ × 31¾ in (64.7 × 80.6 cm). London, Courtesy of Sotheby Parke Bernet.

52. (*Opposite above*) Maximilien Luce, *Landscape with willow trees*, 1887. Oil on canvas, 19⅝ × 24⅛ in (49.8 × 61.3 cm). Glasgow City Art Gallery.

53. (*Opposite below left*) Louis Hayet, *The Vegetable Market*, 1894. Oil on board, 7⅜ × 10⅜ in (18.6 × 26.5 cm). New York, Collection Arthur G. Altschul.

54. (*Opposite below right*) Hippolyte Petitjean, *Mountain landscape*. Watercolour, 22¾ × 14¾ in (58 × 38 cm). London, Courtesy of Christie's.

posters of Chéret; both were inspired by the Cirque Fernando and Lautrec's little clown is the same as Seurat's, but seen from behind. But how different is Lautrec's rapidly brushed scherzo from Seurat's altogether more vibrant image.

Seurat became an almost legendary figure in his short life and attracted numerous followers and apologists among painters and writers. The importance of his work, however, was only gradually realized and it was thirty years before a monograph about him appeared. Valuable eye-witness accounts of his personality and ideas often went unrecorded, although since then indefatigable researchers have managed to assemble as complete a picture as we are likely to get. Although not an unsociable man, Seurat left much of the explaining of Neo-Impressionism to his most gifted follower Paul Signac. After his death his paintings were difficult to see; van Gogh, Gauguin and Cézanne were in the ascendant and, in the hands of Seurat's followers, Pointillism frequently degenerated into a tight dry application of rules which seemed to restrict its practitioners rather than encourage development. Pissarro abandoned Pointillism after three or four years. His reasons, outlined in a letter of March 1896 to Henry van de Velde, show in fact how great was the gap between Impressionism and Pointillism, how inevitable it was that Monet and Renoir should have had so little sympathy with Seurat and his school:

'Having found after many attempts (I speak for myself) that it was impossible to be true to my sensations and consequently to render life and movement, impossible to be faithful to the effects, so random and so admirable, of nature, impossible to give an individual character to my drawing, I had to give it up. And none too soon! Fortunately it appears that I was not made for this art which gives me the impression of the monotony of death.'

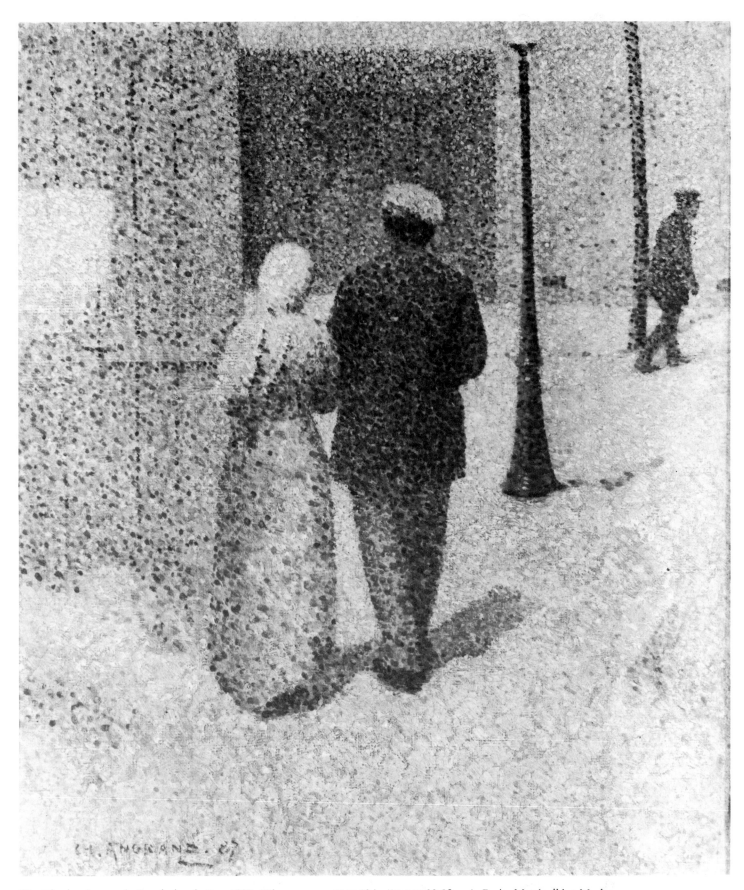

55. Charles Angrand, *Couple dans la Rue*, 1887. Oil on canvas, 15 × 13 in (38.1 × 33.02 cm). Paris, Musée d'Art Moderne.

56. Maximilien Luce, *The Church at Gisors,*
1898. Oil on canvas,
London, Courtesy of Christie's.

Although he abandoned the technique and fiercely criticized it later, other aspects of Neo-Impressionism had helped Pissarro to find a temporary solution to his doubts about his painting in the early 1880s and doubts about Impressionism which he shared with Monet and Renoir at the same time. But Pissarro continued to hold Seurat in great esteem and remained a close friend of Signac and other Pointillists, particularly Maximilien Luce.

Happily, in spite of certain claims of universality made for Neo-Impressionism, individual temperaments survived and among the followers of Seurat and Signac there are some delightful lesser talents. Henri-Edmond Cross is the most substantial, best known for his land- and seascapes of the south of France with their almost Fauvist freedom of colour and increasing independence of the dot in favour of rectilinear patches of pigment. The theme of nudes in an Arcadian setting, common to several of the Neo-Impressionists (and to painters such as Denis and Roussel) was attempted by Cross with warm sensuality and rhythmic fantasy, although there is clearly a subtle

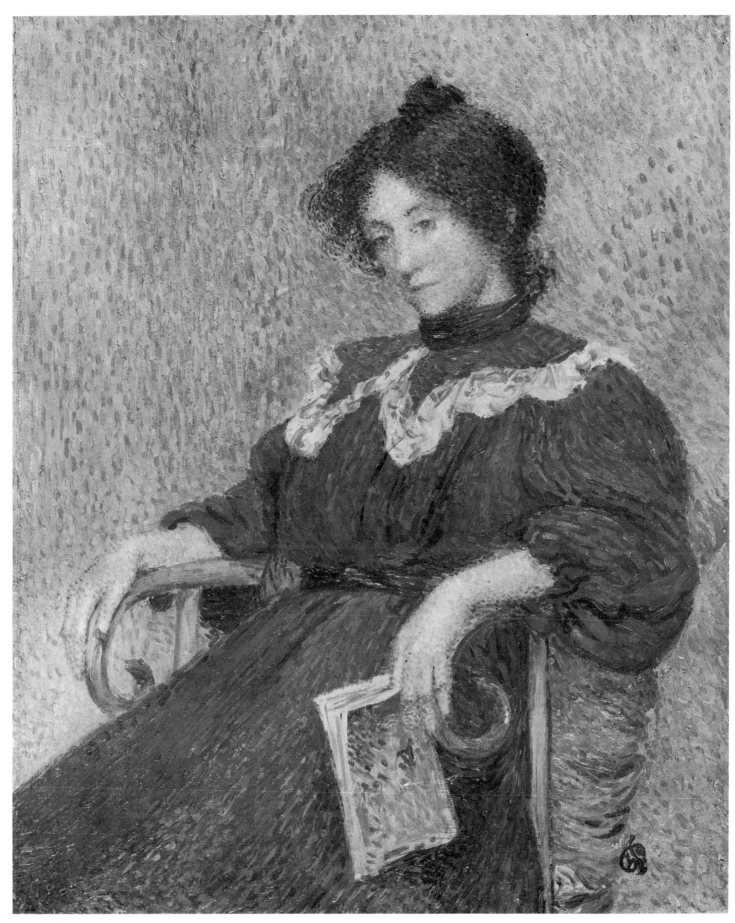

57. Hippolyte Petitjean, *Portrait of Mme Petitjean*, c. 1898. Oil on canvas, 16 × 13 in (40.6 × 33 cm).
Los Angeles, County Museum of Art (Gift of Mrs Leona Cantor)

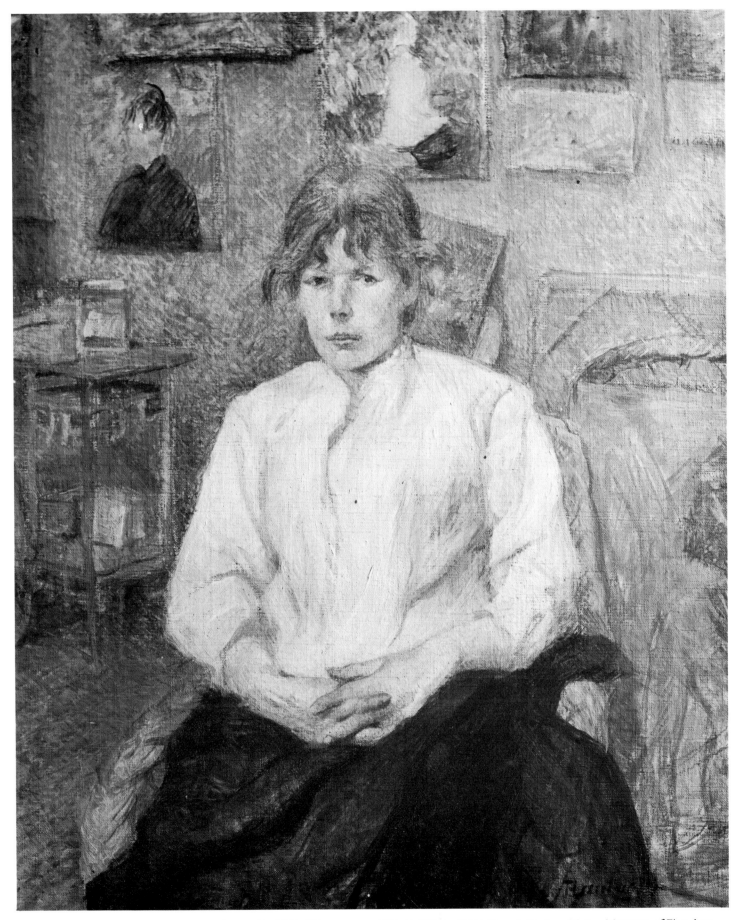

58. Henri de Toulouse-Lautrec, *Woman in a studio*, 1888. Oil on canvas, 22½ × 18½ in (57 × 47 cm). Boston, Mass., Museum of Fine Arts (Bequest of John T. Spaulding).

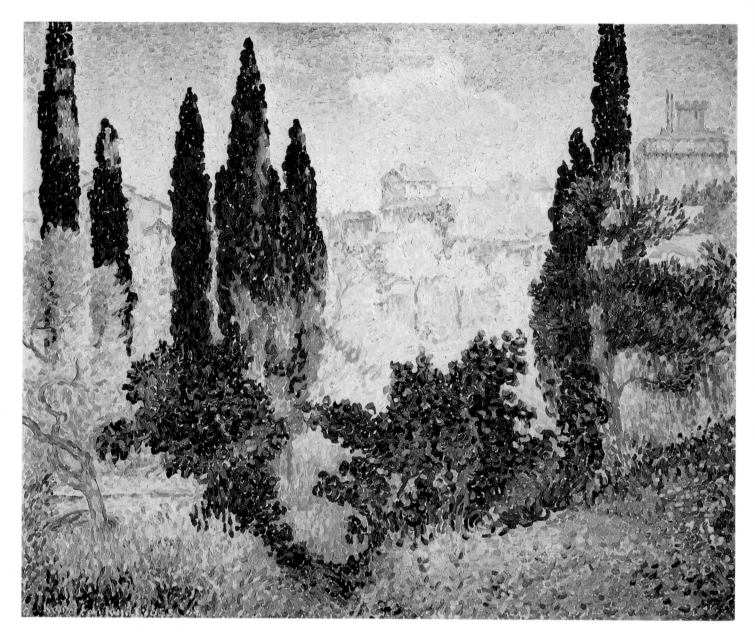

59. Henri-Edmond Cross, *Cypresses at Cagnes,* 1908. Oil on canvas, 31½ × 39½ in (80 × 100 cm). Paris, Musée d'Art Moderne.

intellect at work. 'Every time I feel tied down to the true fact, the documentation, the feeling "this is how it looked" ', he wrote in his journal, 'I must ignore it and remember the final aim of rhythm, harmony, contrasts.' Cross's brilliant expansive paintings at the turn of the century foreshadow the work of Derain and Matisse at Collioure in 1905; Derain's large *L'Age d'Or* of the same year seems inconceivable without the example of Cross's Mediterranean nymphs.

Among more modest Pointillists were Pissarro's son Lucien, who later became an influential figure in English painting after his move to London; Albert Dubois-Pillet, soldier as well as painter; the benign anarchist Luce, long-lived, prolific, adapting his early Divisionist practice in celebration (rather dourly, it must be admitted) of the working population of London and Paris, their suburbs, building sites and quaysides; Charles Angrand, working in the tradition of Millet and Barbizon with his rural and domestic subjects; and Hippolyte Petitjean, overwhelmed for the most part by his veneration of Puvis de Chavannes.

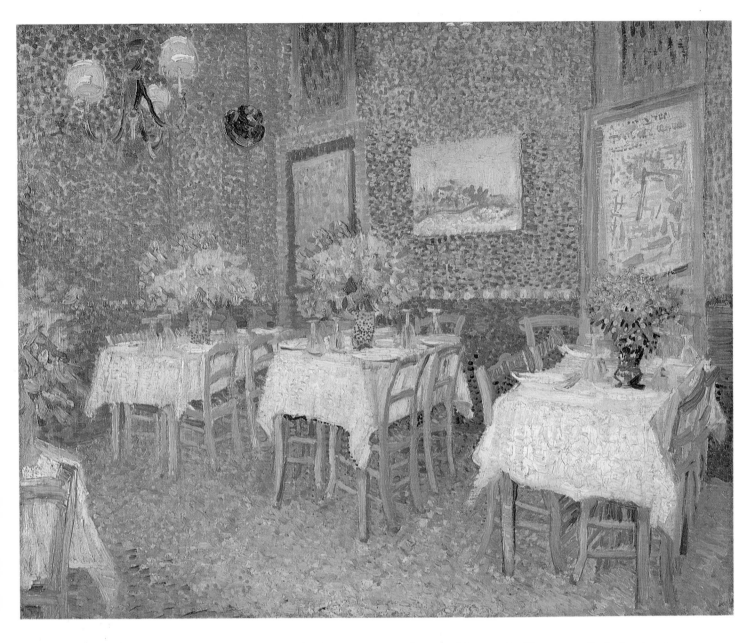

60. Vincent van Gogh, *Interior of a restaurant*, 1887. Oil on canvas, 17¾ × 21¼ in (45 × 54 cm). Otterlo, Rijksmuseum Kröller-Müller.

At Lagny-sur-Marne to the east of Paris a further group influenced by Seurat produced some charming landscapes; Luce worked there as did Delavallée when he was not at Pont-Aven in Brittany painting under the influence of Gauguin and Bernard.

For Seurat the technique of Pointillism was inseparable from his determined conception of art; for many of his followers it was a terrible cul-de-sac, but a method, being of a precise nature, which was easily practised. But in painters such as Signac and Cross, with markedly individual visions, it became an instrument of liberty.

It was left to later generations to discover fully Seurat's more profound qualities as the detached poet of contemporary life. With all his gaiety and melancholy, combined with an organizational logic, he takes his place alongside Uccello, Piero della Francesca and Poussin as one of the great designers. Like them, he had the capacity to press his pictures to their furthest limit, eliciting from them the most surprising harmonies and for us an unsuspected exhilaration.

53

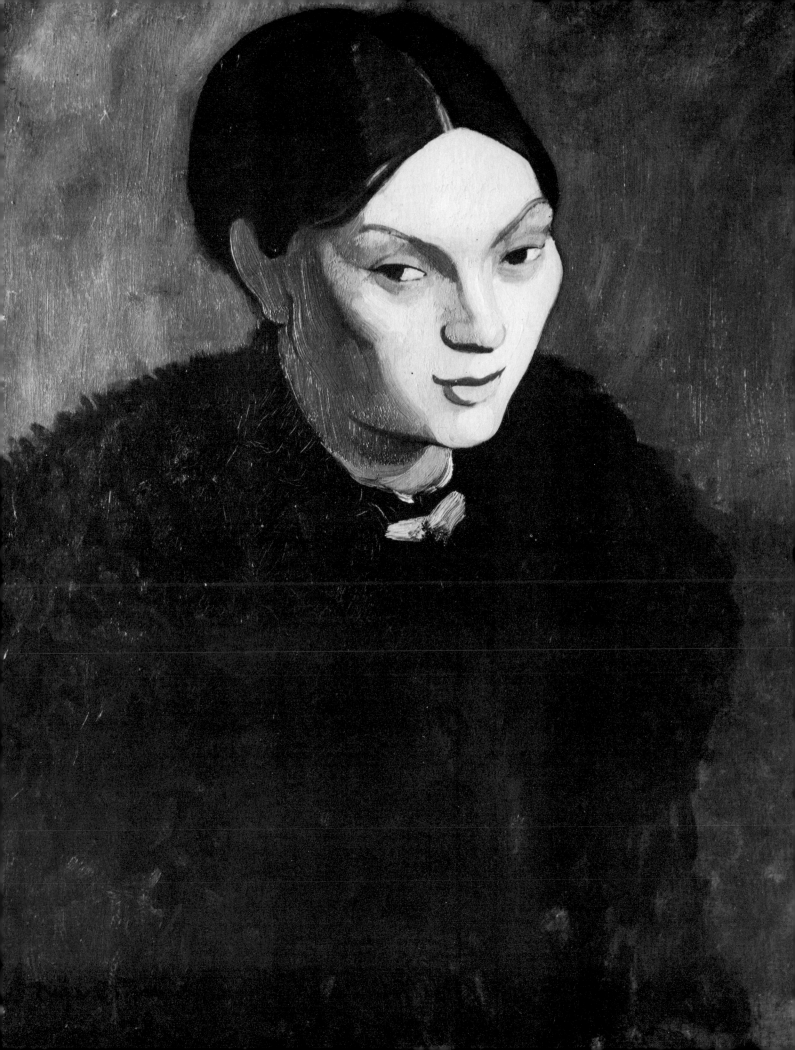

3
Gauguin and the Pont-Aven Group

If we look at Gauguin's early painting *Market Gardens, Vaugirard* (plate 68), we see that, in its subject matter and unusual viewpoint, it is a modest product of Impressionism. Gauguin already knew Pissarro and owned a representative collection of Impressionist paintings. But on closer inspection we see something rather different from the typical Pontoise landscape of Pissarro. Gauguin has used a definite structure of close horizontal planes, his colour is more subdued and his handling of paint shows less gestural bravura than, for example, Monet's. It appears that the picture was painted slowly and meticulously, with short parallel brushstrokes such as we find in Cézanne's work of this period. An individual note is sounded by the tree thrusting its way into the picture, a feature absent in Pissarro's or Sisley's more classically composed landscapes, where the foreground is left relatively free as an inroad into the picture space. Gauguin's admiration for Degas might account for this; certainly his influence is of great importance in the evolution of Gauguin's early style culminating in *The Vision of the Sermon* (plate 63) of 1888. By then Gauguin was a professional painter; at the time of the Vaugirard landscape he was still a stockbroker, a Sunday painter and *père de famille*.

Gauguin was dismissed from his job in 1882 during the collapse of the Paris Bourse, a change which coincided with his growing contacts with contemporary painters, the notice taken of his pictures at the Impressionist exhibitions and an overwhelming desire to devote himself to painting. The consequences of his decision led him from bourgeois family life in Paris with his Danish wife to Brittany, Martinique and a relatively early death in the South Seas in 1903 – a progress of material suffering and misery irresistible to romantic biographers and film producers.

In 1886 we find him at Pont-Aven in Brittany, a small village already well known to painters – albeit of a different kind from the experimental and opinionated Gauguin. The area was strongly Catholic with traditions of language and costume still intact and with a remote

61. Louis Anquetin, *Portrait of Madeleine Bernard*, 1892. Oil on canvas, 23¼ × 19⅛ in (59 × 48.6 cm). Providence, Rhode Island School of Design, Museum of Art. Emile Bernard's sister Madeleine knew and was painted by several of her brother's friends including Gauguin. She was briefly married to Charles Laval (plate 105) and died young in 1895, a year after her husband.

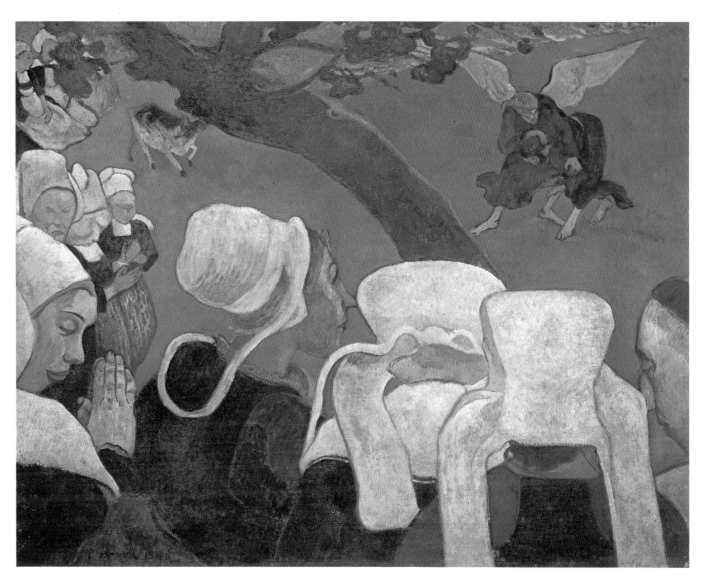

independent appeal similar to that which was drawing English painters to Cornwall at much the same time. Gauguin had rarely painted works inspired by emphatically contemporary subjects – there are no race meetings, café-concerts or industrial suburbs; van Gogh's and Seurat's peasants at work (plates 19 and 23) are a consciously chosen theme, but Gauguin's haymakers, Breton pigminders and shepherds carry no social significance beyond the fact that they belong to a still unindustrialized landscape. He treats them with a detachment far removed from van Gogh's *Potato Eaters* of 1885.

Gauguin's natural sense of decoration and his fascination with the exotic found expression through the elaborate headdress and costume of the Breton women. But the area soon began to work more profoundly on his imagination, particularly in his second extended visit of 1888 when he wrote: 'I find wildness and primitiveness there. When my wooden shoes [the Breton *sabots*] ring on this granite, I hear the muffled, dull and powerful tone which I try to achieve in painting.' We see something of Gauguin's meaning in the work of two years later, when he found himself at the centre of a group of admirers at the Pension Gloanec at Pont-Aven.

63. Paul Gauguin, *The Vision of the Sermon (Jacob and the Angel)*, 1888. Oil on canvas, 28¼ × 36¼ in (73 × 92 cm). Edinburgh, National Gallery of Scotland.

62. (*Opposite*) Paul Sérusier, *Landscape: Le Bois d'Amour ('Le Talisman')*, 1888. Oil on panel, 10¾ × 8¼ in (27 × 21 cm). Alençon, Collection François Denis.

57

64. (*Above*) Paul Gauguin, *In Brittany*, 1889. Watercolour with gold paint, 14⅝ × 10¼ in (37.4 × 26 cm). University of Manchester, Whitworth Art Gallery.

65. (*Above right*) Louis Anquetin, *La Place Clichy, Evening*, 1887. Oil on canvas, 27 × 21¼ in (68.6 × 54 cm). Hartford, Connecticut, Wadsworth Atheneum (Ella Gallup Sumner and Mary Catlin Sumner Collection).

66. (*Right*) Emile Bernard, *Portrait of the artist's grandmother*, 1887. Oil on canvas, 20¾ × 25¼ in (53 × 64 cm). Amsterdam, National Museum Vincent van Gogh.

58

Youngest and most receptive among them was Emile Bernard. He was precocious, widely read, much given to critical speculation and already conducting a fruitful correspondence with van Gogh, then painting in Arles. His portrait had been painted by Toulouse-Lautrec, a fellow student at Cormon's atelier (plate 10), and he was in touch with certain Symbolist writers in Paris. With Louis Anquetin (another Cormon student) Bernard had expressed his dissatisfaction with Impressionism by evolving a style of painting which came to be known as *Cloisonnisme*. Paint was applied in even minimally modelled areas bounded by strong linear contours reminiscent of stained glass and medieval enamelling. Anquetin's *La Place Clichy, Evening* of 1887 (plate 65) shows such features in an almost dogmatic way; its decorative surface seems to have precluded any deeper investigation. It remains, nevertheless, an important picture in the development of Synthetism, the name frequently given to the Pont-Aven style.

Bernard's early painting had a more pungent and personal feeling, as, for example, *Portrait of the Artist's Grandmother* (plate 66), which he gave to van Gogh in exchange for a self-portrait. His boldly speculative mind and youthful enthusiasm flourished in Brittany and he produced *Breton Women in a Meadow* (plate 71), a vital touchstone in the history of painting at this time. It shows women and children, some in local costume, in a summer meadow; the horizon line has been banished, there is little definition of planes, a uniform green indicates the grass, and complementary accents of red enliven the sober blues, blacks and whites of the Breton clothes. Although the painting is by no means entirely successful – details obtrude here and there and the connecting

67. Paul Gauguin, *Head of a young Breton woman,* c. 1888–9. Charcoal, 11⅞ × 12⅜ in (30.3 × 31.4 cm). Chicago, Art Institute of Chicago.

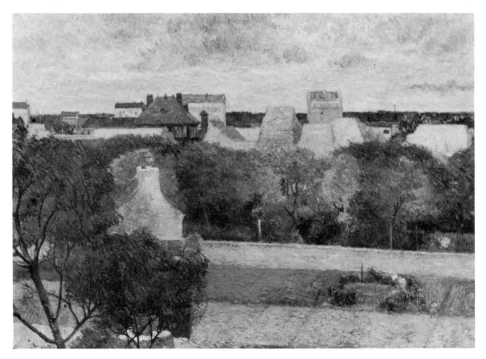

68. Paul Gauguin, *Market gardens, Vaugirard,* 1879. Oil on canvas, 26 × 39½ in (64 × 100.3 cm). Northampton, Mass., Smith College Museum of Art.

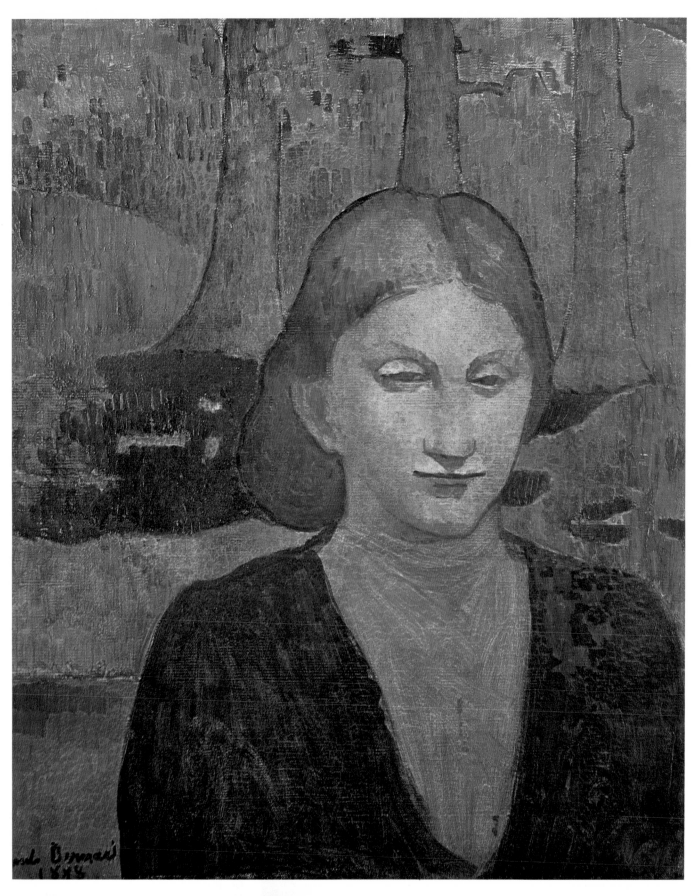

69. Emile Bernard, *Portrait of Madeleine Bernard,* 1888. Oil on canvas, 24 × 19¾ in (61 × 50 cm). Albi, Musée Toulouse-Lautrec.

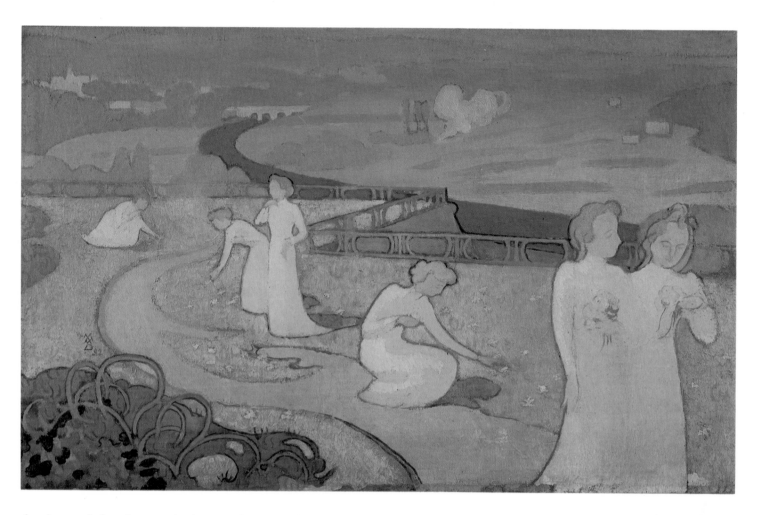

rhythm of the figures lacks tension – it had a tremendous effect on those who saw it. Gauguin acquired it through an exchange and considered it sufficiently unusual and important to take with him a few months later when he went to Arles to stay with van Gogh.

This picture, however, probably contributed nothing more than a confirmation to Gauguin of the direction his own painting had already begun to take, for shortly afterwards came the celebrated *Vision of the Sermon (Jacob and the Angel)* (plate 63), a work altogether more powerful, inspired and audacious. Bernard's relationship with Gauguin is an old hobby-horse of controversy; Bernard himself became bitterly disgruntled at the lack of recognition that he felt was his due in later years. In 1891 he quarrelled with Gauguin. Had Bernard's painting subsequently fulfilled the youthful promise of this Pont-Aven period, less perhaps would have been heard on the subject; unfortunately it did not and, although some attractive paintings followed, he later refuted his Pont-Aven aesthetic (although careful to backdate some of his works to exaggerate his own originality), meandered among the Italian primitives and returned to a more conventional style in portraits and religious decorations.

70. Maurice Denis, *April,* 1892. Oil on canvas, 15 × 24 in (38 × 61 cm). Otterlo, Rijksmuseum Kröller-Müller.

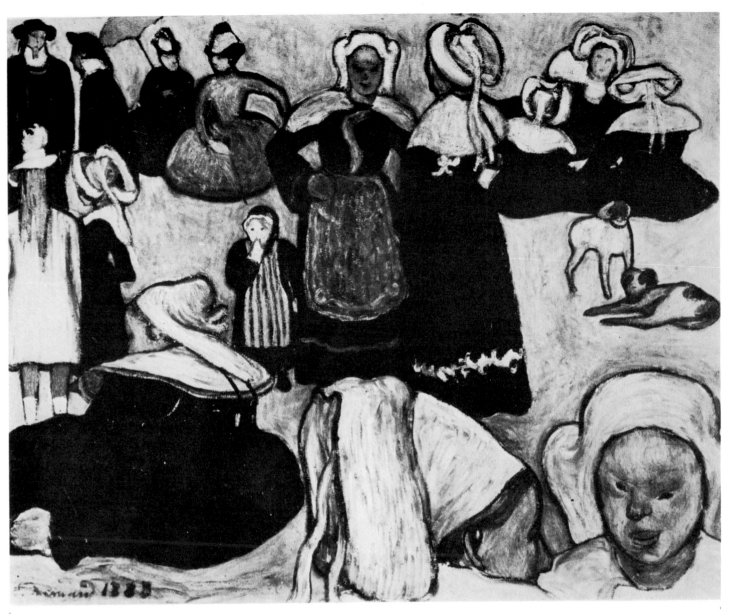

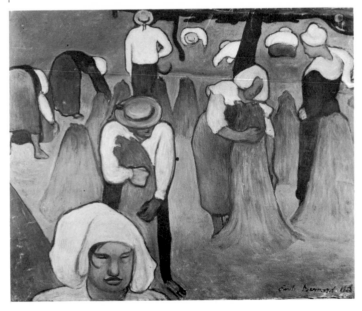

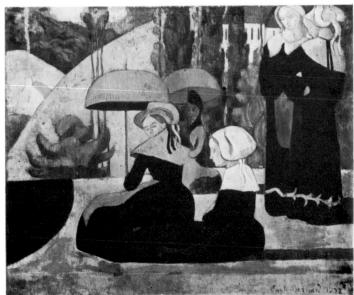

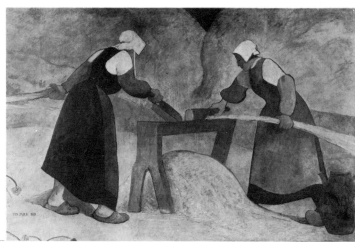

In 1887 Gauguin had visited Panama and Martinique with Charles Laval, a painter whom he had met in Brittany and who was later to marry Bernard's sister Madeleine. Gauguin's work in Martinique is marked by more individual use of colour and a crisper outline. He continued to admire Degas and Cézanne, but Impressionism became increasingly distasteful to him and Pointillism was too scientific and too laborious to satisfy his romantic and often impetuous temperament. He wanted a return to poetry and music (as in the work of Puvis de Chavannes) and to fundamental human feelings; he wanted to use colour without the fetters of naturalism, to introduce imagery that took one away from the everyday world of the Impressionists and Pointillists.

We have seen so many developments in twentieth-century art that it is perhaps difficult to appreciate just how daring and new *The Vision of the Sermon* must have then seemed. It brings together several features of Gauguin's painting which before had been used individually or only tentatively. It creates a new concept of space through colour; it is rooted in Gauguin's feeling for primitivism, as well as being a product of the most sophisticated aesthetic currents of his time. The ostensible subject is the visionary effect of the words of a sermon on a group of Breton women after having left the church. The priest (with Gauguin's features) is seen at the bottom right, and the women, making three distinct groups, fill almost half the painting, as Jacob wrestles with the Angel in the other (their composite form is echoed by the cow, straying from one reality to another, on the left). Some of the women watch intently; others are already praying; the priest casts down his eyes with an air almost of modesty. The flat unmodelled trunk of a tree forms a physical barrier between the vision and the 'real' world of women in their Sunday clothes; the uniform red connects them psychologically. The idea of combining the 'real' with an imaginary or visionary world had a long history in painting before Gauguin, but was particularly prevalent among certain Symbolist painters. What Gauguin detested in

74. (*Above left*) Emile Bernard, *Breton woman in a landscape*, 1888. Ink and watercolour, 7⅞ × 12⅛ in (19.9 × 30.9 cm). Amsterdam, National Museum Vincent van Gogh.

75. (*Above right*) Meyer de Haan, *Peasant women beating hemp*, 1889. Fresco, 52½ × 78¼ in (133.3 × 198.7 cm). London, Courtesy of Sotheby Parke Bernet.
This painting of Breton life was executed on the wall of the dining room of Marie Henry's inn at Le Pouldu which in 1889 became a further headquarters of the Pont-Aven school. The present picture, one of several which decorated the room, was discovered in 1924 beneath several layers of wallpaper.

71. (*Opposite above*) Emile Bernard, *Breton women in a meadow*, 1888. Oil on canvas, 29⅛ × 36¼ in (74 × 92 cm). France, Collection the Denis Family.
Van Gogh described this painting as 'a Sunday afternoon in Brittany, Breton peasant women, children, peasants, dogs strolling about in a very green meadow; the clothes are black and red, and the women's caps white. But in this crowd there are also two ladies, the one dressed in red, the other in bottle green. . . .' Van Gogh was impressed by the picture when Gauguin brought it with him to Arles and he copied it in watercolour.

72. (*Opposite below left*) Emile Bernard, *Black Wheat*, 1888. Oil on canvas, 28¼ × 35½ in (73 × 90 cm). Lausanne, Collection Samuel Josefowitz.

73. (*Opposite below right*) Emile Bernard, *Breton women with parasols*, c. 1889. Oil on canvas, 31¾ × 39½ in (80 × 100.5 cm). Paris, Louvre.

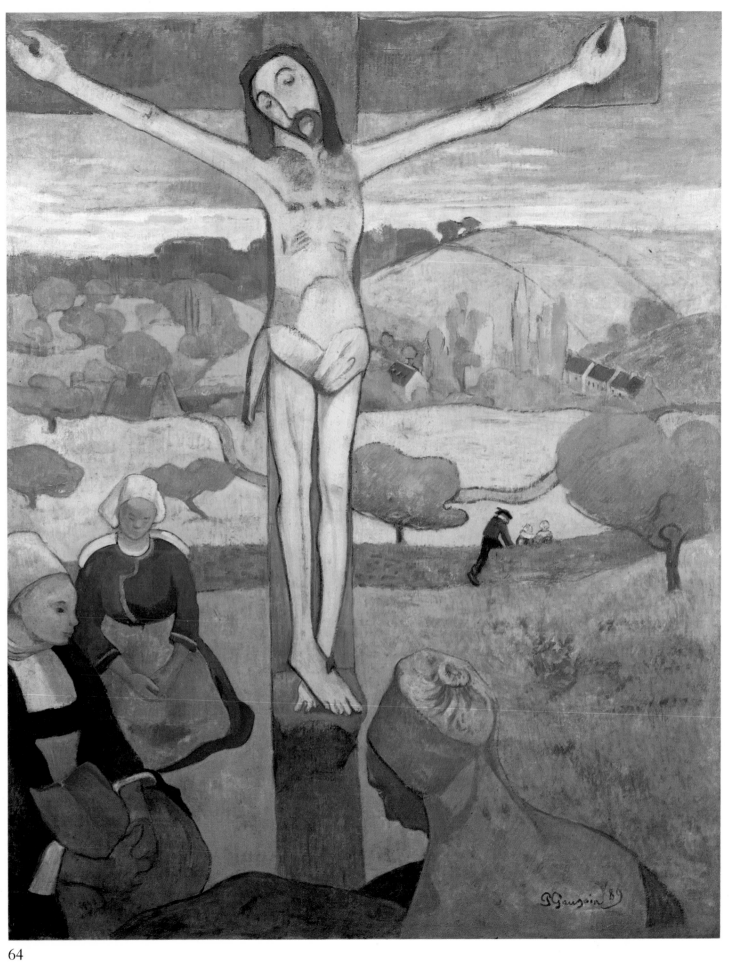

77. Paul Sérusier, *Farm at Le Pouldu*. Oil on canvas, 21¼ × 28½ in (54 × 72 cm). London, Private Collection.

contemporary Symbolist art was its use of a naturalist vocabulary which he regarded as a betrayal of painting in favour of literariness.

The Vision of the Sermon is certainly not literary; what narrative it has is contained by a synthesis of all the elements of which the picture is composed. The sources of its imagery have been much discussed. Gauguin must surely have seen such groups of praying women in this devoutly Catholic area where roadside calvaries were abundant. The figures of Jacob and the Angel were partly inspired by wrestlers in Hokusai's *Mangwa* albums; Gauguin had painted *Young Boys Wrestling* just before *The Vision;* they also bear a marked resemblance to two wrestling boys in the foreground of Puvis de Chavannes's *Doux Pays.* Japanese perspective and Degas's theatre scenes also contribute to the painting's complex evolution (and a comparison with Seurat's *Parade,* finished early in 1888, is instructive despite the enormous divergence of subject). Gauguin himself wrote of the work in a letter to van Gogh:

76. (*Opposite*) Paul Gauguin, *The Yellow Christ,* 1889. Oil on canvas, 36¼ × 28¾ in (92 × 73 cm). Buffalo, Albright-Knox Art Gallery.

65

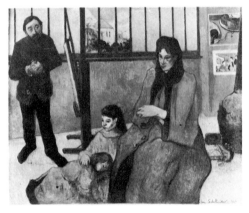

78. Paul Gauguin, *Farm at Le Pouldu*. Oil on canvas. New York, Private Collection.

79. Paul Gauguin, *The Schuffenecker Family*, 1889. Oil on canvas, 28⅜ × 36¼ in (72.1 × 92.1 cm). Paris, Musée d'Art Moderne. Emile Schuffenecker (1851–1934) met Gauguin when they were both working in business and encouraged Gauguin to paint. Both abandoned careers in commerce for painting although Schuffenecker continued to work in a quasi-Impressionist style. He was however sympathetic to the Pont-Aven school and was mainly responsible for the Café Volpini exhibition of 1889. He was one of Gauguin's closest friends until they quarreled in 1891.

'I think that in the figures I've achieved a great simplicity, at once rustic and superstitious. The whole is very severe. For me, in this picture, the landscape and the struggle only exist in the imagination of the people praying after the sermon. That is why there is a contrast between the people, who are painted naturally, and the wrestling figures in their landscape, which is non-natural and out of proportion.' (September 1888).

And to his friend Emile Schuffenecker he wrote that he had sacrificed everything for style, 'in order to impose on myself something different from what I know how to do'.

The Vision's importance is incalculable; it belongs to that group of pictures essential to our understanding of the development of modern painting – to Manet's *Déjeuner sur l'Herbe*, Monet's *Impression. Sunrise*, Cézanne's *Maison du Pendu* and Seurat's *Une Baignade*. Contemporary tendencies towards simplification, a new use of colour, symbolic subject matter and a return to a more imaginative view of the world find resolution in a painting that goes beyond the still 'experimental' look of Bernard and others, and enters, in Gauguin's words, the *centre mystérieux de la pensée* ('the mysterious centre of thought').

In the autumn of 1888 Gauguin stayed with van Gogh in Arles, an episode discussed later in more detail. In the following year Gauguin returned to Brittany, at Le Pouldu on the Finistère coast. 'I am by the sea in a fishermen's inn,' he wrote to his wife, 'near a village of 150 inhabitants, living like a peasant and regarded as a savage. And I've been working day in, day out, in a pair of canvas trousers. . . . I don't talk to anyone and I haven't had any news from the children. I'm completely alone.' (Autumn 1889). This solitary existence was soon interrupted by the arrival of Charles Laval, his Martinique companion and, more importantly, Jacob Meyer de Haan, a hunchbacked amiable Dutch painter of modest talent and independent means which he generously shared with Gauguin. This considerably extended Gauguin's long stay at Le Pouldu, a period of relative happiness in his life.

Paul Sérusier, who had met Gauguin in the previous year when he was twenty-four and a student at the Académie Julian, joined the Brittany party. It was a decisive meeting. Under Gauguin's frank direction Sérusier painted a small landscape in the Bois d'Amour at Pont-Aven. It became known as *Le Talisman* (plate 62) because of the galvanic effect that it had on Sérusier's fellow students to whom he showed it with all the ardour of a convert. One, Maurice Denis, later wrote: 'He showed us – not without making a certain mystery of it – a cigar-box lid on which we could make out a landscape that was all out of shape and had been built up in the Synthetist manner with patches of violet, vermilion, Veronese green and other colours, all put on straight from the tube and with almost no admixture of white. . . . Thus we learned that every work of art was a transposition, a caricature,

the passionate equivalent of a sensation experienced.' (M. Denis, 'The Influence of Gauguin', *L'Occident,* October 1903). Sérusier became Gauguin's close friend, later sharing a room with him in Marie Henry's inn at Le Pouldu. He was far better educated than Gauguin, with a mind which quickly turned into aesthetic doctrine Gauguin's less carefully defined words about painting. Sérusier and Maurice Denis became the chief theorists of the Pont-Aven and Nabi groups, of which Sérusier was also a member.

It was in Brittany that Sérusier produced his most enduring works (as was true of de Haan and others), which for the most part are land-scapes with figures from the Breton scene, painted in much the same spirit as Bernard's work. But when Sérusier turned to allegory, he became a professorial bore, pedantic and sometimes sentimental – traits which his light colour and archaic simplifications do not disguise. Treatment and subject (later drawn frequently from medieval romance) show a dislocation which his sincerity could not rescue. But for a few years from 1889 he undoubtedly painted some of the strongest and most personal pictures to emerge from the group around Gauguin. A work such as *Farm at Le Pouldu* (plate 77), in its resonant colour and lucid organization, is a moment of perfect realization.

When Gauguin decided to go to Tahiti in 1891, he urged the young painter Armand Séguin to accompany him. Séguin deserves a mention in any account of the Pont-Aven school as being in some ways Gauguin's favourite 'pupil'. Gauguin wrote the preface to the catalogue of Séguin's one-man exhibition in 1895 and continually encouraged him. Poverty prevented him from joining Gauguin in Tahiti, as it prevented him from concentrating on painting; he earned a living from graphic work and is seen at his best in such prints as *Breton Woman Reclining by the Sea,* its evocative overtones being close to Bernard's *Madeleine au Bois d'Amour* (plate 83). Séguin died young in 1903, the year in which he published a valuable autobiographical fragment with first-hand impressions of the painters in Brittany at this period.

Denis was only indirectly connected with the Pont-Aven group, as a visitor rather than as a resident. The main body of his work in the 1890s is more profitably discussed in the context of the Nabis (see Chapter 6). But as an interpreter of Synthetism, a friend of most of the Pont-Aven painters, an admirer of Gauguin and a influential writer from 1890 onwards, his presence is felt from, as it were, the wings of the central action. He had seen at once the importance of what might be called the only Pont-Aven exhibition – *L'Exposition des Peintures du Groupe Impressioniste et Synthetiste* – held at the Café Volpini at the time of the Universal Exhibition in Paris of 1889. It included a large selection of Gauguin's paintings; too many, it was thought, by Emile Schuffenecker and work by Laval, Bernard, Anquetin and others (but neither Sérusier nor de Haan exhibited). The use of the word *Impressioniste* on the

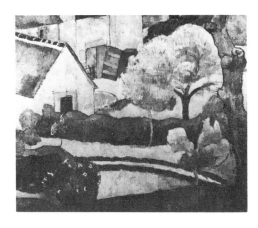

80. Jan Verkade, *Farm at Le Pouldu*, 1891. Oil on canvas, 24 × 30¾ in (61 × 78 cm). Lausanne, Collection Samuel Josefowitz.

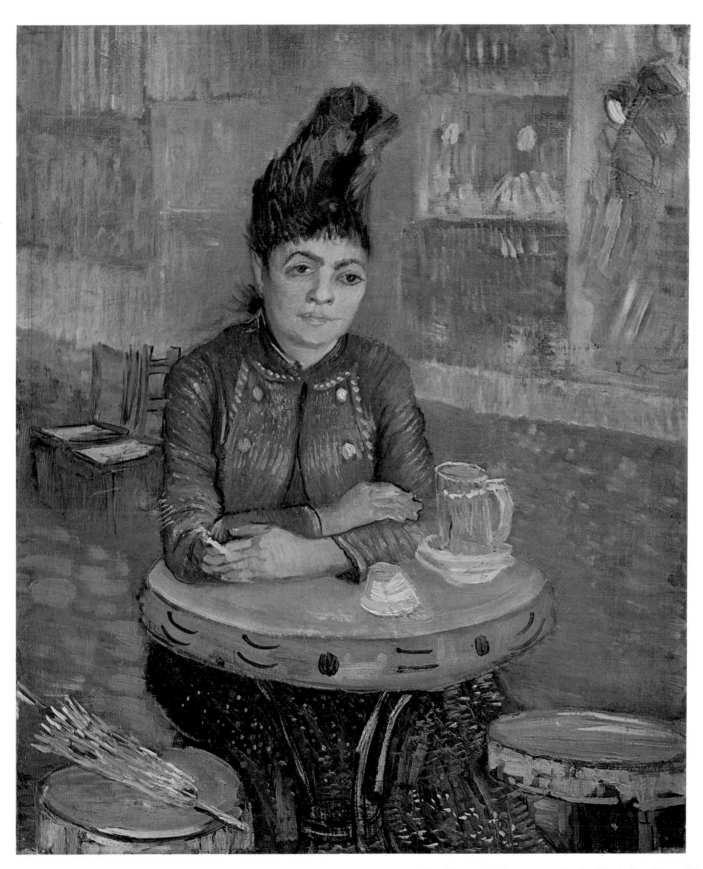

81. Vincent van Gogh, *Woman in the Café du Tambourin,* 1887. Oil on canvas, 21¾ × 18¼ in (55.5 × 46.5 cm). Amsterdam, Stedelijk Museum.

82. (*Opposite*) Vincent van Gogh, *The Italian Woman (La Segatori),* 1887. Oil on canvas, 31⅞ × 23⅝ in (81 × 60 cm). Paris, Louvre.

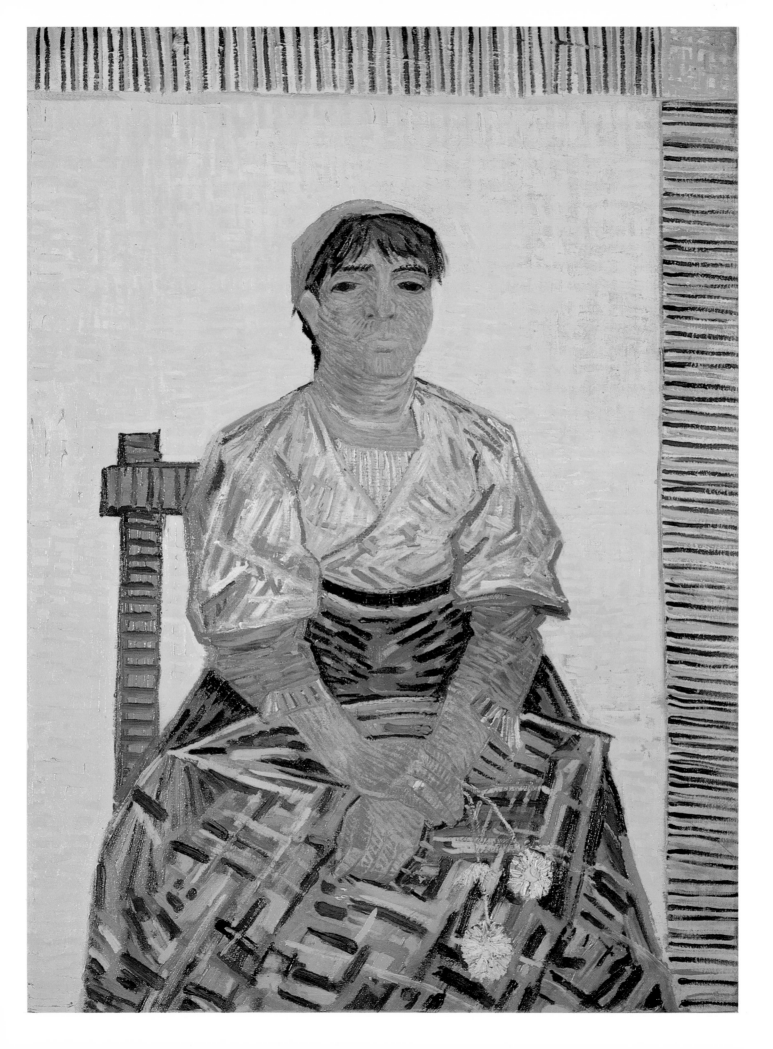

83. (*Right*) Emile Bernard, *Madeleine in the Bois d'Amour,* 1888. Oil on canvas, 54⅜ × 64⅛ in (138.1 × 162.9 cm). Paris, Musée d'Art Moderne.

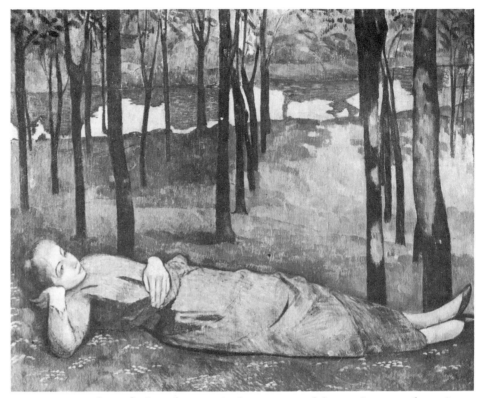

84. Paul Gauguin, *Nirvana: Portrait of Jacob Meyer de Haan,* 1889. Oil on canvas, 7¾ × 11½ in (20 × 29 cm). Hartford, Connecticut, Wadsworth Atheneum (Ella Gallup Sumner and Mary Catlin Sumner Collection).
The Dutch painter Meyer de Haan was a loyal friend of Gauguin until a quarrel over the affections of Marie Henry at Le Pouldu upset their friendship. *Nirvana* has been interpreted as Gauguin's revenge in which he makes 'a massacre of his rival's features, attributing to him the possession of demoniacal instincts'.

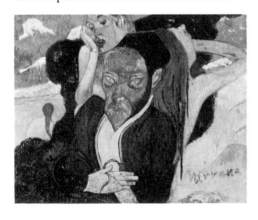

posters caused confusion then, as it does now; of the various explanations perhaps the most satisfactory is that the participants (Gauguin, in particular) had no wish to upset the Impressionists. Nothing was sold; critics missed the point; the Impressionists *were* upset; Anquetin was favoured by some with the leadership of the new movement; others saw Gauguin's influence as pernicious and one critic rated the dull, if able, Schuffenecker the best of the group. For the future Nabis, however, for Aristide Maillol, Suzanne Valadon and other painters the exhibition was a revelation. As Denis wrote:

'The appearance, in an undistinguished setting, of an art totally new, marked the beginning of the reaction against Impressionism. The Symbolist crisis which occurred soon afterwards helped to spread Gauguin's ideas, so that all the applied arts, including decorative painting, objets d'art, posters and even caricature, underwent a renewal.' (M. Denis, *Théories (1890–1910)*). The art, as we can now see, was neither totally new nor was it the 'beginning' of the Post-Impressionist reaction; but there was sufficient novelty, even in the poorer exhibits, to justify such commendation.

The work produced in Brittany varies enormously in quality, although several painters were stimulated by the robust presence of Gauguin and by the enthusiastic exchange of ideas to produce paintings which were outstanding in otherwise modest or undistinguished careers. We have seen this in Bernard and Sérusier; it also applies to the mystic Filiger with his inspired gouaches of the landscape, more thoroughly

Cloisonniste than any of his contemporaries; to Meyer de Haan and Jan Verkade (plate 80). Briefly we can distinguish three particular types of painting among the group. In the first there were landscapes and scenes of Breton life, peasants at work and portraits. These paintings were characterized by clear outlines, strong patches of flat colour often chosen for its expressive and poetic value rather than its descriptive function. The winding contours, divided fields and abrupt changes of direction in the Breton landscapes were particularly conducive to the sinuous linear patterning which was so prevalent a feature of their works and which Gauguin developed in Tahiti. It is a stylistic hallmark, already noticed, of Seurat's later works and Lautrec's posters.

Other painters drew inspiration from the cultural heritage of an area of France that seemed to lie (and this was part of its attraction) outside the mainstream of French civilization. They concentrated on symbolic and allegorical painting with a tendency towards medieval tapestry and stained glass; figures are caught up in a dream world that is remote, leisured and elegant and yet they seem infected by a nostalgia for that very world itself. We see this most prominently in the work of Sérusier, Bernard and Verkade.

In the third group are those pictures which, while obviously taken in some way from nature (much was executed in the studio from memory), were heavily influenced by literary symbolism and the decorations of Puvis de Chavannes. In their dreamy and evocative atmosphere they are related to the whole European Symbolist movement. Bernard's two pictures of his sister Madeleine are examples, the portrait (plate 69) with its indefinable secretive expression and the reclining figure (plate 83) enveloped in mysterious contemplation, sensuous and ethereal at the same time.

Few of the painters can be allocated precisely within these three groups. They were all enamoured of theory which sometimes even preceded the works themselves. Yet they were flexible enough to be influenced by the random *chose vue,* by the work of their companions and art from a variety of periods. Least of all can Gauguin, with his great variety of subject and treatment, be placed in any one compartment. There is the elusive caricature of Meyer de Haan with its philosophical references (plate 84) and the more straightforward portraits (plate 79) and landscapes; the drawings of acute, sometimes witty, observation and the great *Yellow Christ* (plate 76) with its symphonic yellows and grave piety, its silent spellbound atmosphere and intense note of personal anguish. With Gauguin's departure the following year for Tahiti the group lost much of its impetus and began to dissolve. But in a very short period it had cleared the board of irrelevant conventions and considerations, establishing the painter's freedom of choice and the autonomy of the picture, factors which were later vital to Matisse and Picasso, Kandinsky and Mondrian.

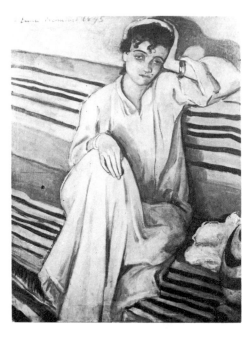

85. Emile Bernard, *Young African,* 1895. Oil on canvas. Essen, Folkwang Museum.

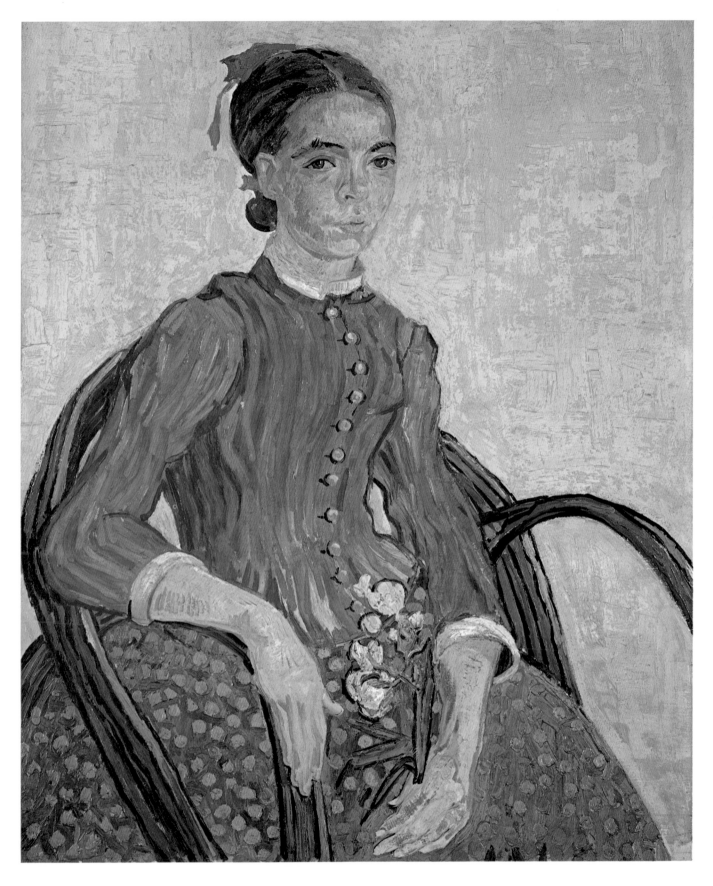

86. (*Above*) Vincent van Gogh, *La Mousmé*, 1888. Oil on canvas, 28¾ × 23¾ in (73 × 60.3 cm). Washington, National Gallery of Art.

87. (*Opposite*) Vincent van Gogh, *Portrait of Dr Gachet*, 1890. Oil on canvas, 26¾ × 22½ in (68 × 57 cm). Paris, Musée du Louvre.

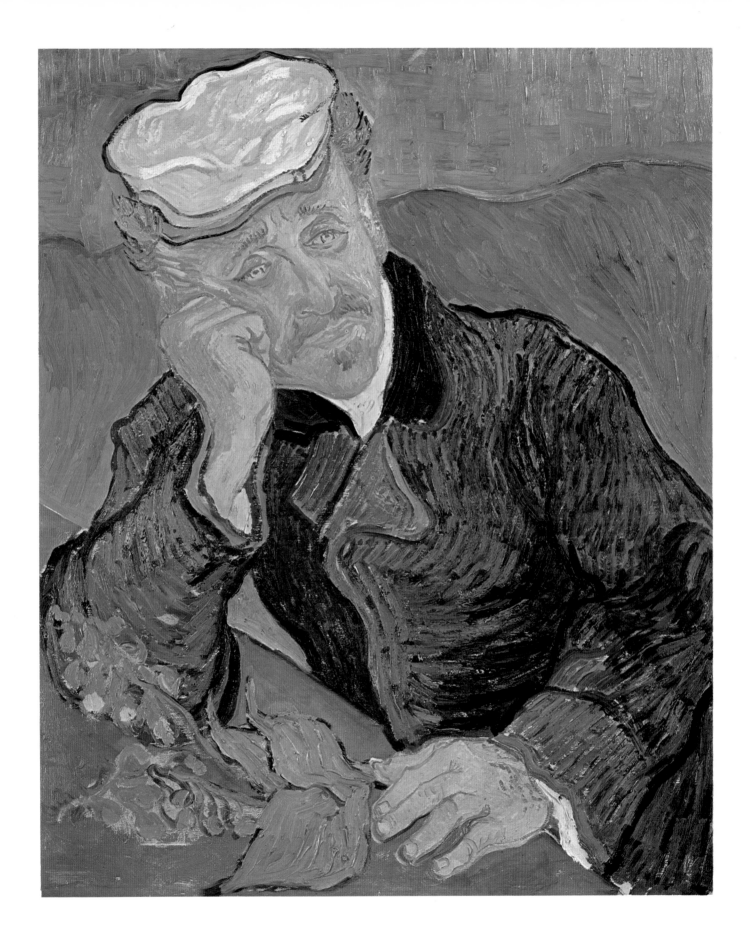

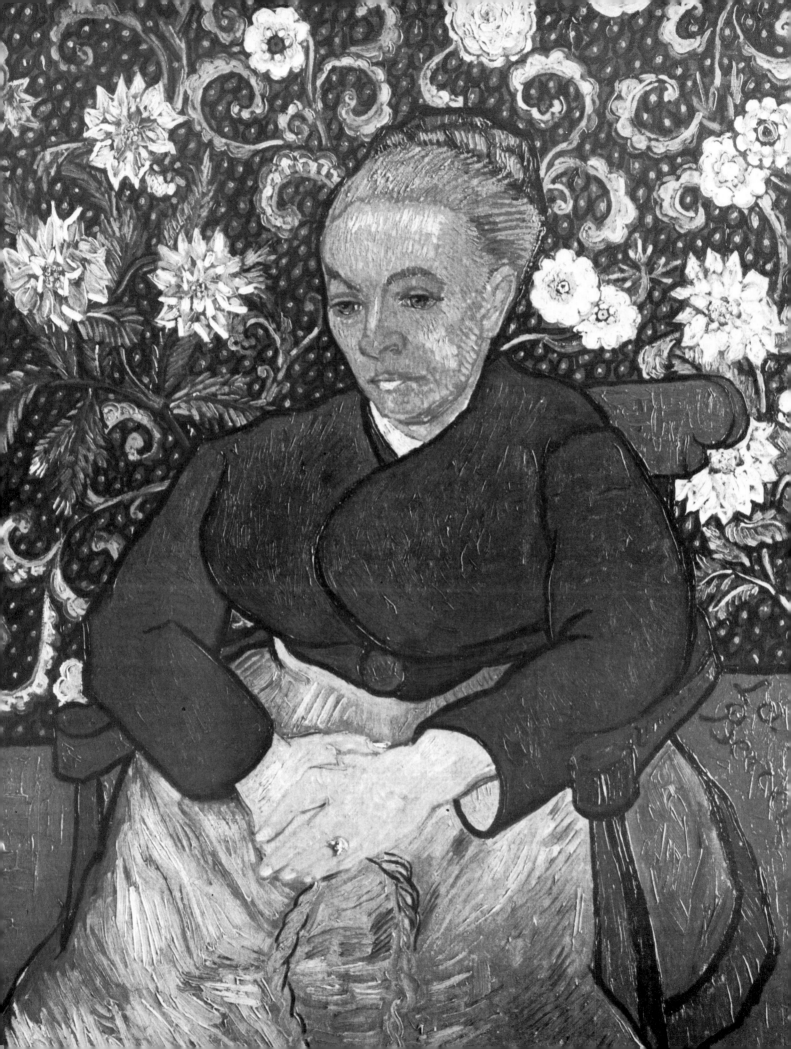

4
Van Gogh, Gauguin and Arles

From February 1888 van Gogh had been painting in Arles in the south of France with extraordinary confidence. It was there that he produced a series of landscapes and portraits which transcended all his previous work. Yet it is deeply significant that he should have written to his brother in August that 'what I learnt in Paris *is leaving me*, and that I am returning to the ideas I had in the country before I knew the Impressionists.' *(Collected Letters of Vincent van Gogh)*. What were those ideas and what had he learnt in Paris? Some discussion of the time that he spent in the capital with his brother Theo (February 1886 to February 1888) is vital to an understanding of the rapid achievement in Arles in pictures which are quintessentially Post-Impressionist. The changes in his painting and his attitude to art during those two years have all the excitement of an unfolding thriller as we move from the muffled dark preliminary work done in Holland to the brillant solution of his time in Arles.

In Holland, working in provincial isolation and as yet ignorant of Impressionism, van Gogh painted and drew peasants working in the flat intensively cultivated landscape, the low cottages of weavers, and portrait studies of men and women whose crude uncomplaining features he revealed in thick contours and dark earthy colours. He had been greatly impressed by the English black and white illustrators whom he knew from his time in London and was as much influenced by the unabashed sentiment and social message of their work as by their forthright technique. He had been long familiar from his years as a picture dealer at Goupil, with the contemporary Hague School (Anton Mauve was a relation by marriage), with the work of Joseph Israëls and such Belgian Realists as de Groux and Meunier. Rembrandt, Hals, Delacroix and Daumier were heroes and all his life Millet was a constant source of reassurance and inspiration. His choice of subject was motivated by Christian piety, by an identification with poor working people and the landscape in which they suffered and laboured. He regarded himself also as a workman, dressing and living as one, whether in the heathlands

88. Vincent van Gogh, *La Berçeuse (Mme Roulin)*, 1888–9. Oil on canvas, 36¼ × 28¾ in (92 × 73 cm). Otterlo, Rijksmuseum Kröller-Müller.

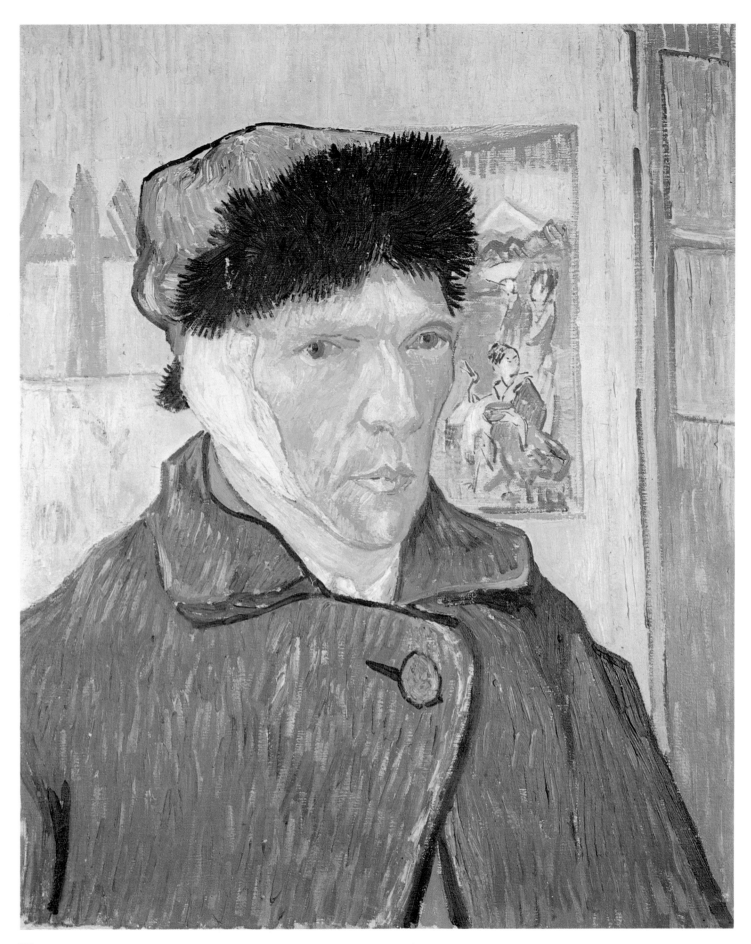

90. (*Above*) Vincent van Gogh, *Still-life with drawing board and onions,* 1889. Oil on canvas, 19½ × 25¼ in (45 × 64 cm). Otterlo, Rijksmuseum Kröller-Müller.

91. (*Right*) Paul Signac, *Still-life with book,* 1883. Oil on canvas, 12¾ × 18¼ in (32.4 × 46.4 cm). Berlin, Staatliche Museen Preussischer Kulturbesitz.

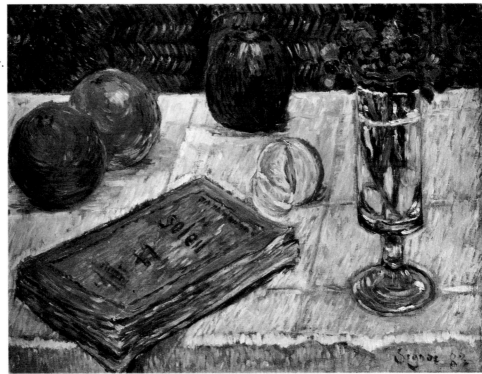

89. (*Opposite*) Vincent van Gogh, *Self-portrait with bandaged ear,* 1889. Oil on canvas, 24 × 20 in (61 × 51 cm). London, Courtauld Institute Galleries.

92. (*Above*) Vincent van Gogh, *The Potato Eaters*, 1885. Lithograph, 10½ × 12½ in (26.5 × 32 cm). Amsterdam, National Museum Vincent van Gogh.

93. (*Above right*) Vincent van Gogh, *The Bridge at Trinquetaille*, 1888. Oil on canvas, 28⅞ × 36⅜ in (73.3 × 92.41 cm). New York, Collection Mrs Siegfried Kramarsky.

94. (*Opposite above*) Vincent van Gogh, *Suburbs of Paris*, 1887. Watercolour, 15⅜ × 21¼ in (39.5 × 54 cm). Amsterdam, Stedelijk Museum.

95. (*Opposite below*) Maximilien Luce, *Outskirts of Montmartre*, 1887. Oil on canvas, 17¾ × 31¾ in (45.5 × 81 cm). Otterlo, Rijksmuseum Kröller-Müller.

of Brabant or among the olive trees and wheatfields of Provence. His embracing socialism was born from this zealous Christianity and his experiences as a lay preacher among the miners of the Belgian Borinage. It is this which gives such intensity of feeling to his studies of Dutch peasant life, culminating in *The Potato Eaters* (plate 92). They are in marked contrast to the more descriptive but sincere depiction of the peasantry in Dutch painting of the time and are conceived in a quite different spirit from Seurat's studies of labourers or the Breton peasants of the Pont-Aven school where nostalgic local colour predominates. 'To draw a peasant's figure in action, . . . that's an essentially modern image,' he wrote, 'the very heart of modern art. . . .' (*Letters,* July 1885).

Van Gogh arrived in Paris at a time of some dissatisfaction with his own work, centring on the problem of colour. In Antwerp, just before coming to Paris, he had seen Japanese art and was once more impressed by Rubens (not without some misgivings); he felt his own use of colour was too dark and morose. Theo's accounts of the Impressionists had obviously been tempting, and after his arrival van Gogh was in a good position to see their work and come to know them personally because of his brother's position with the gallery Boussod et Valadon. At first he was somewhat disappointed and found relief in the work of the Provençal painter Monticelli and in his continuing admiration for older artists such as Delacroix and Millet. At Cormon's atelier he met Bernard, Anquetin, Lautrec, the Australian John Peter Russell and the Englishman A. S. Hartrick. It was some time, however, before he began to be noticeably affected by the recent painting that he saw, although naturally enough Impressionist subjects soon appeared. The still semi-rural gardens of Montmartre attracted him with their windmills and open spaces. Moving down into the city we find

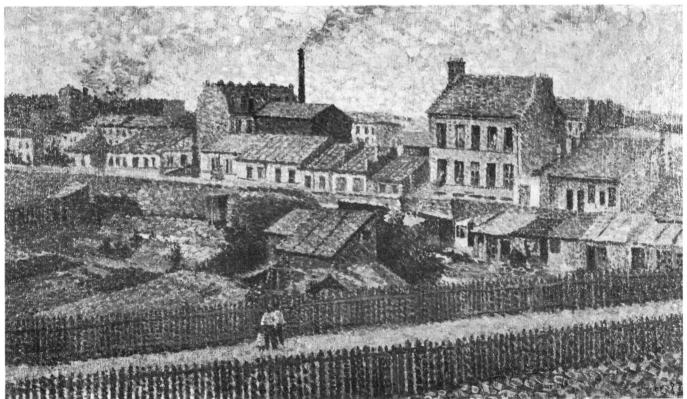

96. (*Left*) Paul
Gauguin, *Landscape
with farm buildings,
Arles,* 1889. Oil on
canvas, 28¼ × 36¼ in
(72 × 92 cm).
Stockholm,
Nationalmuseum.

97. (*Below*) Paul
Gauguin, *Tahitian
Landscape,* c. 1891.
Oil on canvas, 26¾ ×
36¾ in (68 × 92.5 cm).
Minneapolis, Institute
of Arts (Julius C.
Eliel Memorial
Fund).

98. (*Right*) Paul
Gauguin, *Bonjour M.
Gauguin,* 1889. Oil on
canvas, 44½ × 36¼ in
(113 × 92 cm). Prague,
Museum of Modern
Art.

80

Bonjour Mr Gauguin

81

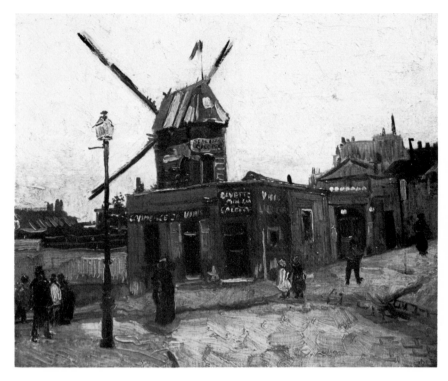

99. (*Above*) Vincent van Gogh, *The Moulin de la Galette seen from the rue Girardon*, 1886. Oil on canvas, 15¼ × 18¼ in (38.5 × 46 cm). Otterlo, Rijksmuseum Kröller-Müller.

100. (*Above right*) Paul Signac, *Windmills in Montmartre*, 1884. Oil on canvas, 14 × 10 in (35.5 × 25.4 cm). Paris, Musée Carnavalet.

more typically Impressionist motifs – rooftops, boulevards, the Tuileries, still-lifes of French novels. His palette lightened under the influence of Monet, Sisley and Pissarro, the latter becoming a friend and admirer, as was his son Lucien.

Van Gogh's friendship with Signac is of particular significance. Monticelli had helped van Gogh in his use of pure complementary colours in a series of flower paintings begun soon after his arrival; but his composition was still mostly conventional. There swiftly followed, however, some still-lifes and views of Montmartre with a striking resemblance to works by Signac, painted somewhat earlier, which van Gogh would have seen. There is the same unusual, often raised, viewpoint, the cutting of objects by the picture frame, a certain spatial ambiguity and frequently also a varied 'hatched' brushstroke (plate 91). In the summer of 1887 van Gogh accompanied Signac on painting expeditions to Asnières where he also worked with Emile Bernard, who had a studio in the garden of his parents' home there. We see van Gogh beginning to employ a limited and unsystematic use of the Pointillist division of tones and an abrupt, sometimes spotted, energetic handling of paint, particularly Pointillist in the *Restaurant Interior* (plate 60). The subject of an empty restaurant with its flowers, white cloths and filtered summer light would have been inconceivable to him a year or two before.

Van Gogh was never an Impressionist and was never interested in the momentary effects of light and atmosphere (although certain Paris paintings come very close). His drawing and handling are more

emphatic, more consciously motivated by a very clear idea of what emotionally interested him in the subject. Usually the interest is of quite a different kind from that of the Impressionists. In his Dutch period we are constantly impressed by his single-mindedness in the hard slog of mastering intractable paint and discovering and solving problems for himself, as though his very existence depended on it. His work in Paris, beginning tentatively and not always successfully, shows a rapid assimilation of the numerous influences to which he was exposed. By nature he was sociable, enjoyed working alongside others and discussing painting, books and ideas with such men as Pissarro and Guillaumin (seasoned and intellectually supple veterans of the Impressionist movement), as well as with the younger Bernard and Signac. He was able to see much more of Japanese art; he admired Degas, and a work such as *Woman in the Café du Tambourin* (plate 81) is close in feeling to some of Lautrec's café scenes with which van Gogh was familiar. To someone less clear-headed and purposeful, this plunge into the art world of Paris – its new pictures, theories, talk of Symbolism and Pointillism, factions and groups – might have proved disastrous.

A look at his *Une Italienne (La Segatori)* (plate 82) shows van Gogh's new position at its most radical. We are struck first by the unadulterated use of brilliant yellows and reds, by the vehemence of his brushstrokes and the frontal placing of the model (not dissimilar from some of his Dutch portrait studies), thrust towards the picture plane by the uniform yellow ground like a figure on a playing card. The background weft of short criss-cross strokes appears again in *L'Arlésienne* and *La Mousmé*. Unlike those two portraits, the composition here is uncertain, but the ringing green and red of the flesh, the synoptic drawing and the bristling life of the head and blazing skirt take us straight through to Vlaminck and the Fauves of 1905.

In the Arles period we discover an astonishing array of methods, often within the same canvas or piece of paper, to convey van Gogh's very strong feelings about the landscape and people. Like the Impressionists, his subject matter is drawn from the world immediately about him. To adapt a phrase of Mallarmé, everything exists to end in a painting. But unlike some of his contemporaries, such as Seurat, he did not attempt large studio compositions built up from innumerable studies (his last work of that kind was *The Potato Eaters*), nor did he investigate the symbolic imagery of Gauguin and others at Pont-Aven. He remained rooted in the physical world. 'I sometimes regret', he wrote to Emile Bernard in 1806, 'that I cannot make up my mind to work to a large extent at home and on an imaginative basis.' Always there was the direct pull of the thing seen, transcribed with the minimum of preparatory studies (he usually painted directly onto the canvas; ink drawings of the same motifs were nearly always done from the paintings

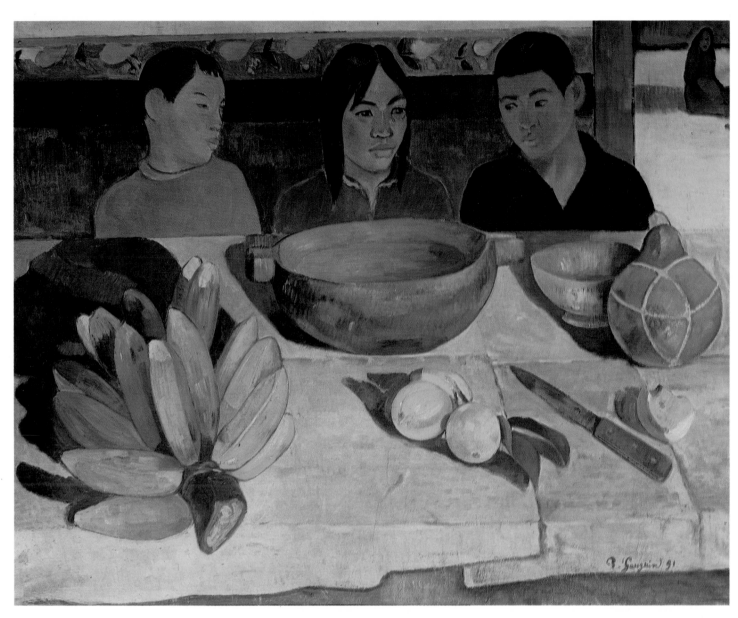

101. Paul Gauguin, *Le Repas,* 1891. Oil on canvas, 28¾ × 36¼ in (73 × 92 cm). Paris, Louvre.

102. (*Opposite*) Paul Gauguin, *Girl holding fan,* 1902. Oil on canvas, 36¼ × 28¾ in (92 × 73 cm). Essen, Folkwang Museum.

themselves). There is a strong sense of the picture having been conceived as a whole before it was begun. Gauguin also advised others to have the painting fully worked out before touching the canvas, but he emphasized memory and its imaginative translation on to the canvas. Van Gogh was stimulated only with the scene in front of him. Nor did he have the innate decorative feeling of Gauguin; he did not elaborate rhythmical phrases for their own sake, nor choose colours which would play a decorative role in the orchestration of a painting. He went straight to the main theme working with an exalted rapidity (his swift execution had astonished his fellow students in Antwerp and Paris). Something of this is conveyed when he wrote to Theo '. . . of the mental labour of balancing the six essential colours . . . sheer work and calculation, with one's mind utterly on the stretch, like an actor on the stage in a

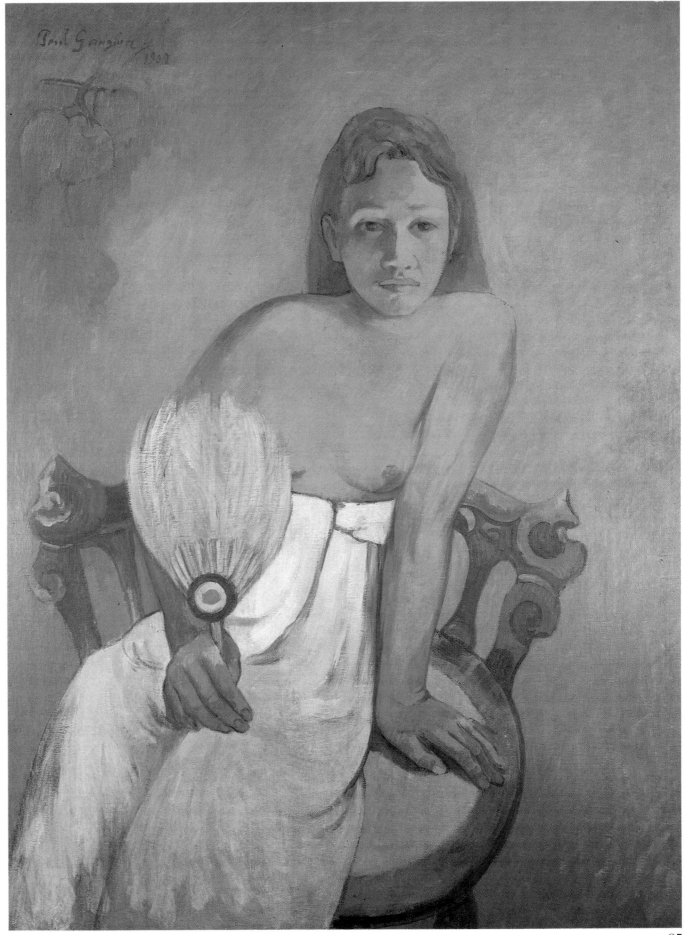

103. Paul Gauguin, *Self-portrait for van Gogh,* 1888. Oil on canvas, 17¾ × 21⅝ in (45.1 × 55 cm). Amsterdam, National Museum Vincent van Gogh.
Van Gogh conceived the idea of an exchange of self-portraits to remind him of his friends in his relative isolation in 1888 in Arles. Gauguin, Bernard (plate 104) and Laval (plate 105) were among those whom van Gogh wanted to form a community of painters in Provence – his 'studio of the South'. In the event only Gauguin joined him there.

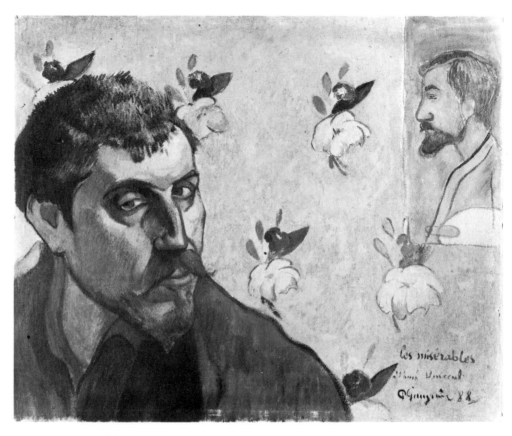

104. Emile Bernard, *Self-portrait for van Gogh,* 1888. Oil on canvas, 18⅛ × 21⅝ in (46 × 54.9 cm). Amsterdam, National Museum Vincent van Gogh.

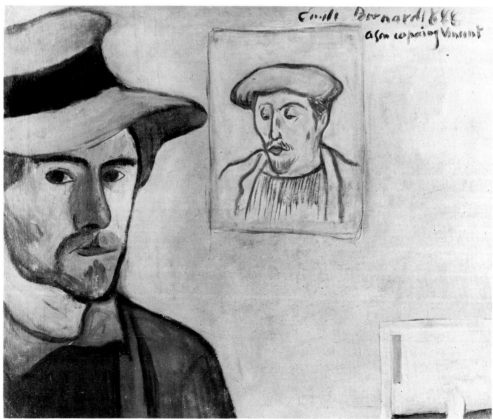

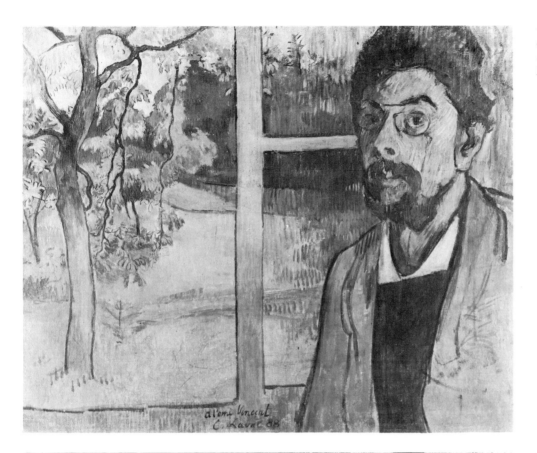

105. Charles Laval, *Self-portrait for van Gogh,* 1888: Oil on canvas, 19¾ × 23½ in (50 × 60 cm). Amsterdam, National Museum Vincent van Gogh.

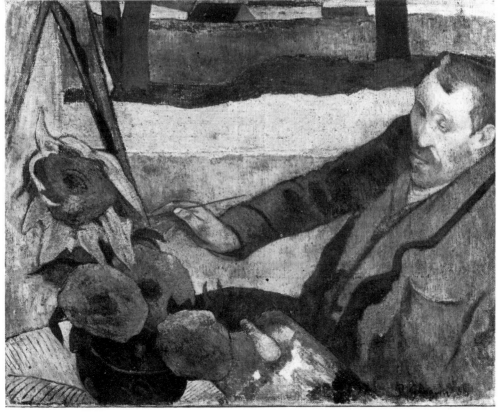

106. Paul Gauguin, *Portrait of van Gogh painting sunflowers,* 1888. Oil on canvas, 29¼ × 36½ in (74.3 × 92.7 cm). Amsterdam, National Museum Vincent van Gogh.

107. Paul Gauguin, *Night Café at Arles (Mme Ginoux),* 1888. Oil on canvas, 28¾ × 36⅜ in (73 × 92.5 cm). Leningrad, Hermitage Museum.

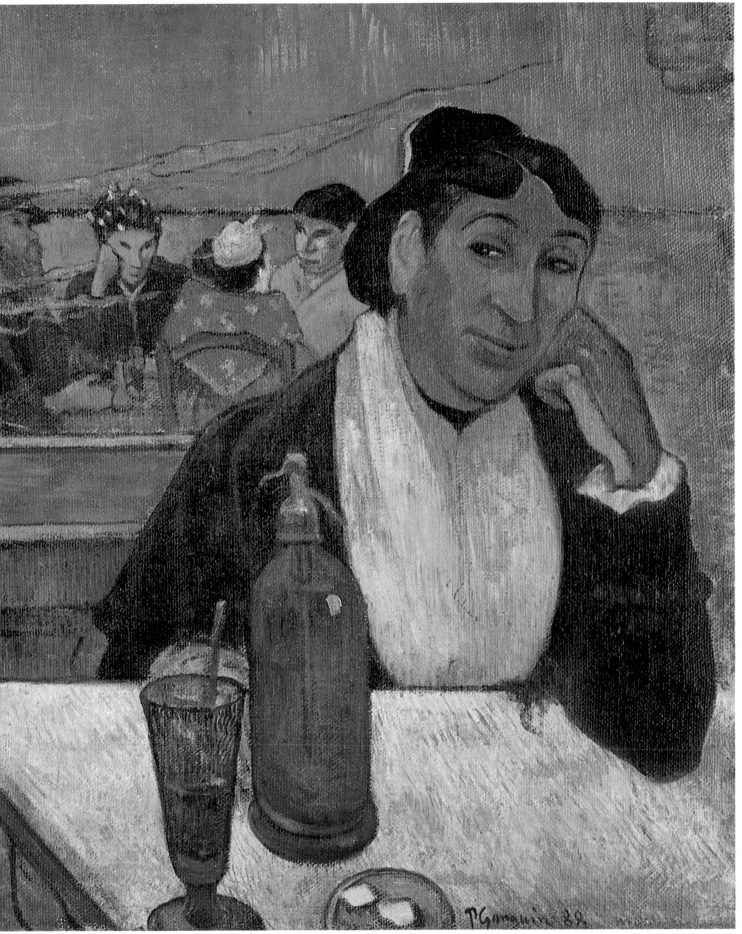

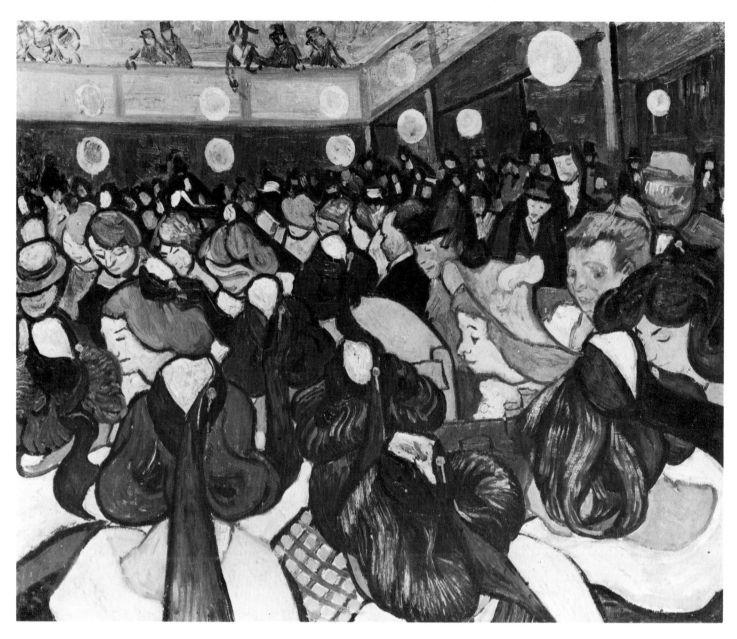

108. Vincent van Gogh, *Dance Hall,* 1888. Oil
on canvas, 25½ × 31⅞ in (65 × 81 cm).
Paris, Louvre.
An unusual picture in van Gogh's output, it
shows the *Cloisonniste* influence of Bernard and
perhaps Anquetin in its heavy outlines and
unmodelled areas of bright colour. It was
painted probably in mid-summer at Arles.

difficult part, with a hundred things to think of in a single half-hour.'

Van Gogh wrote that, in painting *The Potato Eaters*, he was reminded of what had been said about Millet's peasants: 'that they seem to have been painted with the very earth that they sow.' He resumed this symbolic emotive use of colour – gnarled hands and faces rescued from darkness in a moment of communication beneath a lamp – in the Arles period. Simultaneously van Gogh evolved a synthesis of form as colour and colour as form – 'You must attack drawing with the colour itself in order to draw well.' Impressionist colour and the clarity of Japanese art (Provence answered to his idea of Japan) pushed him further in this direction, one which he had already begun to take before the stimuli of Paris, as it were, at first interrupted and then later confirmed it. The emotional charge, which in his earlier work comes from his subject matter, is now conveyed by radiant symbolic colour. From wheatfields, a bridge, sunflowers, a chair, portraits of men and women he distils something of their essential form and colour. His own statements on

the intentions of his use of colour may seem to us obscure, as when he writes of the picture of his bedroom with its scarlet blanket and yellow chairs that the colour 'is to be suggestive here of *rest* or of sleep in general'. But there is no doubt that profound poetic emotions are aroused by an underlying humanism in his depiction of his subjects that in other hands might seem thin and banal. This is one of the reasons for his continuing universal popularity.

Gauguin's visit to Arles (from 23 October to 26 or 27 December 1888) was in several ways a disaster in spite of the initial harmony between the two painters and their productivity. They lived in the 'yellow house', 2 place Lamartine, which van Gogh had earlier leased and furnished as a possible headquarters for the 'studio of the South', to which he hoped to attract such painters as Bernard, Laval and Gauguin. He felt that a community stood a greater chance of achievement (and would gain materially from cooperative living) than individuals working in isolation. It was not to be a school with an aesthetic programme and rules but more of a fraternal association. From the start he saw Gauguin as the leading figure and Theo as business manager and ministering angel. The divisions of opinion and electric atmosphere between these two very different individuals have perhaps been over-stressed at the expense of their mutual agreement and affection. But by December there were furious quarrels and the episode ended with van Gogh's first serious mental crisis. It was induced by their incessant arguments and by the threat of Gauguin's departure (and the collapse of van Gogh's dreams for a painters' community), and was aggravated by the fact that Theo, who was supporting them both, had announced his imminent marriage.

What particularly concerns us is the relationship between van Gogh and Gauguin as painters. Gauguin enjoyed having disciples but discovered that, although van Gogh was temporarily willing to submit his art to ideas inimical to it, his temperament and conceptions were already both forceful and essentially different.

Some months before Gauguin's arrival van Gogh had painted certain 'experimental' works, which indeed are some of the least satisfactory in a year of extraordinary achievement. He had been variously influenced in this by his correspondence and exchange of drawings (see plate 109) with Bernard, probably by his knowledge of Anquetin's paintings seen in Paris and by his interest in the work of the Pont-Aven group. He tackled busy figurative subjects unusual for him, with very strongly defined contours and arbitrary colour. *Dance Hall* (plate 108) and *Arena at Arles* are two such paintings, the former sharing affinities with Bernard's work. Gauguin's presence inspired further paintings in which the *Cloisonniste* effect is very noticeable and in which elements of working from memory are juxtaposed with more immediate observa-

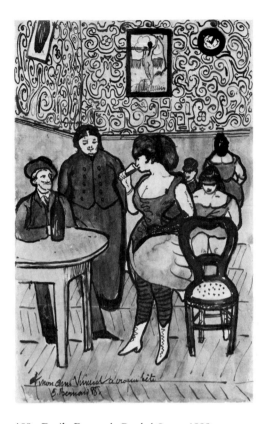

109. Emile Bernard, *Brothel Scene*, 1888. Watercolour, 12 × 7¾ in (30.5 × 19.7 cm). Amsterdam, National Museum Vincent van Gogh.

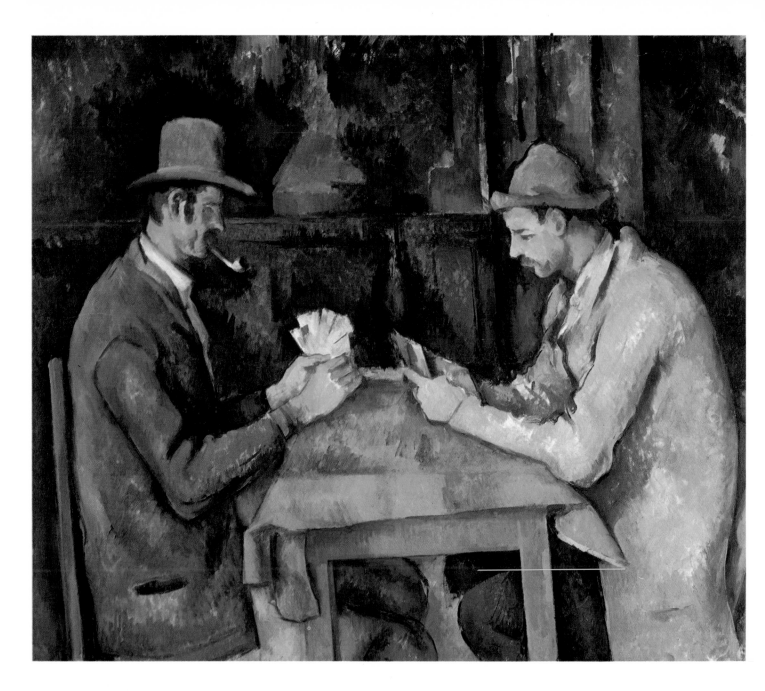

110. Paul Cézanne, *The Cardplayers*, c. 1893.
Oil on canvas, 23½ × 28¾ in (60 × 73 cm).
London, Courtauld Institute Galleries.

tions (for example, *Les Alyscamps, Arles* [plate 112] and *Memory of the Garden at Etten* in which he combines Dutch and Arlesian motifs, emphatic contours and Pointillist technique).

Gauguin inevitably also used certain subjects or particular images common to van Gogh (and at the end of his life cultivated and painted the sunflowers which van Gogh had made especially his own). But whereas Gauguin wished to create painting that was musical and harmonious before it was descriptive of an individual or 'scene', van Gogh was not prepared to divorce the two and, indeed, they are inseparable in so much of his best work. This is one of the reasons for his profound impact on Northern Expressionist painting and, in France, for his relatively small influence on the actual conception of what a work of art should be. The success and failure of his painting depends to a large extent on the intensity of his reactions to the subject. To ensure

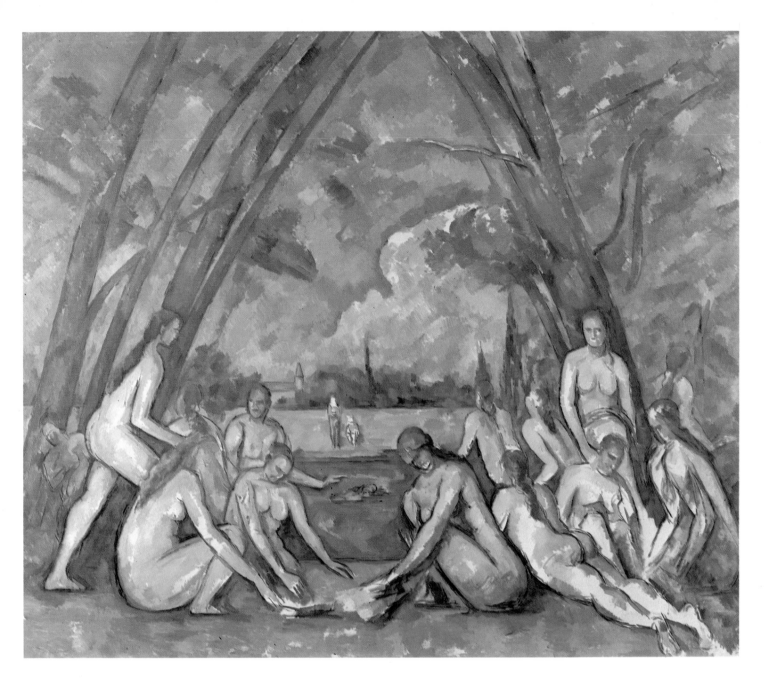

the survival of his particular vision, such reactions had to be held in perfect balance with all the other elements that constitute a painting. It is remarkable that, considering the painful and disruptive circumstances of his life, he so often achieved this.

If in some senses van Gogh is an isolated figure, it is not, as we have seen, because he shared little with his contemporaries, but because he brought such a compassionate view of humanity to his conception of painting. The types of subject taken by Lautrec or Gauguin are unthinkable when removed from the form in which they are presented to us. This is much less so in the case of van Gogh, whose compulsion to express his vision of the world would have found other mediums if painting had never presented itself. His letters are as much a contribution to literature as they are a biographical document of prime importance. When he realized at Auvers in July 1890 that his madness

111. Paul Cézanne, *Large Bathers*, 1899–1906. Oil on canvas, 82 × 98½ in (208 × 249 cm). Philadelphia, Museum of Art (W. P. Wilstach Collection).

112. (*Above*) Vincent van Gogh, *Les Alyscamps, Arles,* 1888. Oil on canvas, 28¾ × 36¼ in (73 × 92 cm). Otterlo, Rijksmuseum Kröller-Müller.
A November painting of Les Alyscamps at Arles, an avenue bordered by Roman tombs leading to the Chapel of St-Honorat. This is one of four paintings of the Alyscamps made by van Gogh during Gauguin's visit to Arles. The ground is red-brown, the trees lilac-blue, a colour combination frequently found in Gauguin's work, including his *Les Alyscamps* in the Louvre.

113. (*Above right*) Paul Gauguin, *Old Women of Arles,* 1888. Oil on canvas, 28¾ × 36 in (73 × 91.44 cm). Chicago, Art Institute.

was an overwhelming threat to that expression, he killed himself.

In 1889 and in the following year Gauguin was in Brittany; from 1891 to 1893 he made his first visit to Tahiti, returning there in 1895; he moved to the Marquesas Islands in 1900 and died there in 1903, a legendary figure in Paris and already beginning to influence a younger generation. In going to the South Seas, Gauguin had hoped to rejuvenate his painting through contact with a relatively unspoilt civilization and in a landscape that was untouched, luxurious and mysteriously evocative – as mysterious as the looks of the native men and women. Certainly his art was made richer and more profound but, as we now know, he found a civilization in the grips of colonial corruption and an island where many of the ancient myths and customs had already vanished and traditional beliefs were almost extinct. But Gauguin's aim was never illustration or description; he combined in his work contemporary and archaic motifs, Christian and Maori beliefs, Polynesian, Javanese, Egyptian and even Greek-inspired design. His figures are ample and sturdy with a slow grace of gesture. Vitality of contour and superb arabesque unite these solid, often fully modelled, figures with completely flat decorative backgrounds and foregrounds.

His concept of space was now usually less audacious than in *The Vision of the Sermon;* planes were often clearly defined, areas of pure colour were made less insistent by subtle variation of tone and brushwork. Elements brought together on one canvas were arranged in a less 'arbitrary' or bizarre manner than in, for example, some of the still-lifes of the late 1880s. But he retained (particularly in work from his first Tahitian visit) some of those Degas-like traits of composition as in *Le*

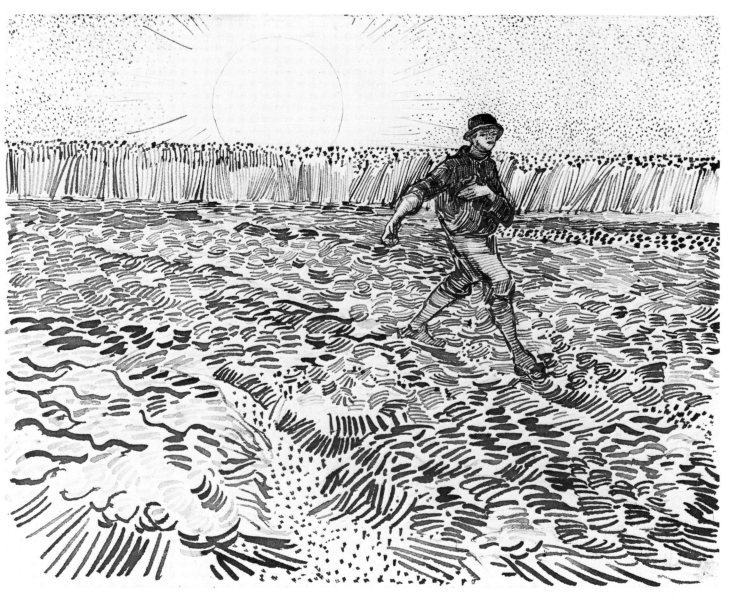

114. (*Above*) Vincent van Gogh, *The Sower,* 1888. Ink, 9½ × 12½ in (24 × 32 cm). Amsterdam, National Museum Vincent van Gogh.

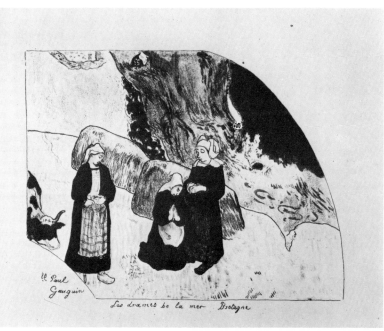

115. Paul Gauguin, *Dramas of the sea,* 1889. Zincograph, 12 × 18¼ in (30.5 × 46.1 cm). London, Courtesy of Christie's.

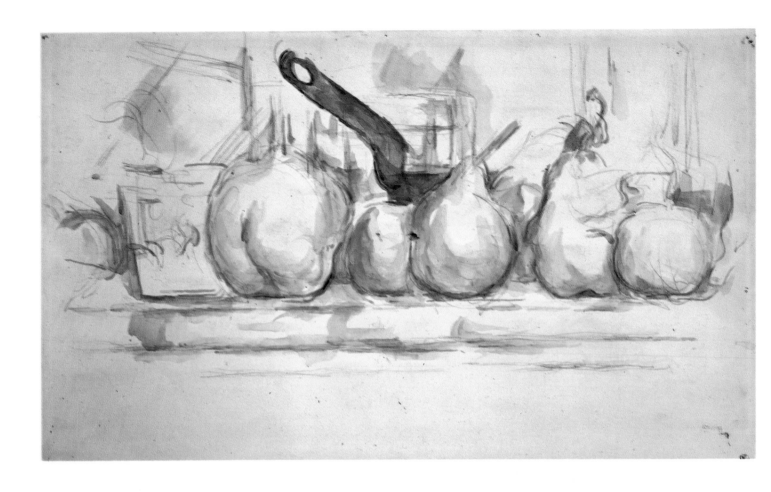

116. Paul Cézanne, *Still-life with apples, pears and pot,* c. 1900–4. Watercolour, 11 × 18¾ in (28 × 47.5 cm). Paris, Louvre, Cabinet des Dessins.

117. (*Opposite above*) Paul Gauguin, *Tahitian Woman,* 1892. Pencil, charcoal and pastel, 12¾ × 11 in (32.4 × 27.9 cm). Chicago, Art Institute (Gift of Emily Crane Chadbourne).

118. (*Opposite below left*) Paul Gauguin, *Head of a Breton Peasant Girl,* c. 1889. Graphite, black and red crayon and black wash, 8¾ × 7⅞ in (22.4 × 20 cm). Cambridge, Mass., Fogg Art Museum, Harvard University (Meta and Paul J. Sachs Bequest).

119. (*Opposite below right*) Paul Gauguin, *Head of Tahitian Man,* c. 1891–3. Charcoal, 12¾ × 11 in (32.4 × 27.9 cm). Chicago, Art Institute (Gift of Emily Crane Chadbourne).

Repas (plate 101), where the still-life reminds us a little of Cézanne. Elegance of line and undulating contour winding through the picture space replaced the sometimes abrupt and angular *Cloisonnisme* of his work in Brittany. He was entranced by the enigmatic quality of the people among whom he lived. 'Animal figures rigid as statues,' he wrote, 'with something indescribably solemn and religious in the rhythm of their pose, in their strange immobility. In eyes that dream, the troubled surface of an unfathomable enigma . . . I have tried to interpret my vision in an appropriate décor and with all the simplicity the medium permits.' The forms of flowers and trees, tendrils and exposed roots encouraged a rhythmical elaboration of the surface which was tentatively announced in some of his Martinique landscape paintings of 1887.

In paintings from his very last years we see a markedly classical spirit in his disposition of figures and their hieratic poses among the groves of trees; the influence of Puvis de Chavannes remained important (he had reproductions of his work with him in Tahiti) and Degas's work continued to inspire him. In a painting of sunflowers of 1901 photographs of studies by Puvis and Degas are pinned to the wall behind, and Degas's racecourse pictures are recalled in two paintings of

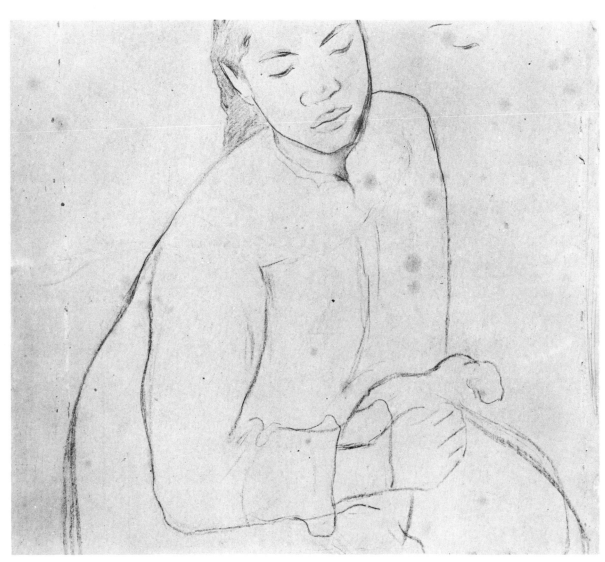

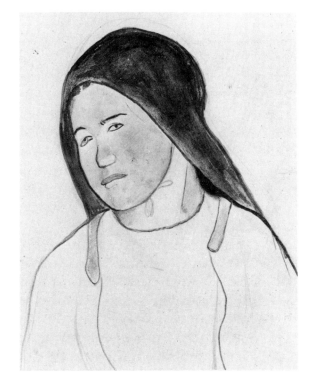

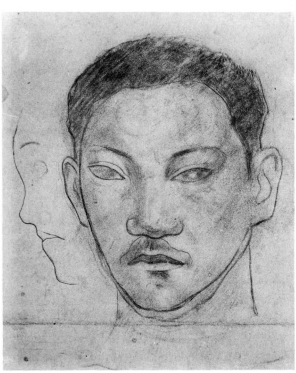

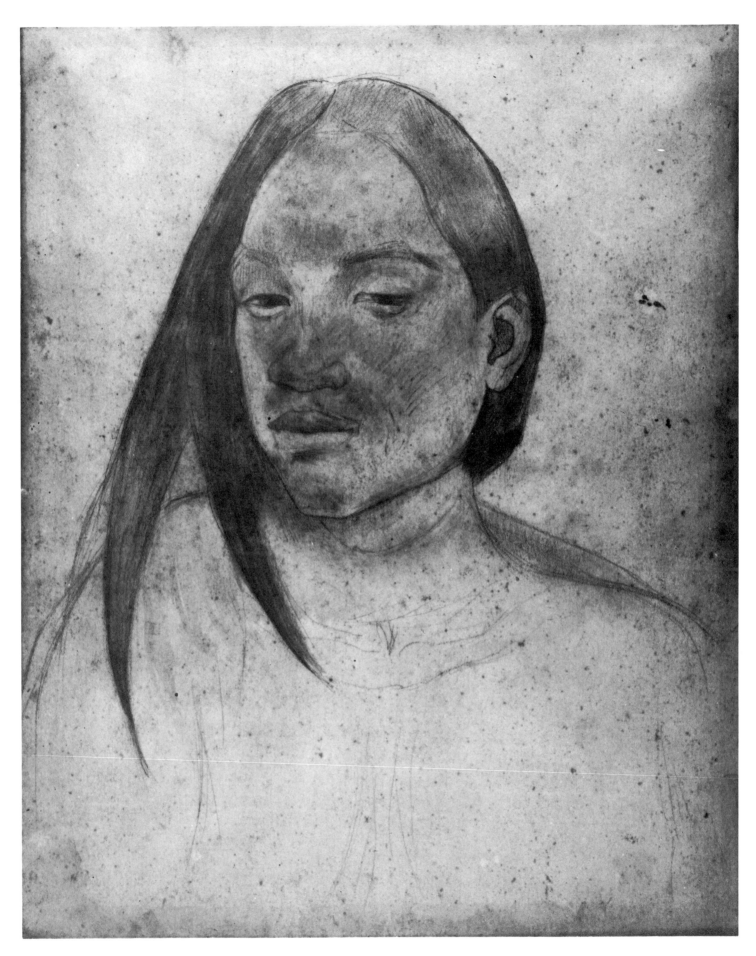

98

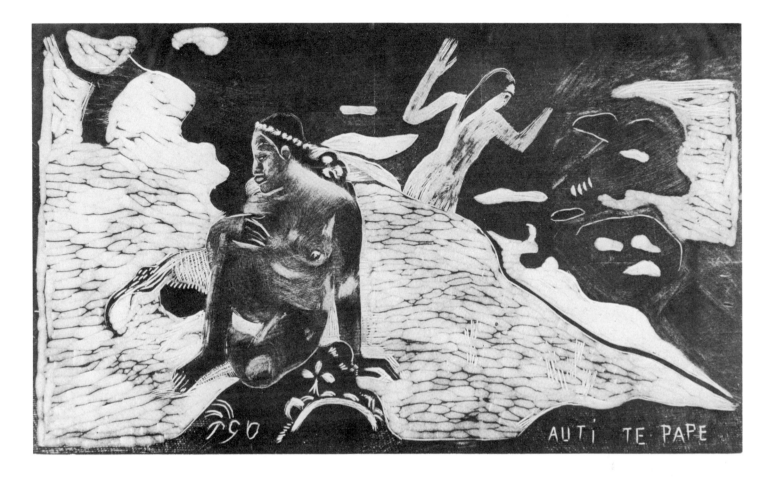

1902 of horseriders on the beach near Atuana. More importantly, Gauguin turned to primitive art, or rather considerably enlarged his early interest in that direction. He carved figures similar to those that he found in Tahiti and which we see as idols in several paintings that evoke the ancient Polynesian religion. This had immense consequences in the early years of this century, when painters and sculptors were deeply influenced by primitive art because of its direct expression, its distortion of the human form and its spontaneous carving and colouring. Gauguin was also in part responsible for the vogue for brilliantly coloured textiles created by designers and influential in, for example, the costumes and décor of the Russian ballet.

Throughout the Tahitian period we are continually reminded of Gauguin's sophisticated position not only in his formal vocabulary, but in the fact of his very presence in Tahiti – a highly self-conscious act of self-exile that had nothing to do with naïve idealization or romantic escape. It was primarily a voyage towards, rather than away from, himself. Of his achievement in Tahiti he was never in doubt: 'The public owes me nothing since my work is only relatively good; but the painters of today who profit from this liberty owe me something.'

121. (*Above*) Paul Gauguin, *Auti Te Pape (les femmes à la rivière)*, 1894–5. Woodcut in three colours, 8½ × 4¼ in (21.7 × 10.8 cm). Private Collection.

120. (*Opposite*) Paul Gauguin, *Head of Tahitian Woman*, c. 1891. Pencil, 12 × 19⅝ in (30.6 × 24.5 cm). Ohio, Cleveland Museum of Art (Mr and Mrs Lewis B. Williams Collection).

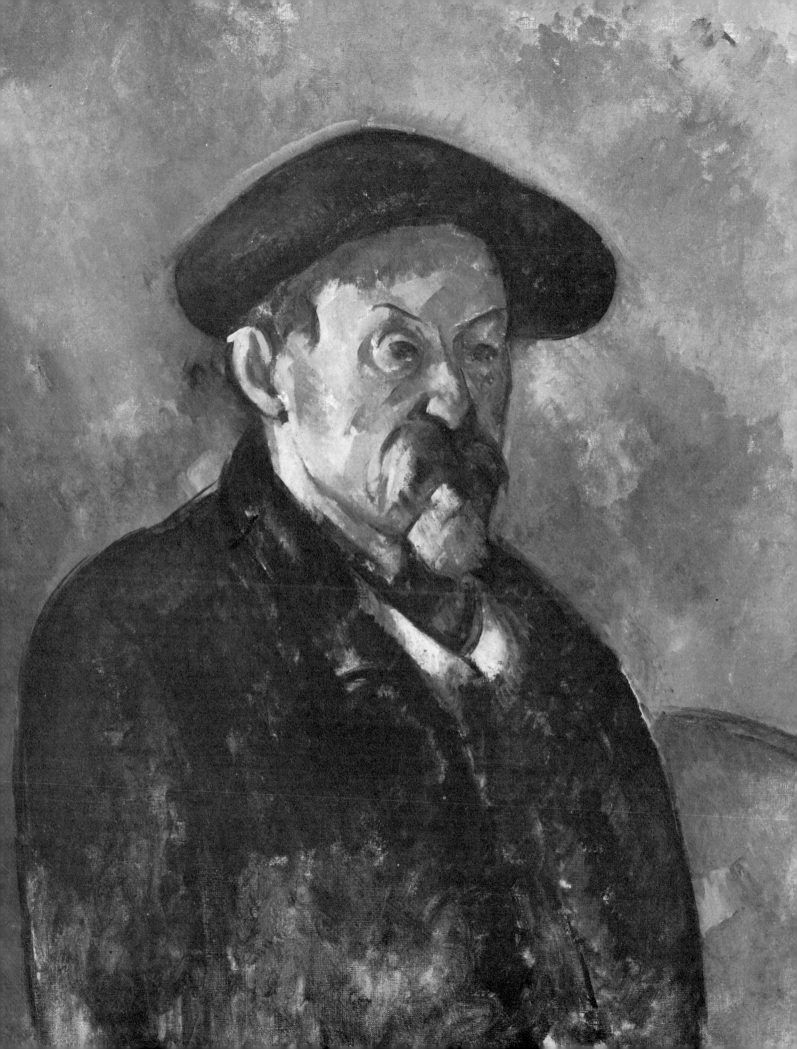

5
Cézanne at Aix

122. Paul Cézanne, *Self-portrait with beret*, 1898–1900. Oil on canvas, 25¼ × 21 in (63.5 × 50.8 cm). Boston, Museum of Fine Arts (Charles H. Bayley Fund).
This is probaly the last of Cézanne's famous series of self-portraits.

In the Introduction I suggested that major painters were ill-served by their inclusion within a particular movement. Looking at their work in so narrow a light, we tend to pick out those elements which make the artist fit, and miss the significance of their whole achievement. During his lifetime and even immediately after his death (at Aix in 1906) Cézanne was still thought by some to be a strange minor figure attached to the Impressionist movement of forty years before. Gauguin, who died three years earlier than Cézanne, was frequently referred to as the prophet of the new movement in painting, and for a short time his work was tremendously influential. His decorative 'charm' and exotic subject matter became the acceptable face of modernism to those who denied a place to van Gogh or Cézanne. The true measure of Cézanne's genius was only gradually taken as people saw how immensely indebted to him were the painters who came to prominence just before the First World War, grouped about the figures of Picasso and Braque, Derain and Matisse.

In age he belonged to the Impressionist generation, a year older than Monet and the same age as Sisley; he became friends with Pissarro and Armand Guillaumin when he was studying at the Académie Suisse in Paris. Pissarro wrote over thirty years later: 'I see that I was right in 1861 when Oller and I saw this strange Provençal at the *Atelier Suisse,* where Cézanne made academic studies to the derision of all the impotents of the school. . . .' Cézanne was by no means an easy companion; his profound admiration for Manet did not prevent him from indulging in excessively crude behaviour in front of him; he quarrelled easily with friends and was morbidly sensitive to anything that hinted of disagreement or criticism. At the same time he retained the friendship of Pissarro and Renoir, painters of his own generation. His relations with the Post-Impressionists – Gauguin, Seurat, van Gogh – were either non-existent or petered out in sarcastic derision and contempt. Only at the end of his life did a younger group of admirers gain a certain foothold in his interest and affections,

123. (*Opposite*) Paul Cézanne, *Harlequin*, 1888.
Oil on canvas, 36¼ × 25½ in (92 × 65 cm).
London, Private Collection.
A painting of the artist's son Paul in harlequin's costume. The figure also appears in *Mardi Gras* of the same year in which Cézanne's son is joined by Pierrot – a young friend, Louis Guillaume. Undoubtedly the pictures influenced the choice of Commedia dell'Arte figures a few years later in the works of Picasso, Derain and Gris.

particularly Bernard, Denis and Charles Camoin. He wrote that he despised all of his contemporaries (as painters) save Monet and Renoir; his view of Bernard's work was disparaging in the extreme, although it seems that Bernard was unaware of this.

Until 1895 his work was little known beyond a circle of painters and a few collectors. In that year his dealer Vollard organized a large exhibition in Paris which attracted much attention; for the first time young painters were able to see more of his work than the few canvases visible in Père Tanguy's shop. Vollard showed Cézanne again in 1889, the year that Matisse bought the *Three Bathers*. Of this picture Matisse wrote in 1936 (on giving it to the Musée d'Art Moderne) that: 'It has sustained me spiritually in the critical moments of my career as an artist; I have drawn from it my faith and my perseverance.' In 1904 the Salon d'Automne showed thirty-two Cézannes and in 1907, the year after his death, there was a memorial group of fifty-six works at the same Salon. Matisse's words are representative of the feelings of innumerable painters who have drawn encouragement from his example, his incredible persistence in 'realizing his sensations after nature', his self-imposed isolation which enabled him to continue his researches. A devotion to painting, he told Gustave Caillebotte, was 'the surest means of directing our sadness'. (November 1878).

It was a search which took him well beyond the Impressionism to which he had been initiated by Pissarro in the early 1870s. He evolved his own conception of painting in solitude, and its parallels with certain discoveries made by the Post-Impressionists are not simply explicable by his having influenced them. It is, however, those similarities which gain for him a special place in a consideration of Post-Impressionism.

Cézanne's friendship with Pissarro gave him the invaluable opportunity of working alongside an older painter whose theoretical turn of mind enabled him to justify and articulate Impressionist practice. Very much the same thing happened to Gauguin in the same decade. Until the early 1870s Cézanne had mainly painted imaginative works of a highly romantic inspiration, often violent and erotic in subject, using rich dark colours and an impetuous, even brutal, brushwork. We can see the various influences of Tintoretto and Rubens, of Delacroix, Daumier and Courbet. Such pictures, so different from the work of his contemporaries, contained elements that predominated in later years under different circumstances. Volumes are passionately stated; rounded heavy figures are almost sculpted in paint; there is a deliberate expressiveness of brushstroke rarely related to the description of surface or texture, a desire to construct rather than simply record and an unwavering correctness of tonal relationships. The forcefulness of his temperament, which found expression in such melodramatic imagery, was transformed, through the example of Pissarro, into a

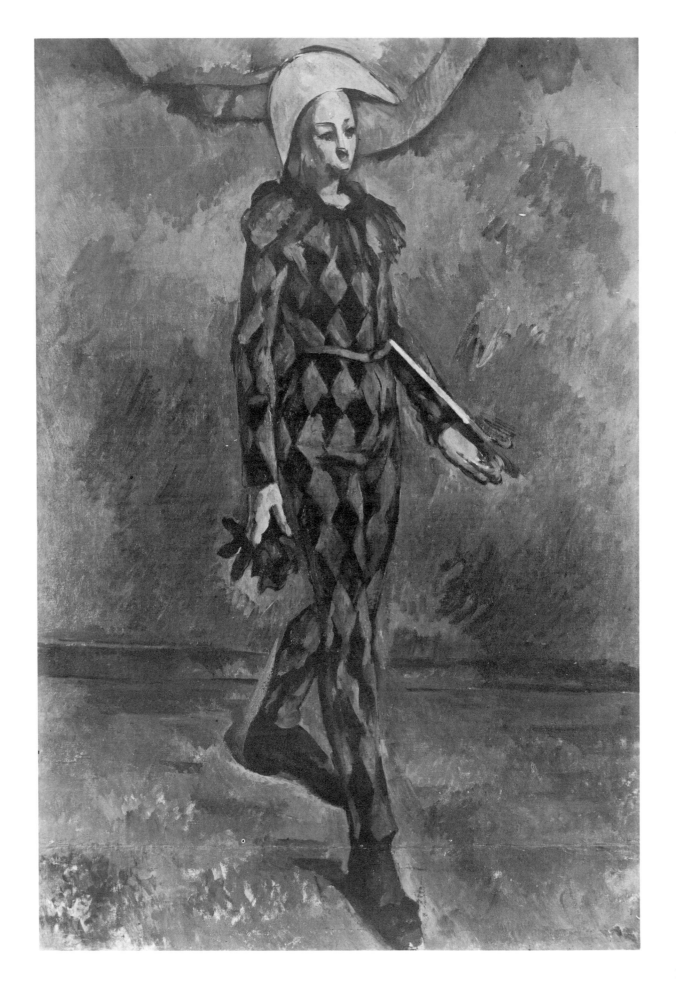

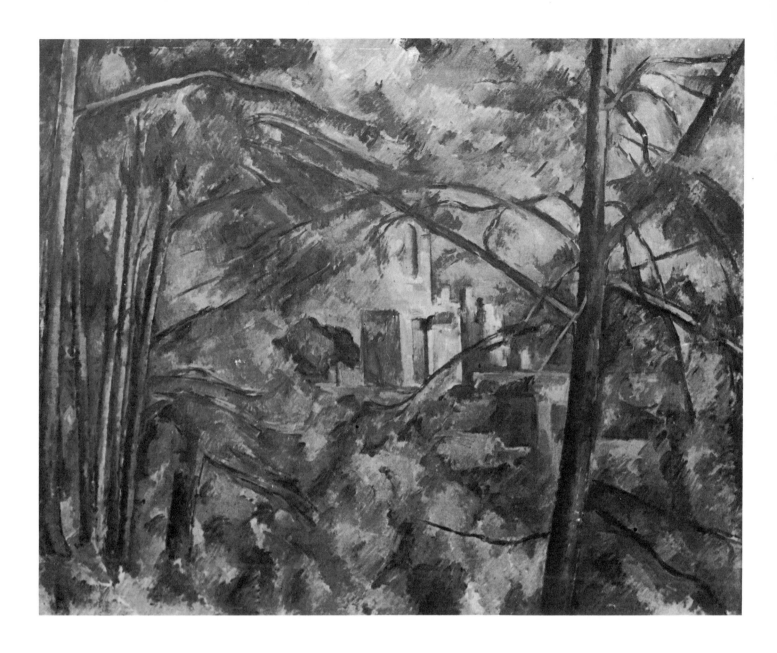

124. Paul Cézanne, *View of the Château Noir at Aix*, c. 1894–5. Oil on canvas, 28¾ × 36¼ in (73 × 92 cm). Winterthur, Oscar Reinhart Collection.

One of the most romantic of all Cézanne's many paintings of the Château Noir and its surrounding property. The house is situated on high ground, surrounded by dense foliage and trees, half-way between Aix and the Mont Ste-Victoire. Cézanne kept a painting room in the courtyard of the house.

fervent apprehension of the visible (as opposed to the imaginary) world in all its complexity.

Cézanne soon realized that a mere record of the play of light and the atmosphere of landscape would not satisfy him. It was not simply that he found a lack of structure in Impressionism. Pissarro was, after all, producing works at that time which were outstanding for their solid, definitive architecture. He needed a method that would control the strength of his sensations before nature, a method that would bring *all* the elements of painting, as he conceived it, into close accord. A structural clarity of line was insufficient for his purpose. The inseparable elements of colour, volume, contour and atmospheric space evolved without losing any of the emotional depth of his reaction to a particular subject. Pissarro's example dammed the flood of his previous ambition to create compositions of Baroque intensity; at the same time Cézanne continued to paint portraits and still-lifes (for not all of his early work was imaginative) with the objectivity that he had so admired in Manet's

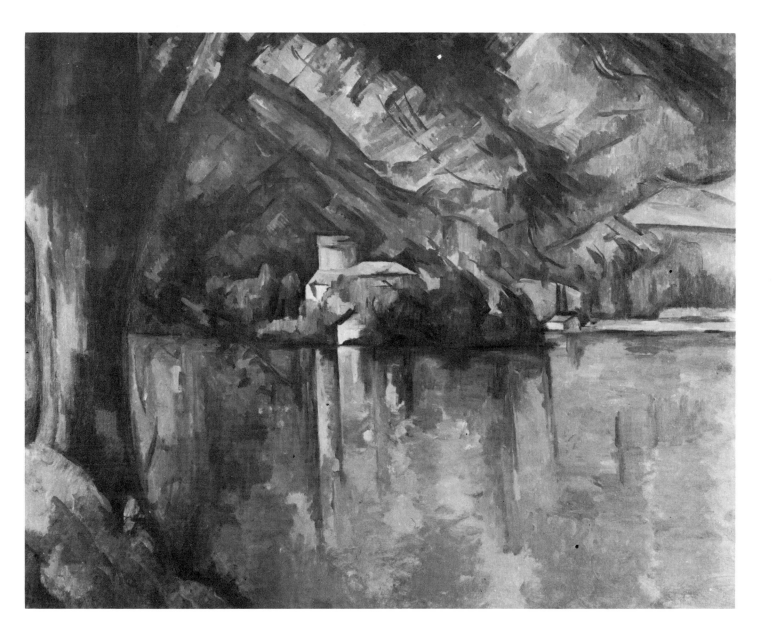

Olympia in 1865. But his romantic 'literary' exuberance was never completely suppressed; it is there in the series of bathers which occupied him to the end of his life. A predilection for sombre and violent images also found later expression in his taste for thick and tangled undergrowth, for cleft rock-faces and the Bibémus quarry, in the skulls of his later still-lifes (plate 127) and the motif of a house high-up and distanced by encroaching foliage as in the many pictures of the Château Noir.

The greater part of Cézanne's work embodies a visual experience which is often extraordinarily free of consciously psychological, literary or symbolic matter. The disturbing and excited aspect of some of his Provençal landscapes does not have that explicit subjective violence of almost similar subjects painted by van Gogh, working not many miles away at Arles and St Rémy. The country around Aix was unpopulated and dramatic, empty and silent; we do not have the feeling, as we do, for example, in Pissarro, of the hum and movement of a cultivated landscape with its people working and their carts on the

125. Paul Cézanne, *The lake of Annecy*, 1896. Oil on canvas, 25½ × 32 in (64.8 × 81.3 cm). London, Courtauld Institute Galleries. Cézanne rarely stirred from Aix and its neighbourhood in the last years of his life. But in 1896, feeling the effects of increasing diabetes, he went to Vichy for a cure and on to Lake Annecy where this painting was begun.

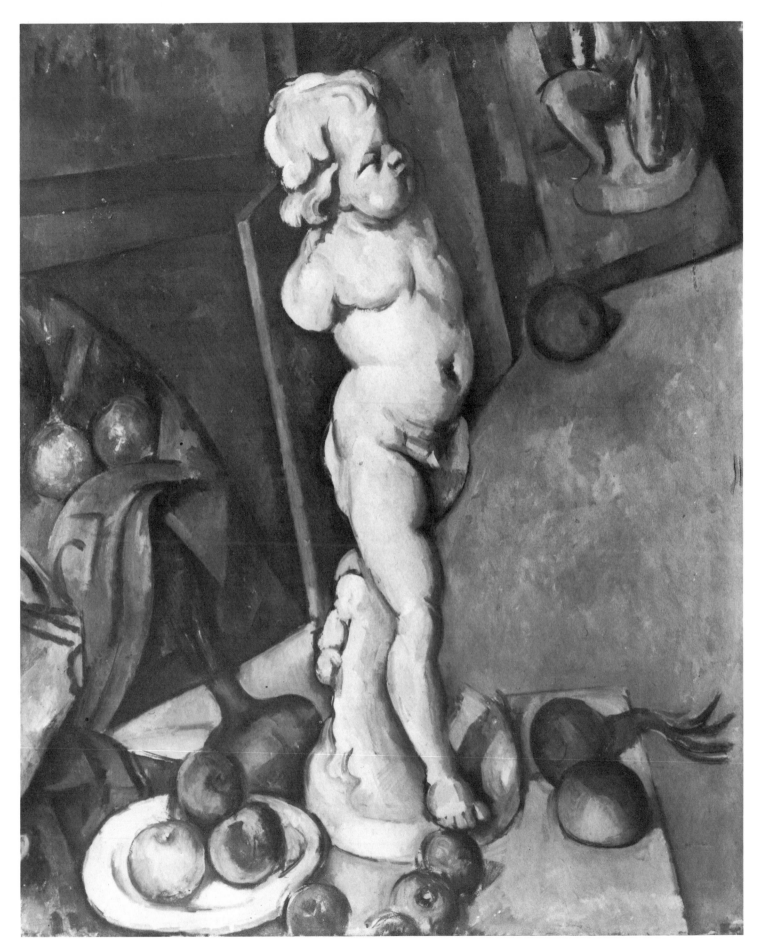

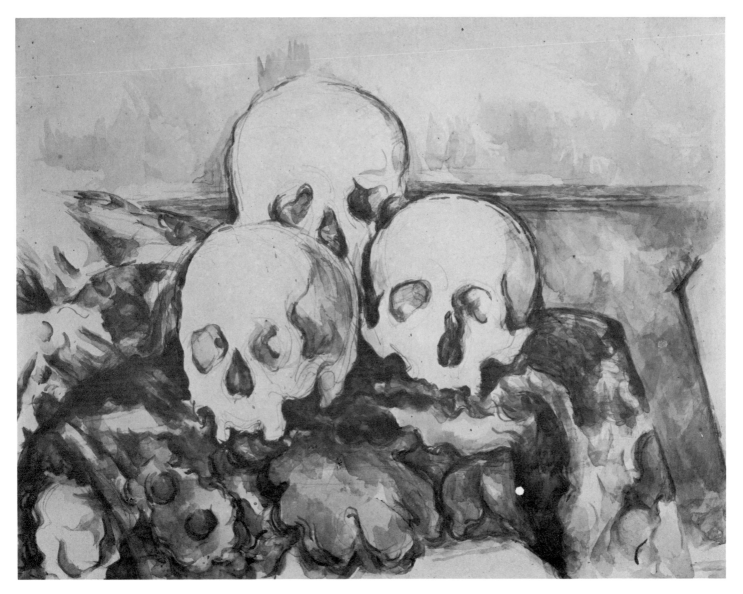

127. Paul Cézanne, *The Three Skulls*, 1900–4. Pencil and watercolour, 18¾ × 24¾ in (47.5 × 63 cm). Chicago, Art Institute of Chicago (Mr and Mrs Lewis L. Coburn Memorial Collection).

road. Cézanne chose sights that were often difficult to get to, away from people and free of temporary distractions. His portraits are nearly all of local people – his gardener, a workman, an old servant (exceptions were such friends as Vollard, Gasquet, the critic Gustave Geffroy and Mme Cézanne, his wife). And there is no evidently conscious attempt to penetrate their character and psychological state (as we find in van Gogh), although a good deal about a particular person does emerge from Cézanne's patient scrutiny of the planes of the face. And when the weather made painting out of doors impractical – in winter or in intense heat or when sitters were impossible to find (for Cézanne was regarded with suspicion and contempt by many of his neighbours in Aix) – there was always the unchanging immobility of the still-life. In a long series we see the same objects repeated over again in different combinations against different walls and hangings – fruit-bowls, dishes, ginger-

126. (*Opposite*) Paul Cézanne, *Still-life with plaster Cupid*, c. 1895. Oil on paper on board, 27½ × 22½ in (70 × 57 cm). London, Courtauld Institute Galleries.

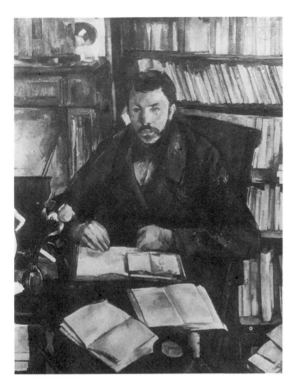

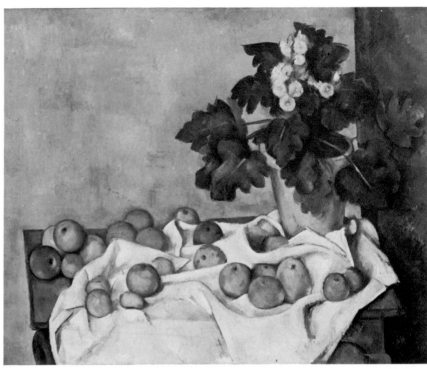

128. (*Above*) Paul Cézanne, *Gustave Geffroy*, 1895. Oil on canvas, 45¾ × 35½ in (116.2 × 89.9 cm). Paris, Louvre, Jeu de Paume. A portrait of the critic and writer Gustave Geffroy, a warm admirer of Cézanne's work. The two men had met originally at the instigation of Monet at Giverny in 1894. In spite of innumerable sittings (in Geffroy's home at Belleville, Paris) the portrait remained unfinished.

129. (*Above right*) Paul Cézanne, *Still-life: Apples and a pot of flowers*, c. 1890–4. 28⅜ × 35½ in (72.08 × 90.17 cm). New York, Metropolitan Museum of Art (Bequest of Samuel A. Lewisohn, 1951).

130. (*Opposite*) Paul Cézanne, *Madame Cézanne*, c. 1890. Oil on canvas, 45¾ × 35 in (116 × 89 cm). New York, Metropolitan Museum of Art (Mr and Mrs Henry Ittleson Jr. Fund).

jars, plaster-casts from his studio, long-lasting fruit and vegetables. To allow himself full rein to explore their formal possibility vases of fresh flowers were replaced by artificial flowers and plants.

It was with such subjects that Cézanne slowly and painfully (as his letters reveal) constructed a method of painting that was nothing less than a new and radical synthesis of visual experience. His idea of painting was as 'a harmony parallel to nature', an interpretation of what he saw, an equivalent rather than an empirical representation. Every element of the painted surface contributed to a definition of the relations between objects, organized within their pictorial space. The 'theatrical' spatial organization developed from the Renaissance onwards had to be overhauled and replaced. To express himself fully Cézanne could no longer obey the rules of classical perspective in which objects and figures are related through an *a priori* conception. He saw each element of his picture as engendering its own space: without the objects, to put it simply, there would be no space. Cézanne was not, of course, alone in this revaluation – *La Grande Jatte* combines different perspectives; Gauguin makes the picture plane shallow; Degas's often raised viewpoint introduced overlapping ambiguously positioned sequences of images. But the thoroughness of Cézanne's researches went further than that of his contemporaries. Objects are drawn to each other or pulled apart, obeying a purely pictorial necessity. The traditional vanishing point is modified or altogether abandoned; the 'foreground' seems further away than features near the horizon (as in *Mt Ste Victoire*

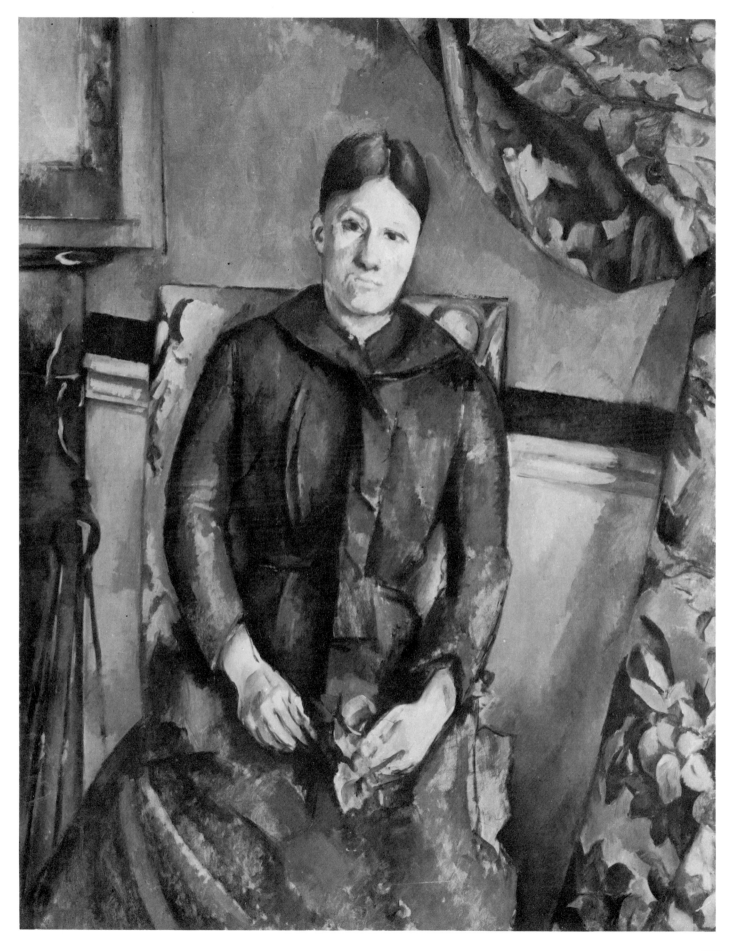

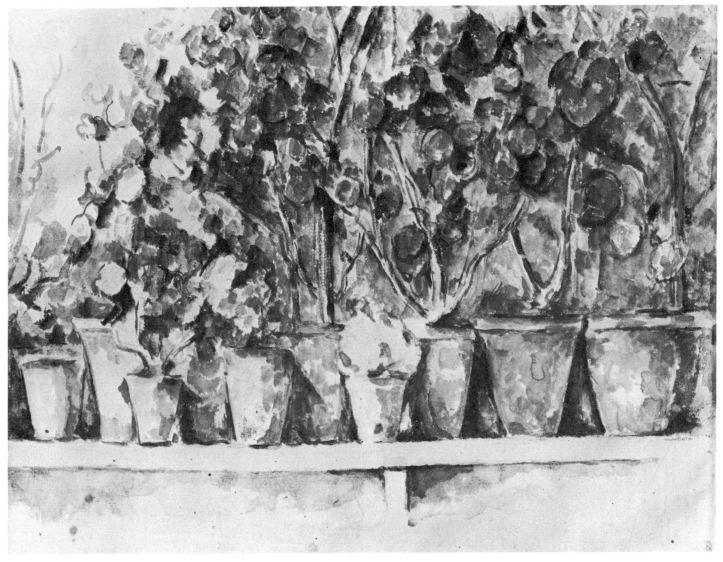

131. Paul Cézanne, *Pot of Flowers*, c. 1885. Watercolour and gouache, 9¼ × 12¼ in (23.6 × 30.8 cm). Paris, Louvre, Cabinet des Dessins.

seen from Les Lauves); everything is viewed in relation to everything else in a carefully contrived immediacy.

Such considerations are inseparable from the surface texture of the picture. One stroke of the brush or patch of colour determined the next – in the density or lightness of tone, the shape, the rhythm and direction of application and the relation to all the other marks on the canvas. Such concentration prohibited bravura of handling or looseness of definition. In following closely the development of Cézanne's method of applying paint, we come near to understanding his meaning when he wrote that painting was 'the most intimate manifestation of ourselves'.

The development of Cézanne's art must be followed from picture to picture with scrupulous attention to specific features which can neither be separated from each other nor from the evolution of his painting as a whole. But about the later work (from the mid-1880s onwards) we can say that his colour became increasingly brilliant and free (even in paintings which seem dark); blue began to pervade the landscape and the large Bathers series; there were certain recurrent combinations of colours of an apparent simplicity – orange and a sharp

132. (*Opposite*) Paul Cézanne, *The Aqueduct*, c. 1898–1902. Oil on canvas, 35¾ × 27¾ in (91 × 71 cm). Moscow, Pushkin Museum.

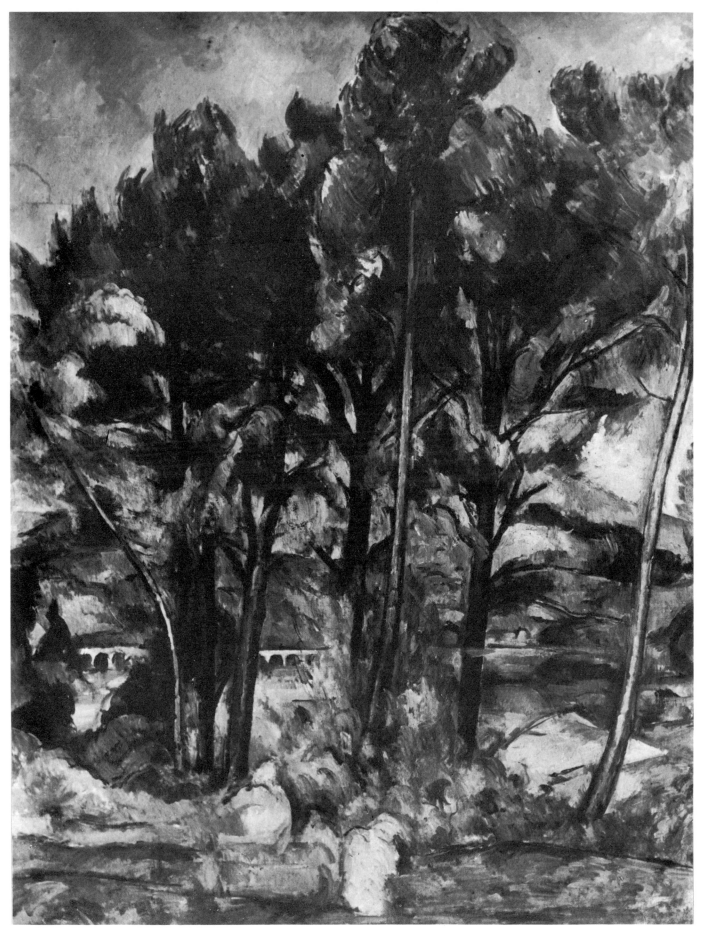

 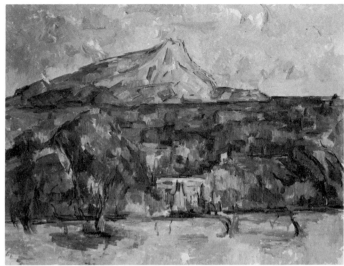

133. (*Above*) Paul Cézanne, *La Montagne Ste Victoire*, 1886–8. Oil on canvas, 25½ × 32 in (64.77 × 81.28 cm). London, Courtauld Institute Galleries.

134. (*Above right*) Paul Cézanne, *La Montagne Ste Victoire*, 1902–6. Oil on canvas, 28¾ × 36¼ in (73 × 92 cm). Kansas, Mary Atkins Museum of Fine Arts.

135. (*Opposite*) Paul Cézanne, *The Gardener*, 1902–6. Oil on canvas, 25⅝ × 21¼ in (65 × 54 cm). Zurich, Bührle Foundation.

chrome green (and an emerald last seen in Delacroix), a range of violets and a warm ochre yellow as though spiced with cinnamon (seen in the *Portrait of Ambroise Vollard*). The colour is less immediately seductive than in Monets and Renoirs of the same period; Cézanne uses a narrower range of colours, although they are infinitely complex in their tonal changes. One or two colours dominate a painting, above all blue – from a strident ultramarine to soft violet tones as in *Les Grandes Baigneuses* (plate 139). As has been frequently noticed, Cézanne reflects much more accurately than does van Gogh the tonality of the Provençal countryside in which they were working in 1888 and 1889 only forty-five miles apart. There are landscapes by Cézanne that have exactly that baked-through, almost monotonous colour which we recognize in hot Mediterranean country. The native-born Cézanne, who knew the country intimately, resists all the enchantment of blossoming orchards and flowering undergrowth, as he resists so much else before a figure or a still-life. Van Gogh, the Dutchman, transformed the land-scape through a seemingly dreamt, symbolic brilliance of colour, very different from Cézanne's. Occasionally, however, these two very dissimilar painters invoke a similar convulsive rhythm throughout a painting, particularly in some of Cézanne's views of the Bibémus quarry and in van Gogh's St Rémy landscapes.

But whereas van Gogh is invariably flat and linear, Cézanne constantly evokes sequences of convex shapes through clusters of parallel brush-strokes. In earlier works these strokes are close together; in later paintings, especially those of Mt Ste Victoire, they become more elastic and the paint more liquid (plate 134), confirming the increasing influence of Cézanne's watercolour technique in which thin areas of colour are superimposed, one on another. This gives the feeling of the multifaceted appearance of nature, layer upon layer slowly revealed; he brings the landscape towards us in horizontal divisions rather than leading us towards it in elaborate chiaroscuro. He leaves patches of bare canvas as articulate and structurally purposeful as painted areas; they are suggestive of air and light within the whole design. This

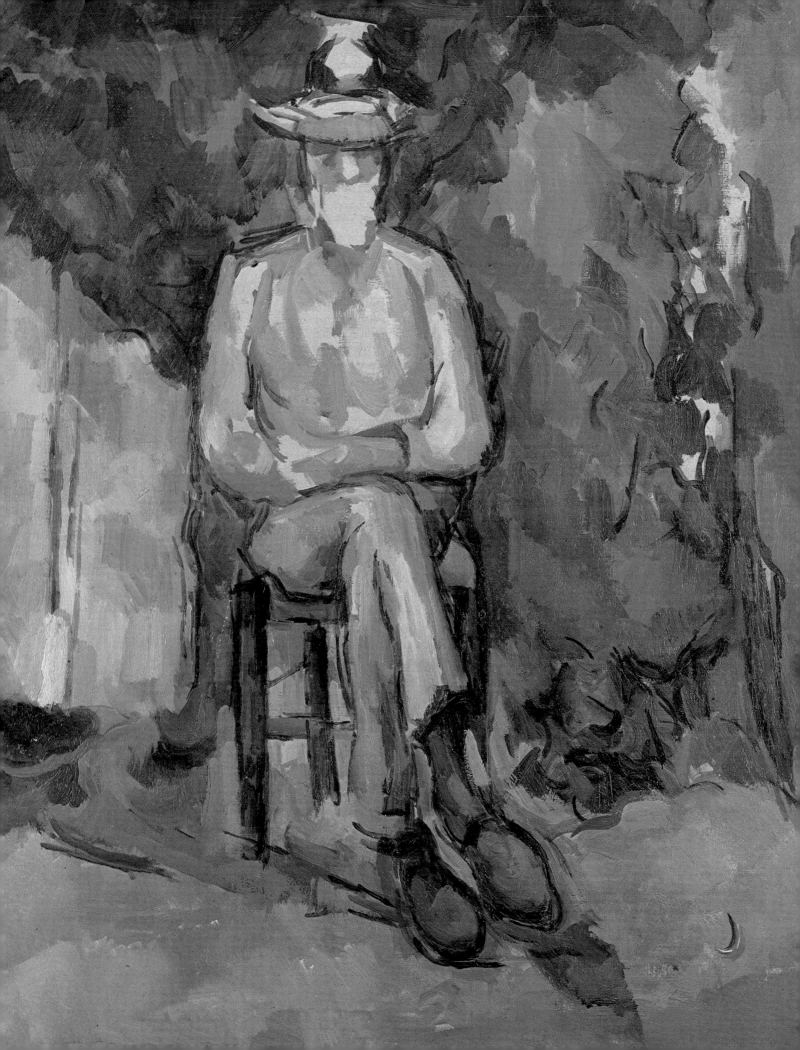

dazzling weft of colour is reinforced by an overall rhythm that puts us in mind of sixteenth-century Venice and of Cézanne's life-long hero Delacroix. Such rhythms are particularly expressive of Cézanne's impetuous and passionate temperament. We see rounded bulging forms, sensually deployed, relating some of his late still-lifes (plate 116) to some of his earliest imaginative works, such as *The Temptation of St Anthony* in the Bührle Collection. At the same time Cézanne was using the most carefully modulated patches of colour in a technique that, although never laborious, (his brushwork is often extremely energetic), is supremely calculated. This synthesis of direct observation and the careful construction of rhythms within the painting equivalent to those of the subject matter constituted the agonizing search of his life. A few weeks before he died he wrote to his son: 'Finally I must tell you that as a painter I am becoming more clear-sighted before nature, but that with me the realization of my sensations is always painful. I cannot attain the intensity that is unfolded before my senses. I have not the magnificent richness of colouring that animates nature.' (8 September 1906).

There is one group of paintings from Cézanne's later years which continues his early imaginative work and is a culmination of a life-long obsession – the studies for and compositions of groups of bathers seen on the banks of a river. Groups of female and male bathers had occupied Cézanne since the 1870s, but it was only in his last years that female bathers took precedence, the largest group being the one in Philadelphia (plate 111) which was the last; the versions in the National Gallery, London (plate 139) and the Barnes Foundation were worked on over the period 1899–1906. Cézanne was attempting one of the great themes of European painting, although there is no narrative impulse behind them – no Toilet of Venus nor Diana and her handmaidens, themes which he had treated some thirty years before (plate 136). Nude bathers was a subject more common among the Salon painters than among Cézanne's friends or contemporaries; only Renoir tackled a similar theme on a large scale (Pissarro's were more modestly conceived). Younger painters such as Bernard, Vallotton and Cross produced open-air bathers and, of course, Cézanne's versions influenced Matisse in his *Luxe, Calme et Volupté* of 1904, a contemporary scene of bathing women on the beach of an Arcadian pre-tourist St Tropez.

The male bathers are partly inspired by Cézanne's recollections of his youth, swimming in the river Arc in the valley below Mt Ste Victoire, an experience mentioned in several poems and letters to his boyhood friend Zola in the late 1850s, even to the shady pine-tree on the bank which recurs in several studies and in the *Three Bathers*, already mentioned. Poses were reputedly taken from sketches made of soldiers bathing and from paintings and sculpture by other artists. This was true too of the groups of female bathers, for Cézanne was

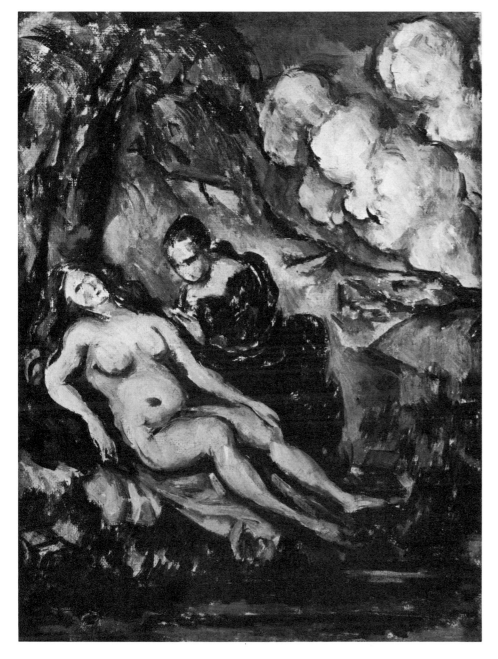

136. Paul Cézanne, *Bethsabee,* 1875–7. Oil on canvas, 12¼ × 9¼ in (31.1 × 23.5 cm). Private Collection.

generally too inhibited to work with a live model. Some poses derived from very early life-drawings, steadily altered and repeated. The landscape settings include various observed and imagined features. The vaulting trees, for example, in the Philadelphia version (plate 111) recall his home at Aix, as well as the framing baldaquin of *The Eternal Feminine* (1875–77). The groups of male bathers are conceived in an energetic and varied rhythm, some undressing or drying themselves and others wrestling (as in Bazille's *Summer Scene* [plate 27]). The female bathers are generally more monumental in their grouping, their bodies relaxed as they prepare to eat a picnic and call others to join them (plate 139).

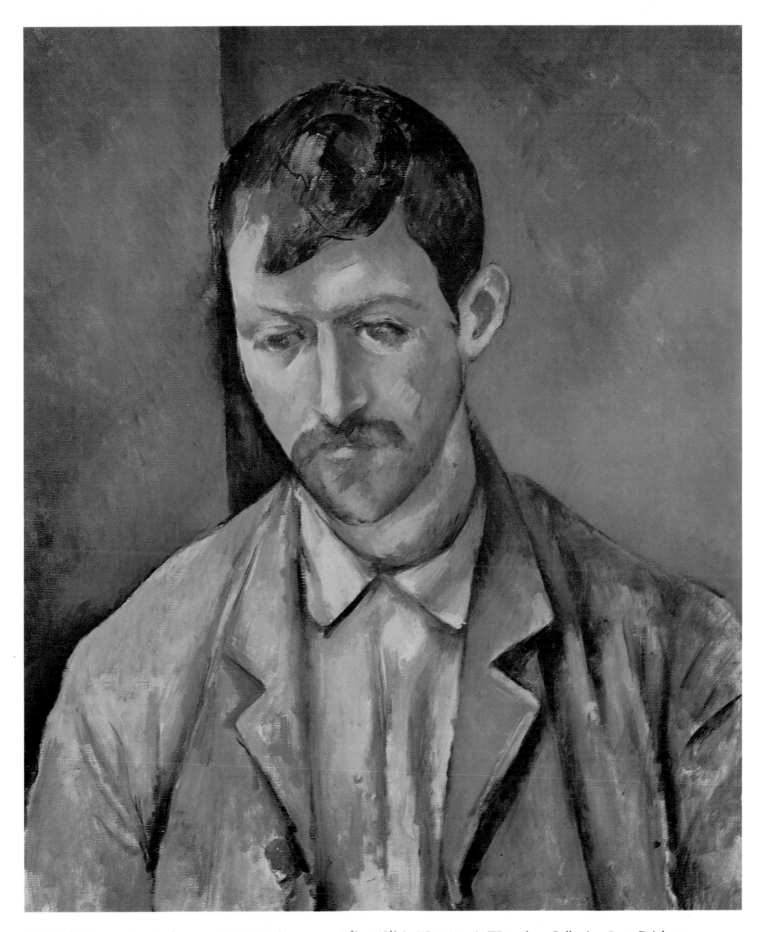

137. Paul Cézanne, *Portrait of a peasant*, 1890–2. Oil on canvas, 21⅝ × 18⅛ in (65 × 46 cm). Winterthur, Collection Oscar Reinhart.

116

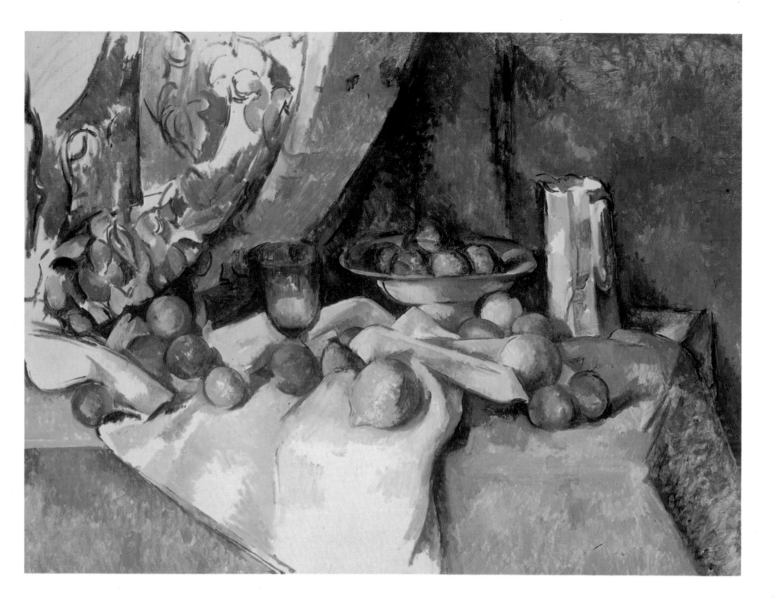

138. Paul Cézanne, *Still-life with apples*, 1895–8. Oil on canvas, 27 × 36½ in (68.6 × 92.7 cm). New York, Museum of Modern Art (Lillie P. Bliss Collection).

They are curious works and still invite controversy. Their subject matter – more reminiscent of an ungainly nudist colony than the classical idyll of a summer's day – is often summarily dealt with by writers on Cézanne before they pass on to the relation of his work to Cubism, to Matisse's *Bonheur de Vivre* and to Derain's *Bathers*. There is a certain poverty of invention in the poses of some of the figures, although not in their grouping as a whole. In the London *Bathers* we sense that the figures are both deeply rooted to the earth and yet completely at home in the pervasive blue air. We appear to be caught up in a private world becoming public. We remember Cézanne's psychological difficulties in working from a model; he mistrusted women and was overpowered by their presence. He has resisted the lazy blossoming animality of Renoir's bathing girls and the European Venus which he admired in Rubens and Titian; he seems to have entered a new territory of heroic form which is embodied in his anxiously sensual and sometimes androgynous figures. The picture plunges us back into the past with its echoes of Titian and Poussin mingling with those of less serene masters – of El Greco's *Laocoön* and the Italian Mannerists.

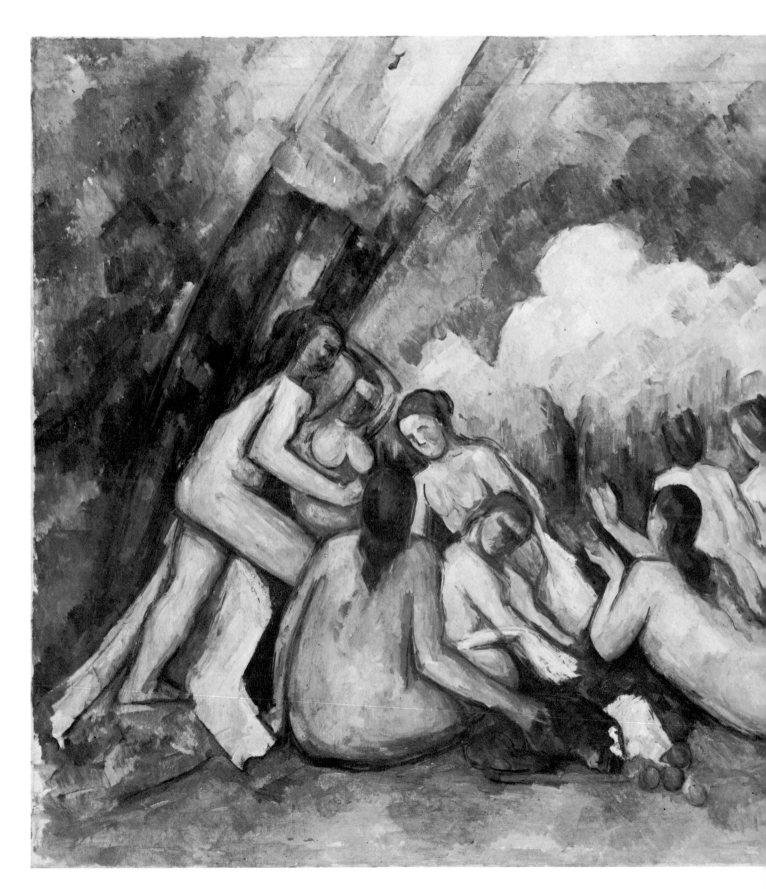

140. (*Above*) Paul Cézanne, *Bathers*, 1890–1900. Colour lithograph, 16½ × 20½ in (41.9 × 52 cm). Baltimore, Museum of Art (Cone Collection).

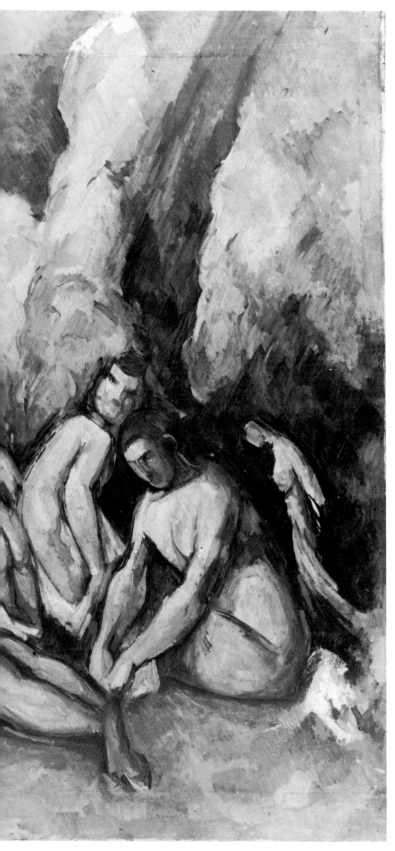

139. Paul Cézanne, *Les Grandes Baigneuses*, 1900–6. Oil on canvas, 51¼ × 76¾ in (130 × 195 cm). London, National Gallery.

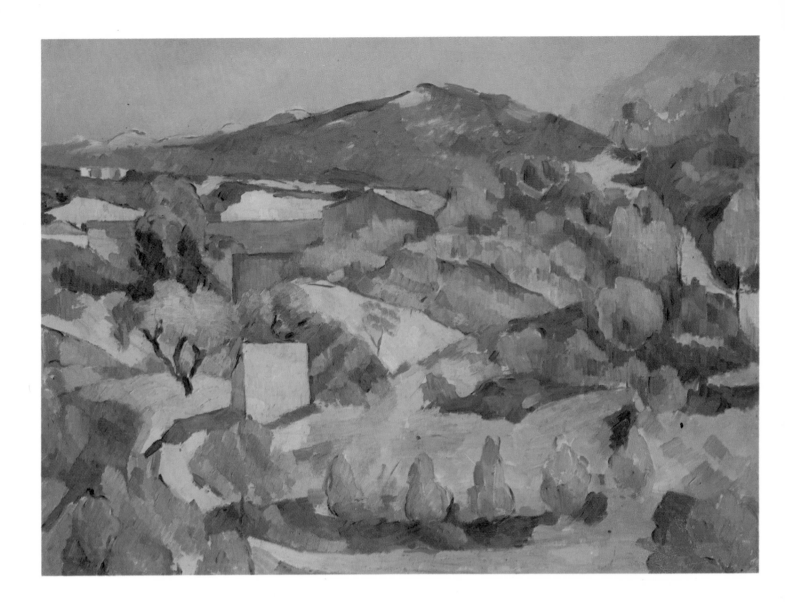

141. Paul Cézanne, *Mountains seen from L'Estaque,* 1878–80. Oil on canvas, 21 × 18½ in (53.3 × 72.4 cm). Cardiff, National Museum of Wales.

Cézanne is invariably frank as to his feelings in front of a landscape or still-life. In the paintings of bathers there seems to be some emotional hesitancy in his attitude. His psychological state while conceiving these pictures was obviously complex. His health was in decline; he was aggravated by the effect on his daily life of the increasing attention paid to his work and he was in despair at the impossibility of achieving what he desired before he died. We cannot escape the poignant image of this elderly recluse tackling on a huge scale a theme that had been a life-long preoccupation, an embodiment of a poetic and sensual dream which went back to his youth. In evolving these forms – lapidary backs, trunk-like thighs, heads divested of sensual appeal like roughly carved idols – Cézanne seems to have approached a world at once primitive and yet essentially modern. All such labels as romantic and classical and constructive are irrelevant. We may prefer to regard the late portraits and landscapes as his greatest achievements but it would be foolish to ignore the magnificent qualities of the bathers, the unfamiliar disquieting emotions that they arouse and the abundant possibilities offered to the artists who followed Cézanne.

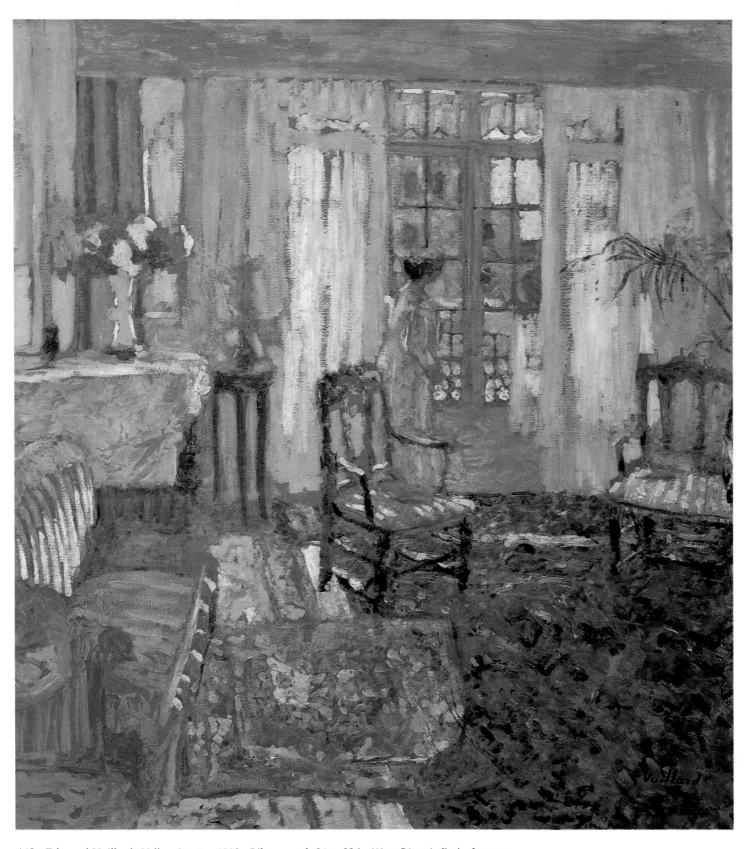

142. Edouard Vuillard, *Yellow Interior,* 1903. Oil on panel, 24 × 22 in (61 × 56 cm). Paris, Louvre.

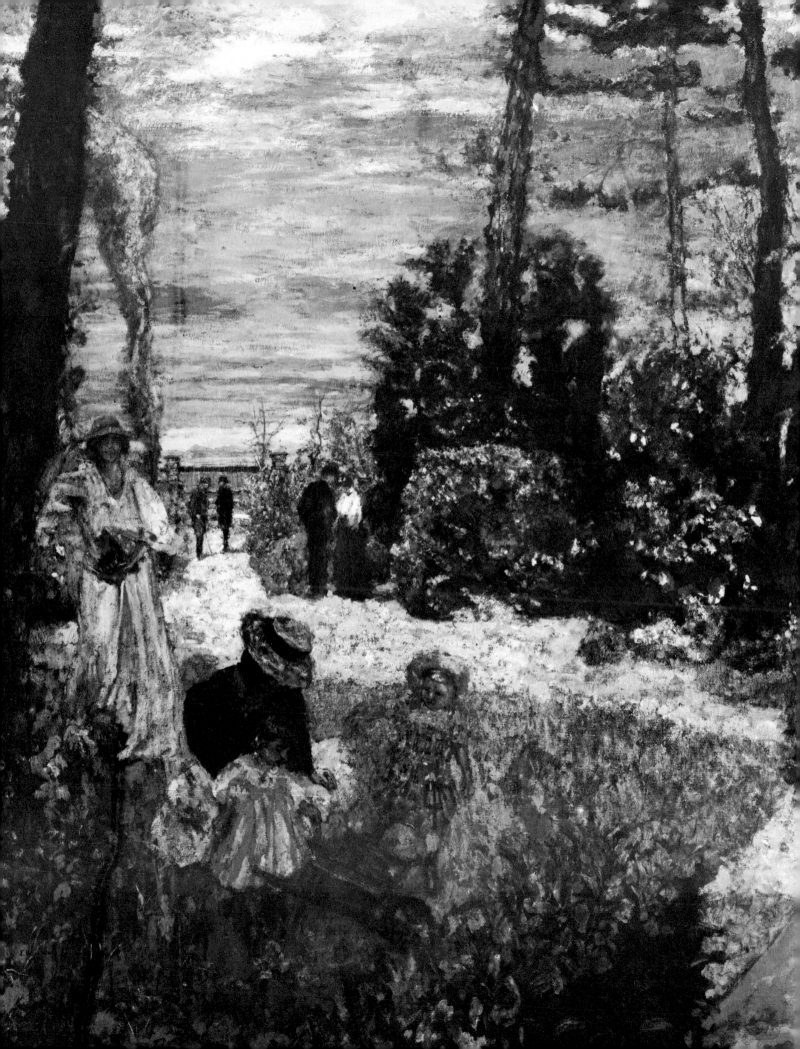

6
The Nabis

The word *nabi* is Hebrew for prophet and was rapidly adopted by a group of friends which included Sérusier and Denis, Pierre Bonnard and Edouard Vuillard, Ker-Xavier Roussel and Paul Ranson. Attached to the group in various ways were Jan Verkade and Meyer de Haan (both Dutchmen and initially associated with Gauguin at Pont-Aven), the Danish painter Mögens Ballin (a particular friend of Verkade), the sculptor Georges Lacombe, the Hungarian painter Rippl-Ronai (who made several portraits of his Nabi friends), the painter and lithographer Henri-Gabriel Ibels, the Swiss illustrator and painter Félix Vallotton (plates 153 and 173) and Aristide Maillol (who at this period had not taken to sculpture). What did this international group of friends have in common? How was it that the Parisian Bonnard came to be associated with Verkade, a Benedictine monk?

We have already mentioned the lively impression made on Sérusier's fellow students at the Académie Julian by his little Pont-Aven landscape *Le Talisman* (plate 62). Gauguin soon became the hero of the hour; heightened colour and emphatic linear design appeared in their painting, although they were never slavish imitators. Sérusier and Denis, through their choice of archaic and primitive subject matter, came close to the Gauguin of *The Yellow Christ*. The decorative possibilities of Synthetism were developed in an exaggerated curvilinear style. They tended to choose subjects which were explicitly symbolic or which had about them, as one writer put it, 'the lingering scent of "once upon a time" '. In this they differed from Vuillard and Bonnard, the two great celebrators of French bourgeois life. All initially shared, however, a rather muted colour range, a concern for the decorative surface of a painting and an ability to evoke poetic mood whether the subject was a Breton Pardon or the lamplit interior of a flat in Paris (plates 171 and 150).

The Nabis, on the whole, came from well-to-do bourgeois families (Sérusier's father, for example, was a director of the perfume firm Houbigant), had received good educations and possessed independent

143. Edouard Vuillard, *Luncheon at Villeneuve-sur-Yonne,* originally painted c. 1902, repainted c. 1935. Oil on canvas, 86 × 72 in (218.4 × 182.9 cm). London, National Gallery. Thadée Natanson (1868–1951) with his brother Alexandre founded *La Revue Blanche* to which many of his Nabi friends contributed. He married the beautiful Misia Godebski and they were intimate friends of Vuillard, Roussel and Bonnard. Writers and painters were often entertained at the Natansons' country house at Villeneuve-sur-Yonne. Vuillard's well-known portrait of Toulouse-Lautrec (Albi Museum) was painted at Villeneuve.

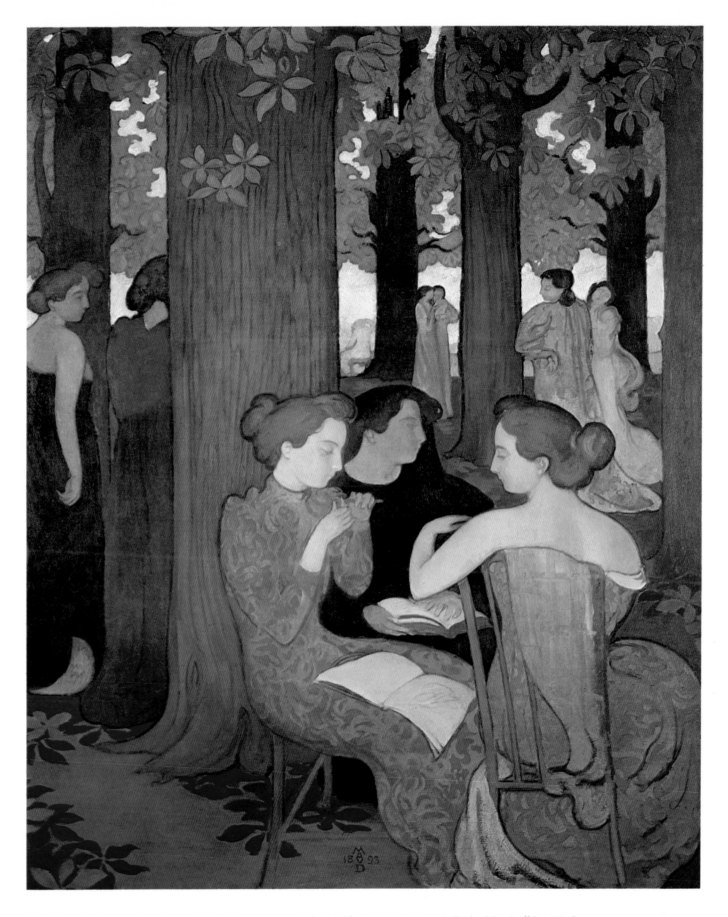

144. Maurice Denis, *The Muses,* 1893. Oil on canvas, 62½ × 52½ in (168 × 135 cm). Paris, Musée d'Art Moderne.

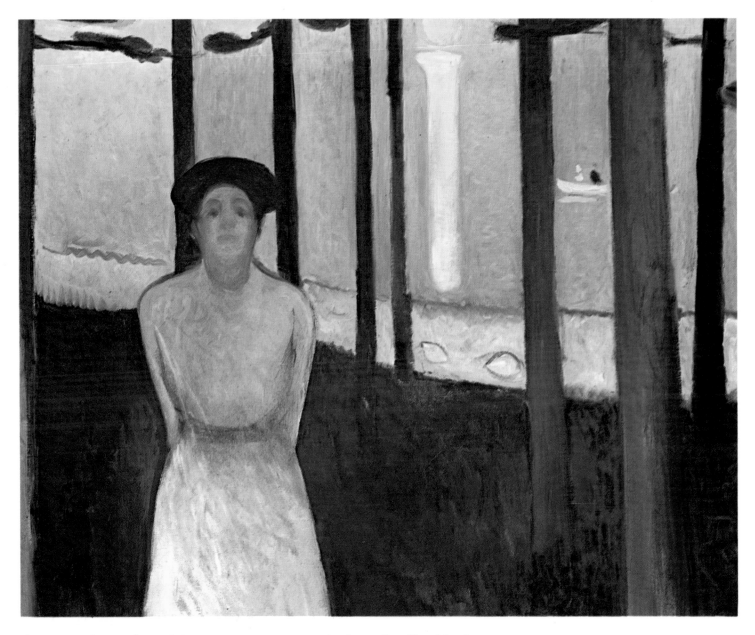

145. Edvard Munch, *The Voice,* 1893. Oil on canvas, 34½ × 43¼ in (87.9 × 109.9 cm). Boston, Museum of Fine Arts.

incomes. Lacombe and Ranson were comparatively well-off and had no need to sell their work. The writer Francis Jourdain commented that 'they could talk for two hours without once mentioning the price of a picture.' They were 'progressive' artists (and in some cases progressive thinkers) who relied very much on the easy stability of comfortable lives. Although as individuals they often had sharply divergent beliefs and temperaments, they were united by strong ties of friendship and family, made even stronger by the marriage of Roussel to Vuillard's sister Marie. Initially they met at monthly dinners in Paris where aesthetics, theosophy, spiritualism and current ideas were discussed. In time these meetings inevitably turned into companionable light-hearted evenings among firm friends. They also met regularly on

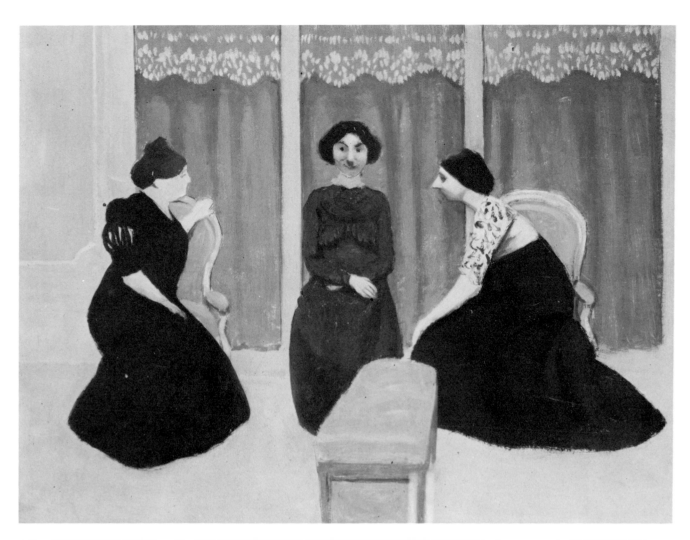

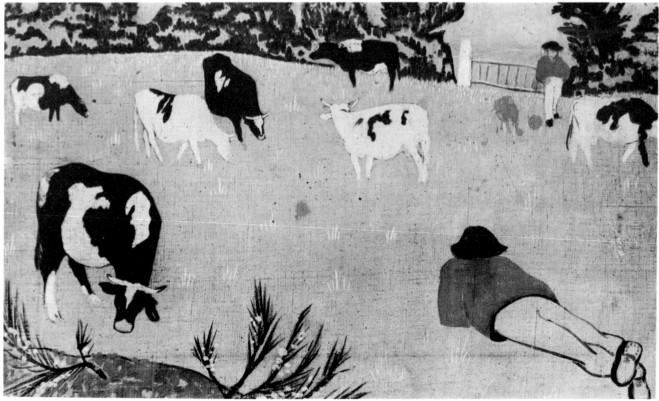

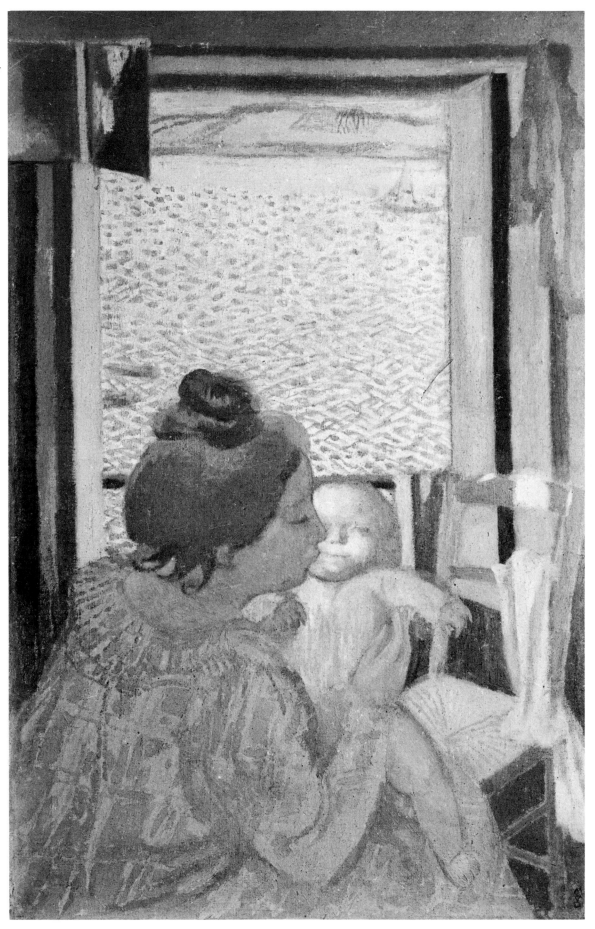

146. (*Opposite above*) Félix Vallotton, *Gossip*, 1899. Gouache on millboard, 15 × 20⅛ in (38.1 × 51.18 cm). New York, Collection Arthur G. Altschul.

147. (*Opposite below*) Paul Sérusier, *Breton landscape with cows,* c. 1892. Oil on canvas, 13¾ × 23½ in (35 × 60 cm). Warsaw, National Museum.

148. (*Right*) Maurice Denis, *Maternité à la fenêtre,* 1901. Oil on canvas. Paris, Musée d'Art Moderne.

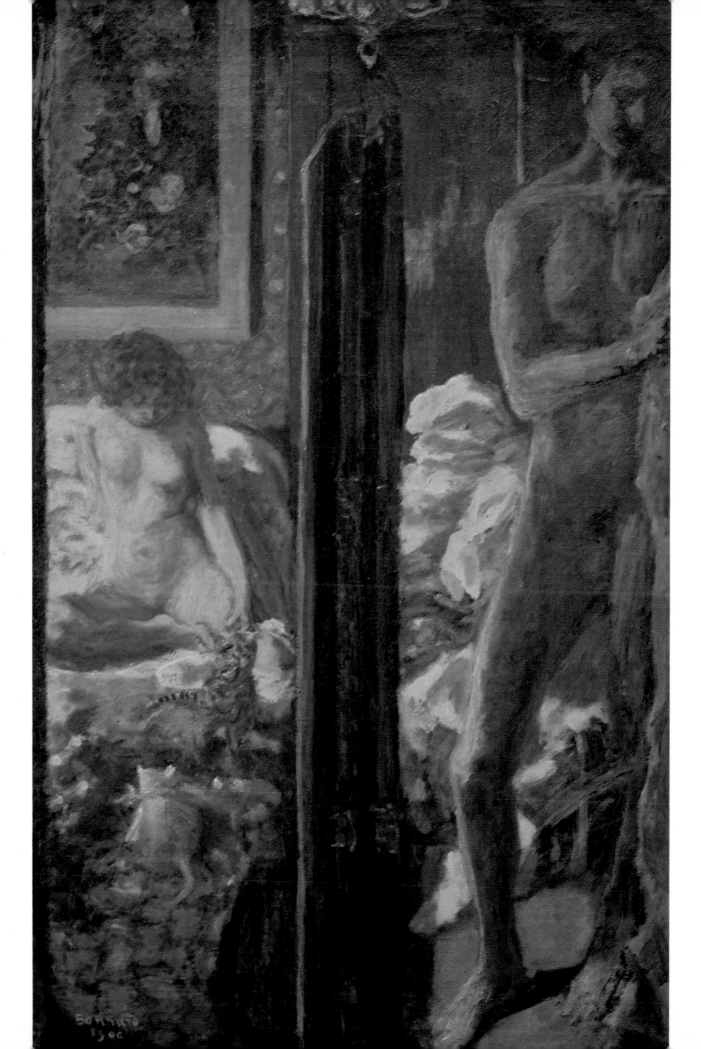

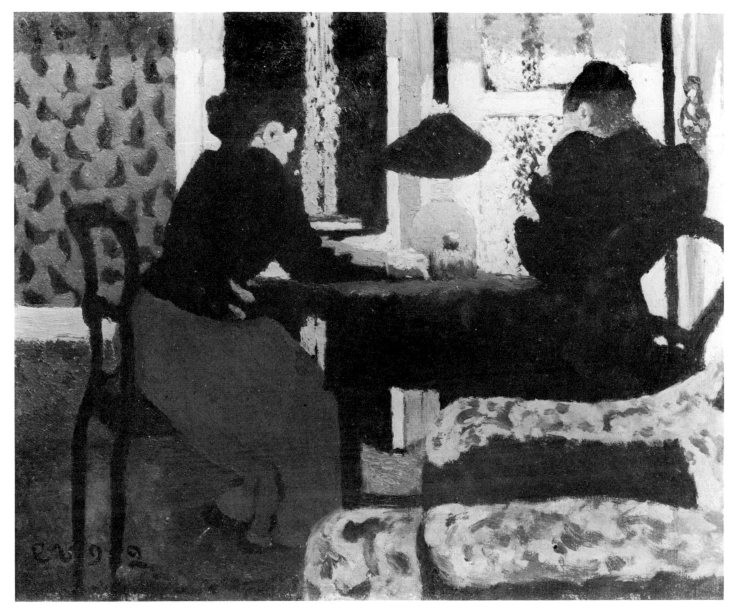

Saturday afternoons at the house of Paul Ranson whose wife, known as *La Lumière du Temple*, posed for many of them, notably Denis. They developed a personal language, a kind of Hebrew-French with dashes of Latin, which was used in their letters to each other; it tended to mystify strangers as did the elements of ritual in their meetings.

In line with the dominant anti-Naturalism of the period they were, with few exceptions (primarily Bonnard), attracted to a variety of religions, although Catholicism predominated. At the age of fifteen Denis had confided to his journal the necessity of his being *un peintre chrétien*. Sérusier was deeply Catholic and Verkade, overwhelmed by the church ceremonies that he had seen in Brittany, was converted in 1892 and became a Benedictine monk at Beuron in the Black Forest. At Beuron there was already an established group of religious artists, painting cold and calculated murals under the direction of Father Didier. Sérusier was deeply impressed by the atmosphere on a visit there to see Verkade. Ballin was another Catholic convert (baptized in Fiesole), and most of his numerous children took holy orders in Denmark.

150. (*Above*) Edouard Vuillard, *Two women by lamplight*, 1892. Oil on canvas, 13 × 16 in (33.2 × 40.64 cm). St. Tropez, Musée de l'Annonciade.

149. (*Opposite*) Pierre Bonnard, *Man and woman*, 1900. Oil on canvas, 46 × 42 in (117 × 107 cm). Paris, Musée d'Art Moderne.

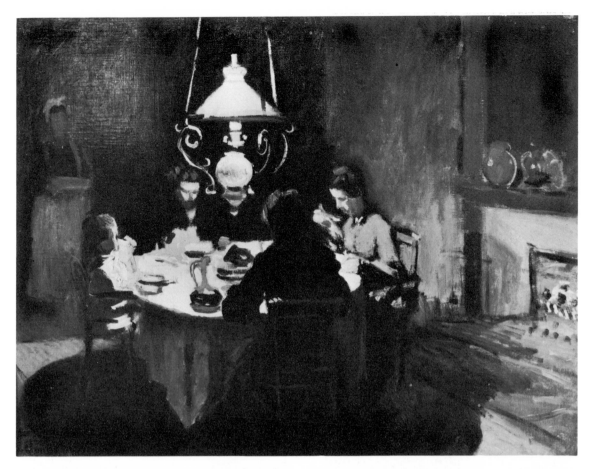

151. (*Left*) Claude Monet, *The Sisley family at table*, c. 1868–9. Oil on canvas, 20 × 26 in (50.8 × 66.4 cm). Zurich, Bührle Foundation. Monet has chosen here a subject frequently taken up by several of the Nabi painters, of people eating around a lamplit table. Examples include Bonnard's *Sous la Lampe* of 1899 and Vallotton's more dramatic picture of himself and his family at their evening meal (plate 153).

152. (*Left*) Georges Seurat, *Family scene, evening*, c. 1882–3. Conté crayon, 9½ × 12½ in (24.2 × 31.5 cm). Oberlin College, Allen Memorial Art Museum (R. T. Miller Jr. Fund, 48.11).

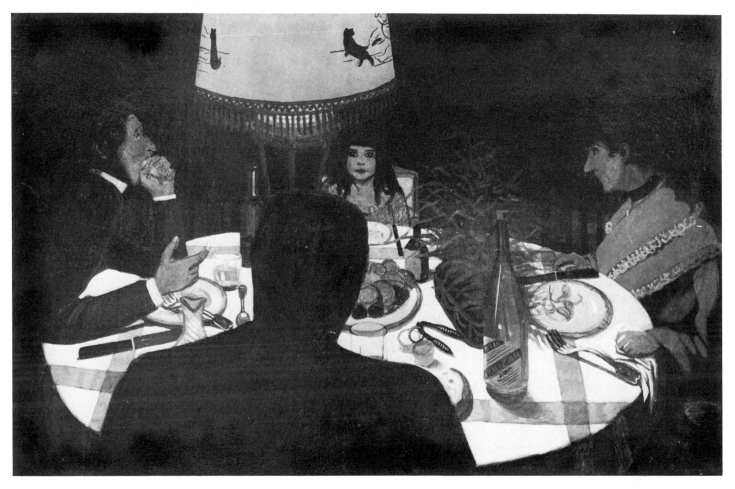

153. Félix Vallotton, *Dinner by lamplight,* 1899.
Oil on wood, 22½ × 35 in (57 × 89 cm).
Paris, Musée d'Art Moderne.

On the whole this fervent espousal of the Church had little beneficial effect on their work (Ballin abandoned painting altogether).

Bonnard and Vuillard were untouched by this aspect of the Nabi group. Although they admired Gauguin, Redon and Mallarmé (whom Vuillard knew well) and were not insensible to the prevailing symbolism of the circle of friends in which they moved, they were closer to the Impressionist generation in subject matter and atmosphere. Vuillard's *Two Women by Lamplight* (plate 150) reminds us of Monet's lamplit interiors, such as *The Sisley Family at Table* (plate 151). They painted street scenes and squares, croquet games, picnics, mothers and children. Some of Caillebotte's views of Paris from upper windows have affinities with Vuillard's work; Bonnard's *Circus Rider* (1897) recalls Degas and the Lautrec of *Le Cirque Fernando* (plate 155). Their women and children in interiors (Bonnard's *The Natanson Girls*) bring to mind Berthe Morisot and Renoir's *La Famille Charpentier*. But in their landscapes and scenes of figures out-of-doors, they show much less interest in capturing the transitory effect of sunlight and shadow. It is the momentary gesture, the sudden turn of the head, the amusing relation between a dog and a child, that we find arresting in their work.

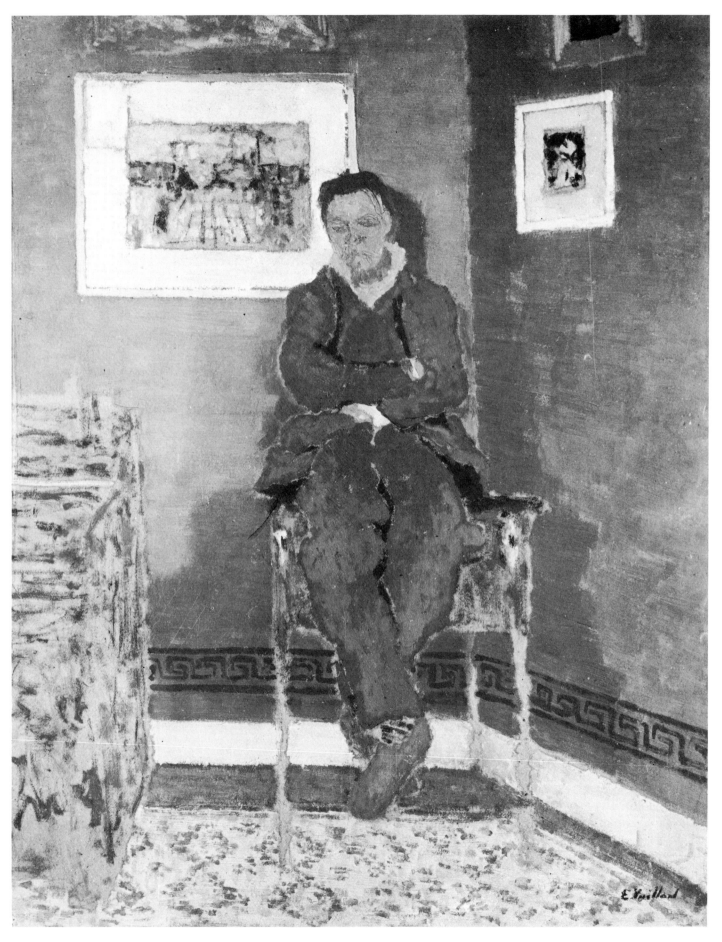

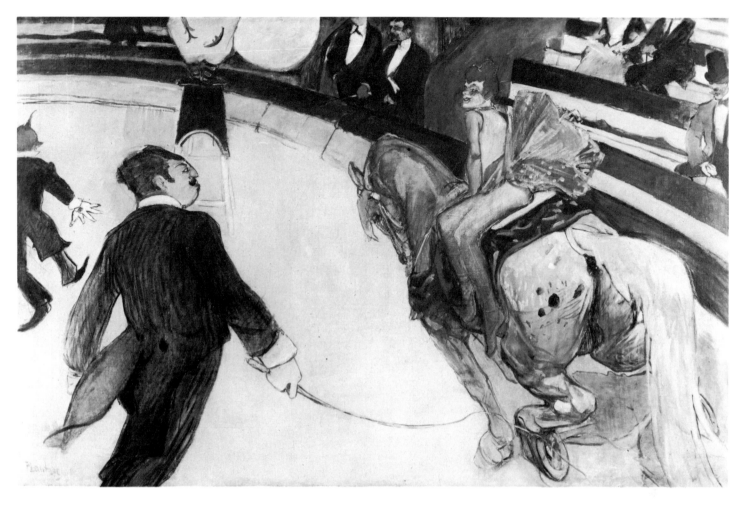

Compositional elements are arranged with a freedom learnt from Degas and the Japanese. (They had been deeply impressed by the large exhibition of Japanese art in 1890 held at the Ecole des Beaux-Arts). The cropping of forms at the picture edge, aerial perspective, the decorative overlapping of figures on one plane, the lack of any compositional hierarchy – each component equally important within the self-contained unit: all these contributed to a highly flexible pictorial vocabulary.

Vuillard's palette was initially discreet and restricted, with sudden patches of bright colour introduced among muted greys, ochres, dusty pinks and pale blues. A brighter range of colour was reserved for outdoor scenes and some of his mural decorations. He preferred the absorbent property and matt surface of pasteboard and used colour considerably thinned by turpentine. Bonnard, while also using a generally muted range of colour (particularly for the grey light of sub-dued interiors), was altogether the most audacious and alert member of the group. He possessed that visual malice which is a characteristic element in the French tradition. It is there in Lautrec and Degas, in certain rococo artists and in early medieval sculpture. He is witty but

155. Henri de Toulouse-Lautrec, *At the Cirque Fernando,* 1888. Oil on canvas, 39⅜ × 63⅜ in (100 × 161 cm). Chicago, Art Institute. Lautrec's first masterpiece showing the same circus as that painted by Seurat three years later (plate 3), including the same clown.

154. (*Opposite*) Edouard Vuillard, *Portrait of Félix Vallotton.* Oil on canvas. Paris, Louvre.

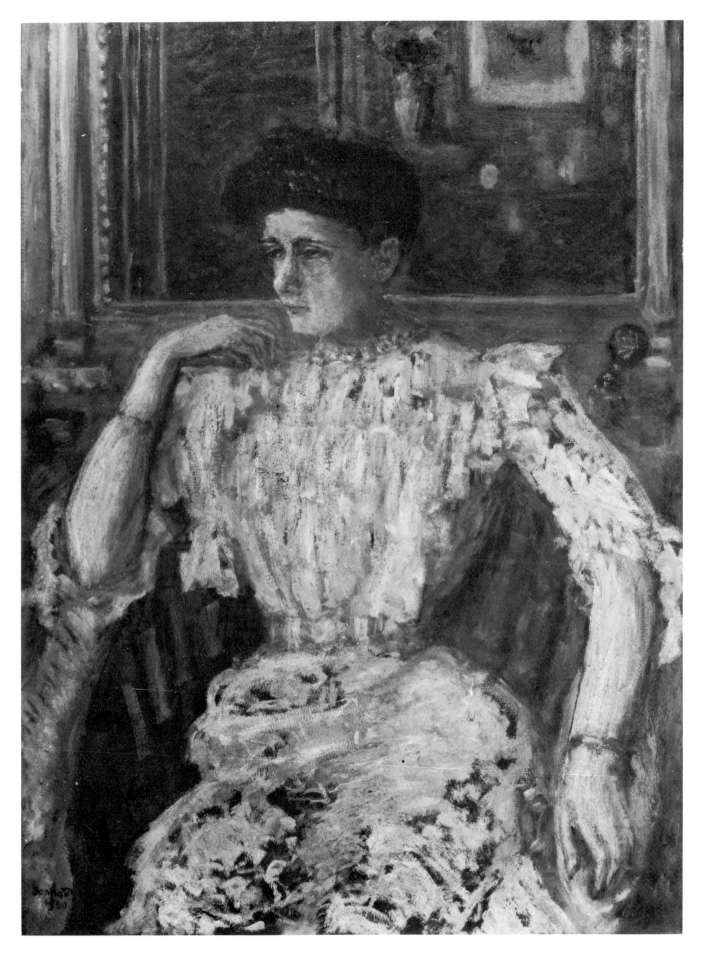

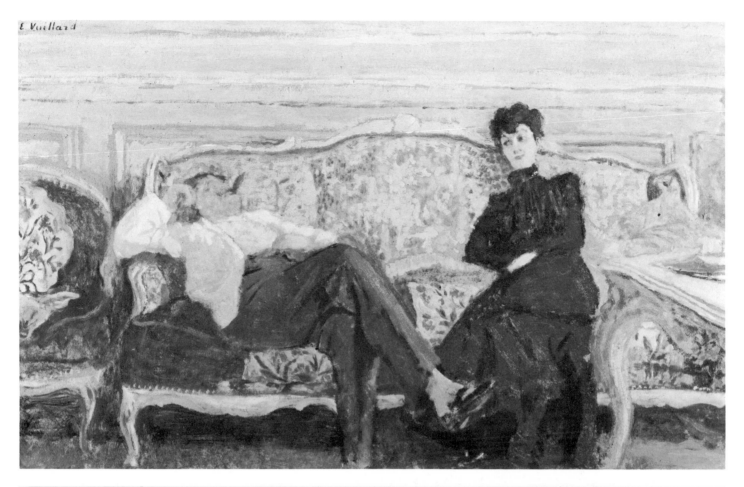

157. (*Top*) Edouard Vuillard, *Monsieur et Madame Feydeau on a sofa,*
c. 1905. Oil on card, 18¼ × 30¾ in (46 × 78 cm). Paris, Galerie Schmidt.

158. (*Above*) Edouard Vuillard, *Le Sommeil,* 1891. Oil on card,
13 × 25¼ in (33 × 64 cm). Paris, Musée d'Art Moderne.

156. (*Left*) Pierre Bonnard, *Portrait of Madame Sert,* 1900. Oil on canvas, 32 × 24 in (81.3 × 61 cm). Private Collection.

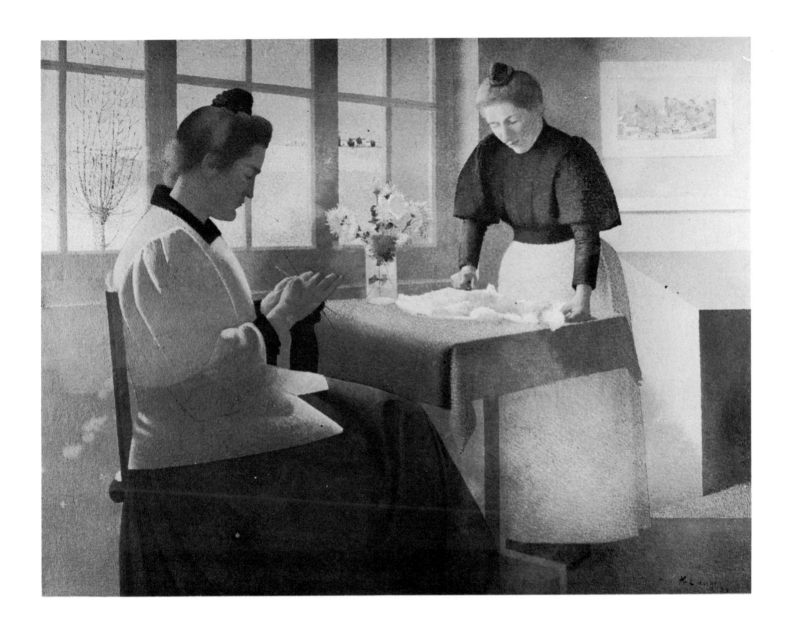

159. Achille Laugé, *Marie Laugé and the laundress,* 1899. Oil on canvas. Paris, Galerie Marcel Flavian.

never arch, playful but never overbearing. He seizes on a form, often disconcerting in its abridgement or in the peculiar angle from which it is viewed, and relates it through subtle rhythms to the overall flow of light and movement of its surroundings. He continually establishes this interplay of the permanent and the transitory, rescuing swift gestures and odd juxtapositions which, in some of his Paris street scenes, are like short sequences from a film. This keen visual observation, his preoccupation with the silhouette and a natural spontaneity of matching form and content, made him a conspicuously original and successful poster artist, much admired by Lautrec, although it must be said generally inferior (particularly in his first posters) to that inventive master.

In many interiors Vuillard and Bonnard chose richly decorated

surfaces – flowered screens and wallpapers, striped and spotted rugs.
Against these the patterns of skirts, elaborate bonnets, vases of flowers
and indoor plants produce a complex and incessantly changing field of
perspectives and rhythmic analogies. Like most of the Nabis, they were
decorators, carrying out posters and book illustrations, murals and stage
décor.

The Impressionists in general restricted themselves to canvas and
paper (a few designed fans); the interiors of their houses were closely
hung with pictures in the nineteenth-century style, as we can see from
photographs. The Post-Impressionist generation – particularly the Pont-
Aven artists and the Nabis – were among the first to see that certain
of their ideas readily lent themselves to pure decoration. Van Gogh had
conceived his series of sunflower paintings to hang together in one room.

160. Maximilien Luce, *Sewing*, 1887. Oil on
canvas. Private Collection.

137

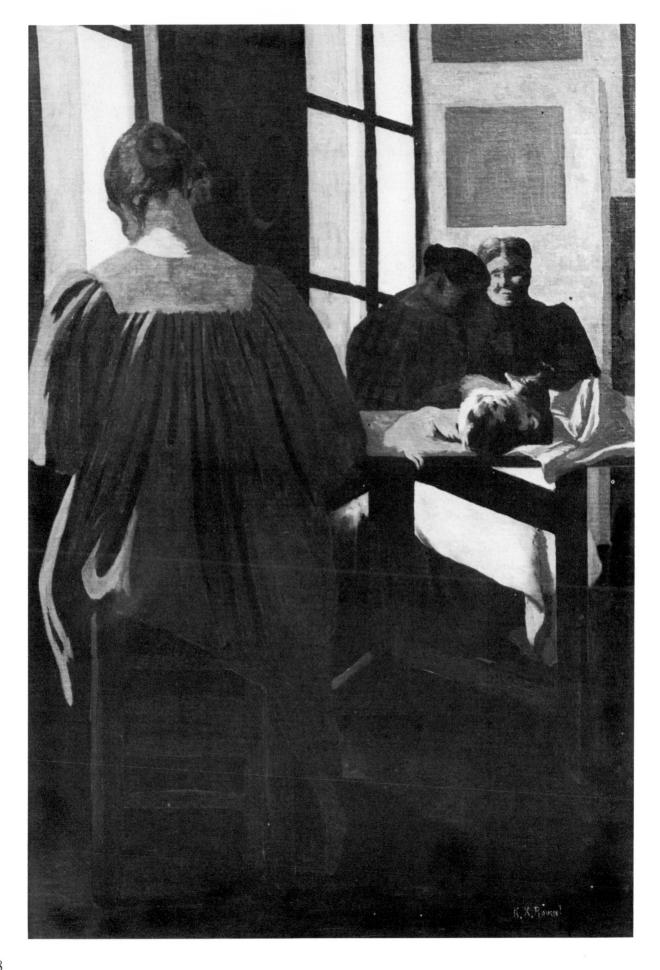

138

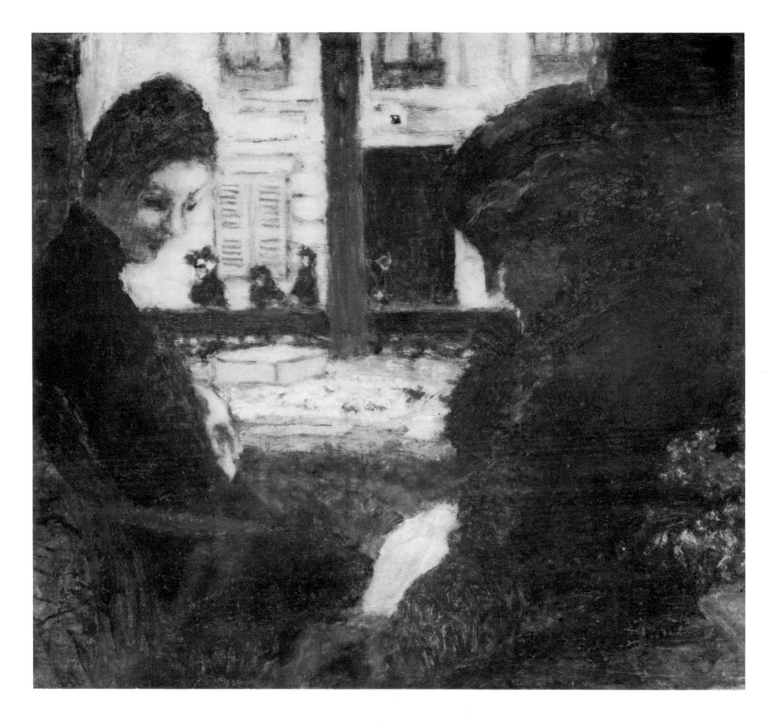

Marie Henry's inn at Le Pouldu was by all accounts an extraordinary sight: gaps between wall decorations were filled with pictures; sculpture and pottery stood on mantelpiece and table. Gauguin decorated the inside and outside of his Tahitian homes with friezes and carvings. One of Sérusier's best works is a three-part screen decorated with Breton girls. In later years Denis designed furniture (although, according to one writer, it conformed more to the aesthetic tastes of Cistercian monks than to the bourgeoisie of the Belle Epoque).

As designers, the Nabis were closely involved with the theatre. They were responsible for the décor of the various short plays given on 21 May 1891 during a benefit evening for Gauguin and Verlaine, shortly before Gauguin's first departure for Tahiti. In the same year

162. Pierre Bonnard, *At the embroideress's,* c. 1896. Oil on canvas, 13½ × 16 in (34.29 × 40.64 cm). London, Courtesy of Sotheby Parke Bernet.

161. (*Opposite*) Ker-Xavier Roussel, *The Seamstresses,* c. 1894. Oil on canvas, 44⅛ × 30⅛ in (112.7 × 76.52 cm). New York, Collection Arthur G. Altschul.

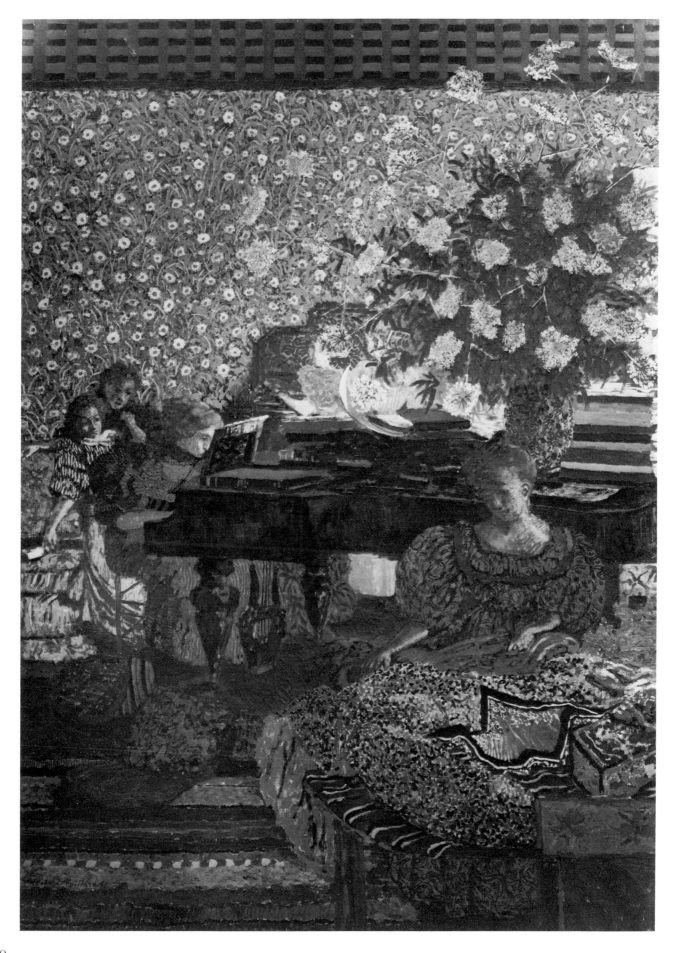

they gave a marionette performance of Jarry's *Ubu Roi*; when the piece was staged in 1896, it was designed by Bonnard and Sérusier. Bonnard, Vuillard and Denis also worked for the actor Aurelian Lugné-Poë in the Théâtre de l'Oeuvre which, founded in 1893, included in its repertory plays by Ibsen, Wilde and Strindberg. Most notable of all such ventures beyond the easel and the studio are the various wall decorations carried out by Vuillard and Bonnard in private houses.

Bonnard designed decorative panels, furniture and ceramics; *Le Peignoir* (c.1892), painted in oil on velvet, is an outstanding testimony to the vitality of Art Nouveau line when combined with Nabi principles. His decorations for the Natansons (1909–10) were inspired by mythology (as were so many of his later paintings); for *la vie moderne* we must turn to Vuillard's three groups of wall decorations executed between 1892 and 1896. The first commission, from Paul Desmarais, was a group of six horizontal panels depicting such subjects as nurses and children in the park, women tending plants on a terrace and the interior of a dressmaker's, the latter giving Vuillard an opportunity to indulge in brilliant patterning. His next commission, from Alexandre Natanson (1894), is perhaps his outstanding contribution to decorative painting. It consisted of nine tall panels collectively entitled *Jardins Publics* – women and children once more among the benches and trees of the Tuileries, the Luxembourg, etc.

Monet's *Women in the Garden* (1866–7) and similar pictures were admired by Vuillard and we find echoes of Puvis de Chavannes, particularly in the interweaving of women walking among tree trunks, the foliage well above them. This is a recurrent theme of Symbolist and Nabi painting towards the end of the century – we see it in Bernard and Denis, in Sérusier's *L'Incantation* (1891) and in contemporary works by Max Klinger and Edvard Munch (plate 197). But Vuillard's treatment has none of their erotic or psychological overtones. In 1896 came four sumptuous decorations for the library of Dr Vaquez entitled *Personnages dans des Intérieurs* (plates 163 and 164), in which Vuillard suggests the quiet intimacy of family life, each person absorbed in her or his occupation and in harmony with the rich restrained colours of their surroundings. Yet Vuillard, sensitive to the currents of his time, imparts to such panels an indefinable melancholy, a certain anxiety, as though fearing for the fragility of the world which he evokes.

Ker-Xavier Roussel was generally closer to the Symbolist movement of the time, to the sinuous archaic line of Denis and Sérusier and the sensuous dream world of Mallarmé's *L'Après-Midi d'un Faune*. This difference is clearly apparent when we contrast Vuillard's vivid decorations of contemporary life with Roussel's panels *Les Saisons de la Vie* (1892). Roussel's slender long-skirted women with their studied gestures are closer to the allegorical world of Puvis and the Denis of *The Muses* (plate 144). Although there are intimate studies of daily life

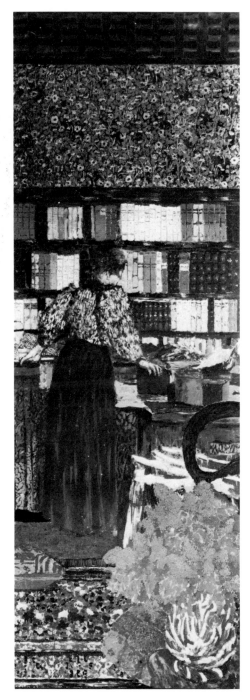

164. Edouard Vuillard, *Personnages dans des Intérieurs: La Bibliothèque*, 1896. Size on canvas, 826¾ × 295¼ in (2100 × 750 cm). Paris, Petit Palais.

163. (*Opposite*) Edouard Vuillard, *Personnages dans des Intérieurs: La Musique*, 1896. Size on canvas, 826¾ × 602¼ in (2100 × 1530 cm). Paris, Petit Palais.

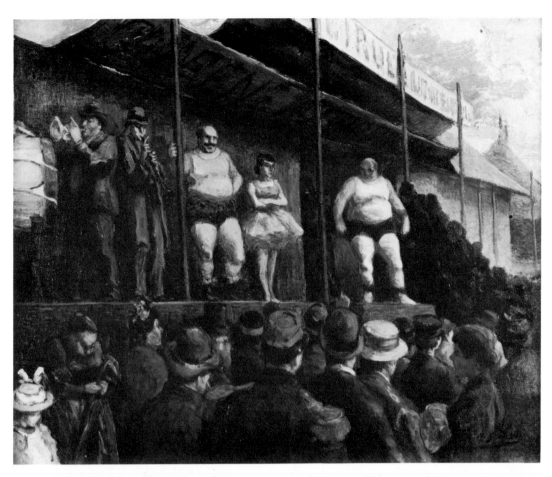

165. (*Left*) Henri–Gabriel Ibels, *Travelling show,* c. 1895. Oil on canvas, 25¾ × 32 in (65.4 × 81.3 cm). London, Courtesy of Sotheby Parke Bernet.

166. (*Below left*) Louis Valtat, *Au Bal,* c. 1895. Oil on canvas, 25¼ × 31½ in (64.14 × 80.1 cm). London, Courtesy of Sotheby Parke Bernet.

167. (*Above right*) Ker–Xavier Roussel, *The fountain of youth,* c. 1935. Oil on canvas, 30 × 45 in (76 × 114.5 cm). London, Courtesy of Christie's.

168. (*Right*) Pierre Puvis de Chavannes, oil sketch for *Summer,* c. 1873. 17 × 24½ in (43.2 × 62.2 cm). London, National Gallery.

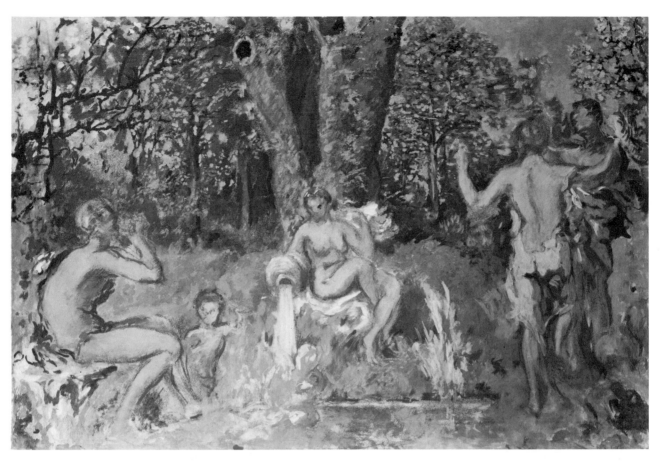

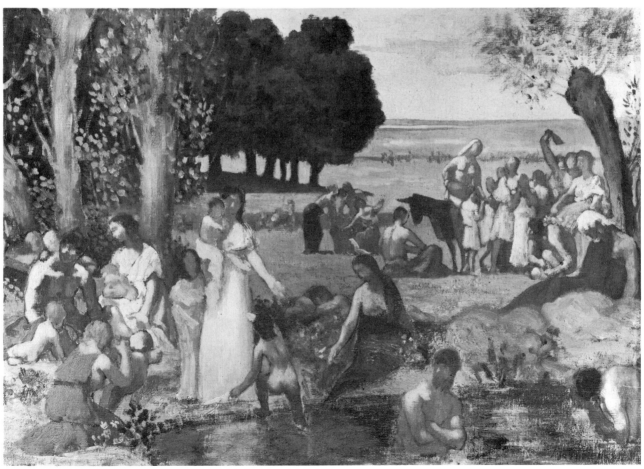

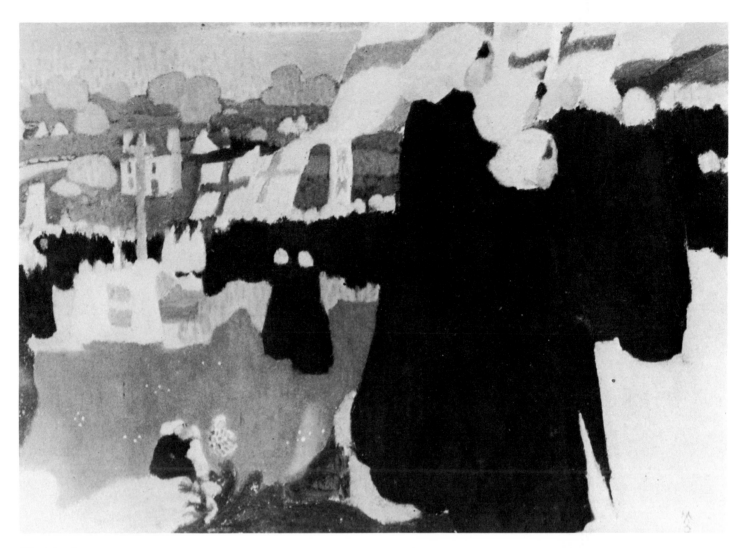

171. Maurice Denis, *Breton Pardon,* c. 1895.
Oil on canvas, 15¾ × 21¾ in (40 × 55.25 cm).
London, Private Collection.

among Roussel's work (plate 161), his painting after the turn of the
century is filled with gods and goddesses, nymphs and bathers; they
are executed in brilliant colour and are airy, spacious and more varied
in brushstroke. Nabi principles disappear in this strange homage to
Rubens and Delacroix taking place in the meadows of the Ile-de-France
or on the shores of the Mediterranean. They remind us of other
contemporary myth-inspired paintings, of Cross and the Matisse of
Luxe, Calme et Volupté. A less radiant vision was reserved by Roussel
for his graphic work where lines of distress and disquieting symbolism
recall his admiration for Goya. The Swiss painter Félix Vallotton
shows a less good-tempered view of contemporary life in his wood-
engravings and early paintings (plates 146 and 153); his heroes were
Dürer and Holbein and his dark interiors and dramatic colour transmit a
more vehement psychological approach than his fellow Nabis.

If Vuillard and Bonnard are the two outstanding painters among
the Nabis – Bonnard, of course, developed after this limited episode
into one of the great twentieth-century painters – Maurice Denis was

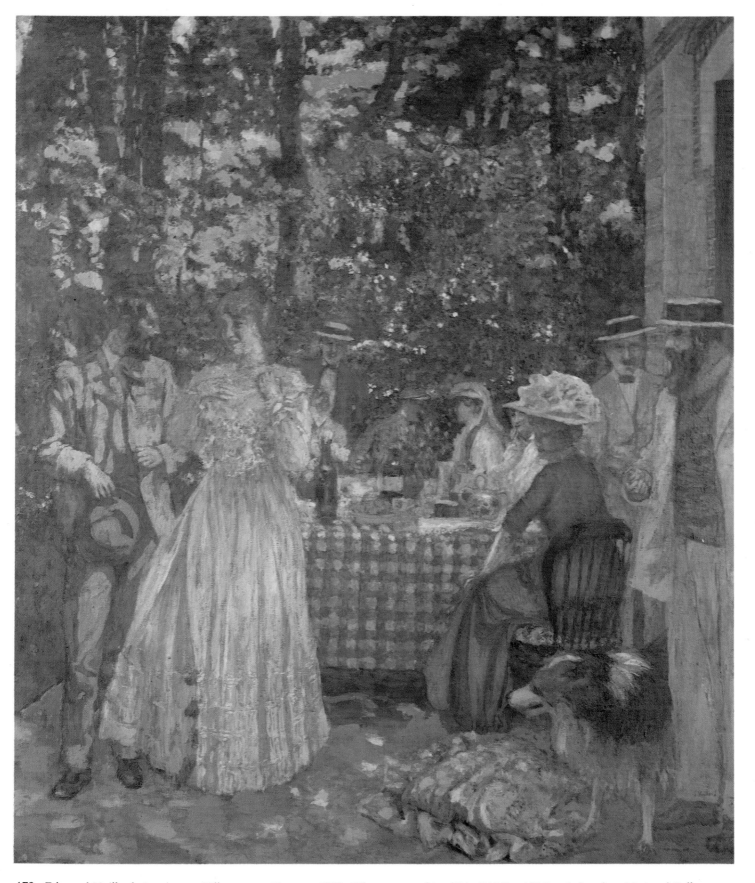

172. Edouard Vuillard, *Luncheon at Villeneuve-sur-Yonne*, c. 1902. Oil on canvas, 86 × 75 in (218.5 × 190.5 cm). London, National Gallery.

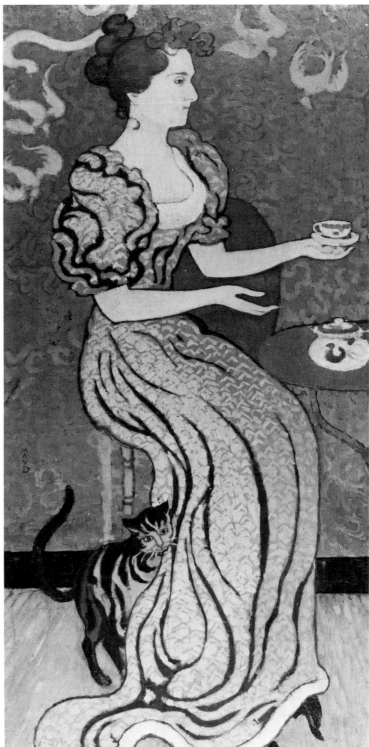

170. (*Above*) Maurice Denis, *Mme Paul Ranson*. Oil on canvas. Paris, Collection the Denis family.

169. (*Left*) Maurice Denis, *Hommage à Cézanne*, 1900. Oil on canvas, 70¾ × 94½ in (180 × 240 cm). Paris, Musée d'Art Moderne.
A group of friends gather round a still-life by Cézanne, once owned by Gauguin, in the gallery of Ambroise Vollard who exhibited Cézanne's work from 1895. From left to right, the figures represented are: Odilon Redon, Vuillard, the critic Mellerio, Vollard, Denis himself, Sérusier, Ranson, Roussel, Bonnard and Mme Denis.

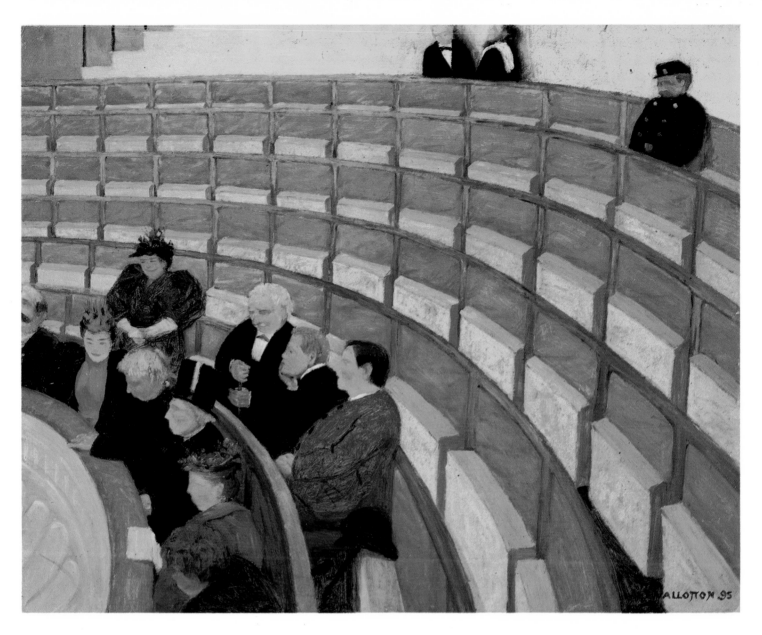

173. (*Above*) Félix Vallotton, *The Third Gallery, Théâtre du Châtelet,* 1895. Oil on canvas, 19¾ × 24½ in (50 × 62 cm). Paris, Musée d'Art Moderne.

174. (*Opposite*) Henri de Toulouse-Lautrec, *Le Divan Japonais,* 1892. Poster, 31¼ × 23½ in (79.5 × 59.5 cm). London, Victoria and Albert Museum.

its theorist in residence, an uneven painter whose development was checked by conflicting loyalties – to a primitive Christian art and to a passionate involvement in the intellectual and aesthetic climate of his period. In some respects he is a more profound and exciting painter than either Bernard or Sérusier, and he reaches in certain works a cool abstract harmony through the delicacy of his line, freshness of colour and surface variety. More frequently, however, his scholarly references to the history of art produce no more than a certain period charm. But his importance as a theorist, apologist and agitator cannot be under-estimated. His Fantin-Latour inspired group *Hommage à Cézanne* (plate 169), with its Cézanne still-life once owned by Gauguin, was exhibited at the Salon des Indépendants in 1900, a curious tribute to the master of Aix.

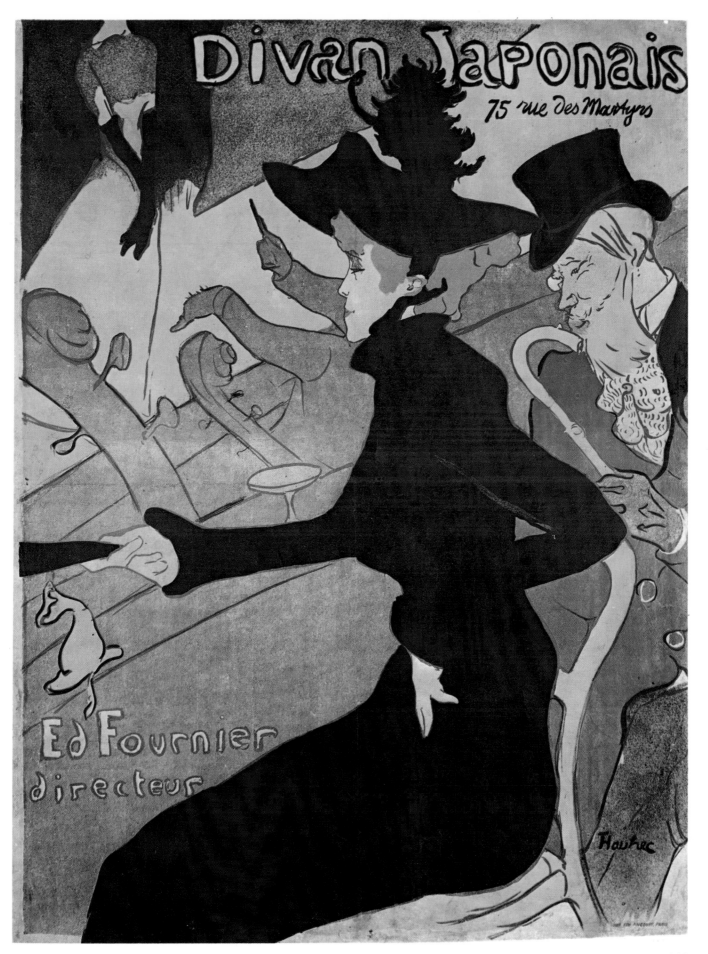

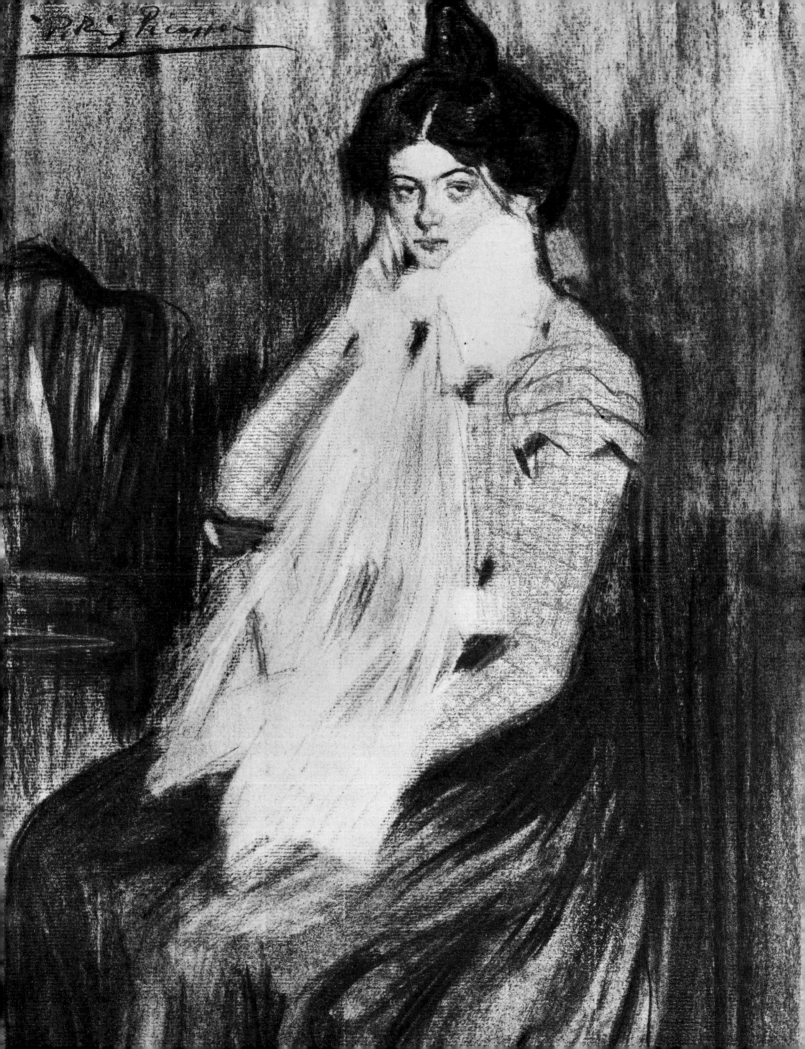

7
Post-Impressionism abroad and visitors to France

We have seen how a few individuals dominated painting in France in the later years of the nineteenth century and how each attracted to them circles of admirers, defenders and imitators. Gauguin's position as leader in Pont-Aven was confirmed during the period that he spent in Paris between voyages to Tahiti by the breadth of his acquaintances among the Symbolist writers and younger painters. Seurat, on the other hand, although remaining on friendly terms with his Neo-Impressionist followers, more than once expressed anxiety about their growing numbers. Cézanne in his last years gave a cautious welcome to and began an invaluable correspondence with two members of the avant-garde, Bernard and Denis.

The new movements did not appear then as distinct as they do now. At first the word 'Impressionist' was used very vaguely and comprehensively for anyone who did not conform to the style of the official Salon. Neo-Impressionism and Synthetism, Symbolism and Neo-Traditionalism were often interchangeable in the eyes of an unfamiliar public. Van Gogh and Gauguin in their letters often refer to themselves as Impressionists, *tout court*; Renoir announced that it was a name he loathed. Labels were perhaps useful for the purposes of exhibiting but were otherwise treacherous – as van Gogh intimated in a letter to Albert Aurier who, in the first article ever written about the painter, claimed him for the Symbolist movement. The little magazines and innumerable newspapers carried a large amount of art criticism and commentary; writers were frequently eager to identify themselves with one group or another (or not to, as the case may be). Félix Fénéon, a great critic, was a consistent champion (at least in early years) of the Neo-Impressionists, as Aurier was of the Symbolists; other important apologists were the painters Signac and Denis and the critic Gustave Geffroy. To the painters, however, loyal dealers were perhaps more important. Chief among the few were Durand-Ruel whose efforts on behalf of the Impressionists were bearing fruit in the later 1880s and 1890s; Ambroise Vollard who took on Gauguin, Cézanne, Renoir and

175. Pablo Picasso, *Lola: Portrait of the Artist's sister,* 1899. Charcoal and crayon, 17¼ × 10½ in (44 × 27 cm). Barcelona, Museo Picasso.

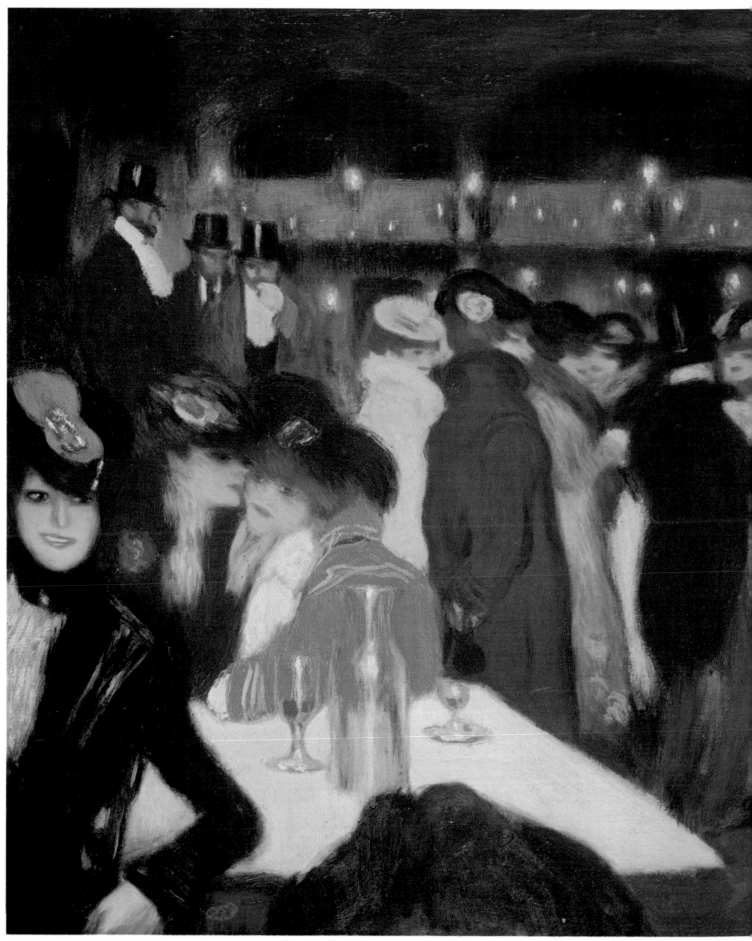

176. Pablo Picasso, *Le Moulin de la Galette,* 1900. Oil on canvas, 34¾ × 45½ in (88.3 × 115.5 cm). New York, Solomon R. Guggenheim Museum (Thannhauser Foundation).

177. (*Above*) Théo van Rysselberghe, *Portrait of Irma Sethe,* 1894. Oil on canvas, 77¾ × 45 in (197.5 × 114.5 cm). London, Courtesy of Sotheby Parke Bernet.

178. (*Opposite above*) A. W. Finch, *Orchard at Louvière,* c. 1891. Oil on canvas, 21¼ × 26¼ in (54 × 67 cm). Helsinki, Ateneum Museum.

179. (*Opposite below*) Théo van Rysselberghe, *Sailboat on the Escaut.* 1892. Oil on canvas, 26½ × 35½ in (67.3 × 90.2 cm). New York, Collection Arthur G. Altschul.

later the young Picasso; nor should we forget the efforts of Theo van Gogh (who died in 1891) and the famous Père Tanguy, whose artists' supplies shop in the rue Clauzel contained a formidable collection (for sale at very small prices) of Pissarro, Cézanne and van Gogh. The shop became a meeting place for young painters like Signac, Angrand and some of the Nabis, and was one of the very few places where Cézanne's work could be studied.

Work by some of the Impressionist generation could be seen outside France as painters like Renoir and Monet became well-known and able to command good prices. Durand-Ruel opened a gallery in New York and organized exhibitions in Germany. But the most stimulating forum for the various manifestations of contemporary art was to be found in Brussels, in the annual exhibitions of the group known as Les Vingt (or Les XX) which was founded in 1883 and held its first exhibition in the following year. It was restricted to twenty members, with the critic Octave Maus as secretary, but twenty other painters were invited to show each year and although most were French, they also included artists from America, England, Holland, Germany and Italy. The exhibitions showed a great cross-section of new painting with a particular emphasis on Neo-Impressionism and Symbolism. In 1887 Seurat exhibited *La Grande Jatte* and paintings of Grandcamp and Honfleur; Pissarro also showed two Pointillist landscapes. They received an abusive press in Brussels: 'Les XX have invited, following their pattern, both Belgian artists and foreigners, practical jokers like Seurat and Pissarro. These innovators are not taken seriously by any artist, and do not deserve to be.' (Quoted in Rewald, *History of Post-Impressionism*). But, in fact, several Belgian painters were immediately interested in Pointillism and there rapidly evolved a Neo-Impressionist outpost with Théo van Rysselberghe as go-between, often in Paris, seeing exhibitions and introducing a variety of new painters to Les Vingt, among them Gauguin, van Gogh and Lautrec. Most of the Belgian Neo-Impressionists worked in the style for a relatively short time and even then not exclusively. Several later renounced it, as had Pissarro, and turned to Symbolism, Art Nouveau or decorative design.

Willy Finch, born of British parents in Belgium, was a founder member of Les Vingt with his friend James Ensor. His English contacts led to the inclusion of Whistler in the first exhibition. Seurat's work was a decisive influence on his painting (plate 178) and he experimented with Pointillist colour theory on decorated pottery. In 1897 he ran a pottery in Finland, in which country he remained for the rest of his life, an important figure in the revival of Finnish design and painting in the early years of the century. In 1904 he organized the first exhibition of recent French art to be held in Finland. Théo van Rysselberghe was among the strongest converts to the movement, a close friend of Pissarro, Signac and Cross. His *Bathers at Cavalaire* (1905), with its

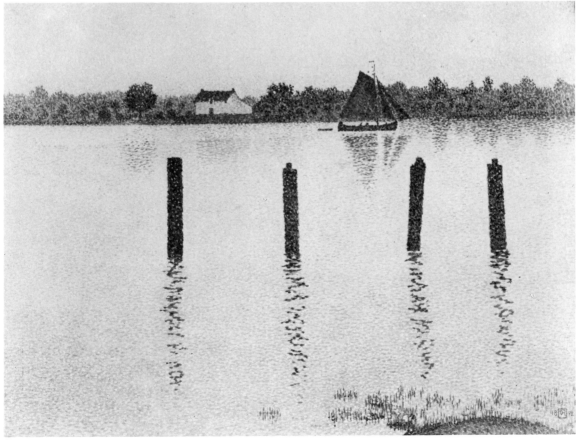

155

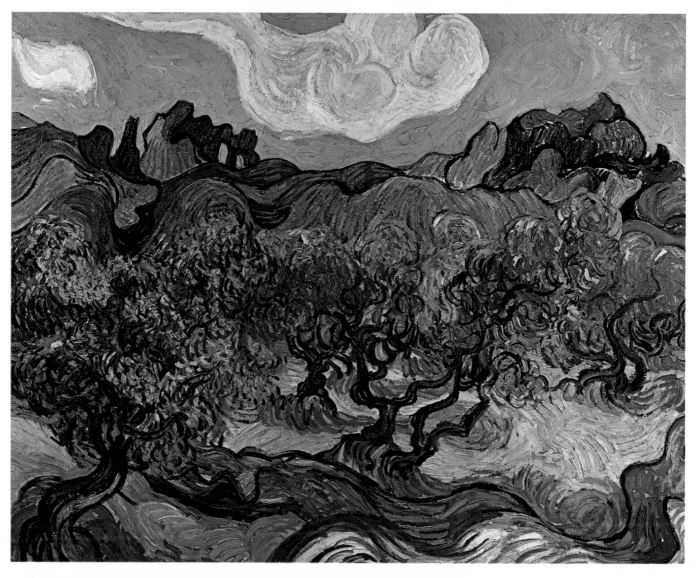

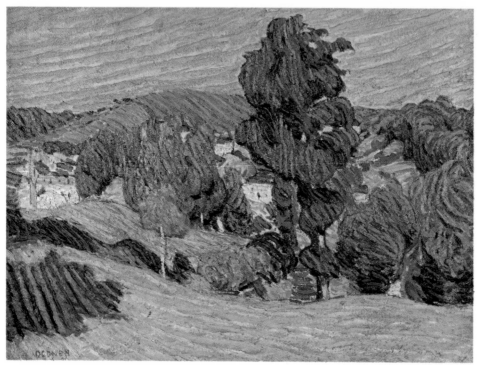

180. (*Above*) Vincent van Gogh, *Landscape with Olive Trees, St Rémy*, 1889. Oil on canvas, 28½ × 35½ in (72.4 × 90 cm). New York, Collection Mr and Mrs John Hay Whitney.

181. (*Left*) Roderic O'Conor, *Yellow landscape at Pont-Aven*, 1892. Oil on canvas, 26¼ × 36 in (67 × 91.5 cm). London, Tate Gallery.

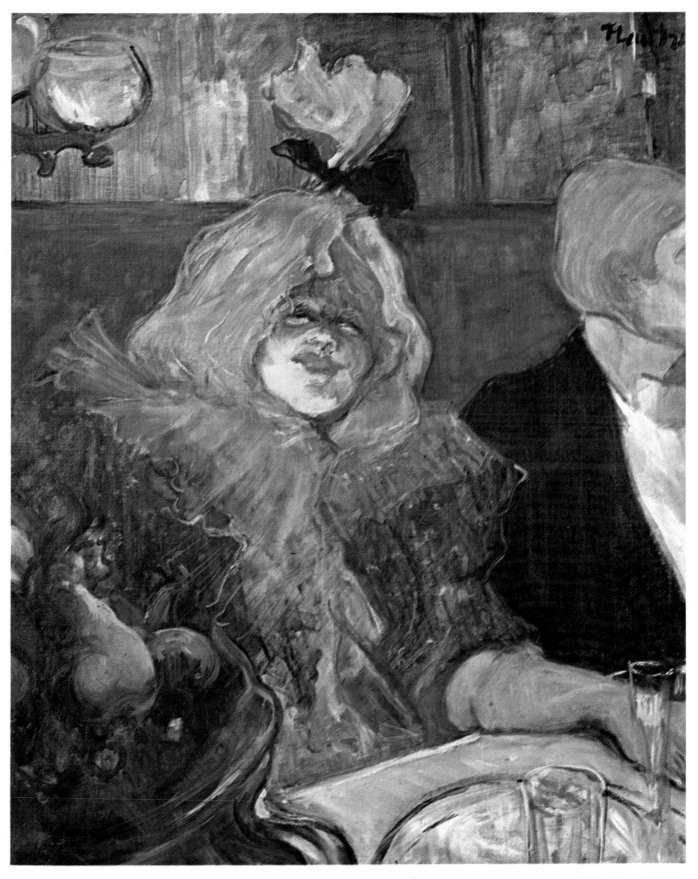

182. Henri de Toulouse-Lautrec, *Au 'Rat Mort'*, 1899. Oil on canvas, 21¾ × 18 in (55 × 46 cm). London, Courtauld Institute Galleries.

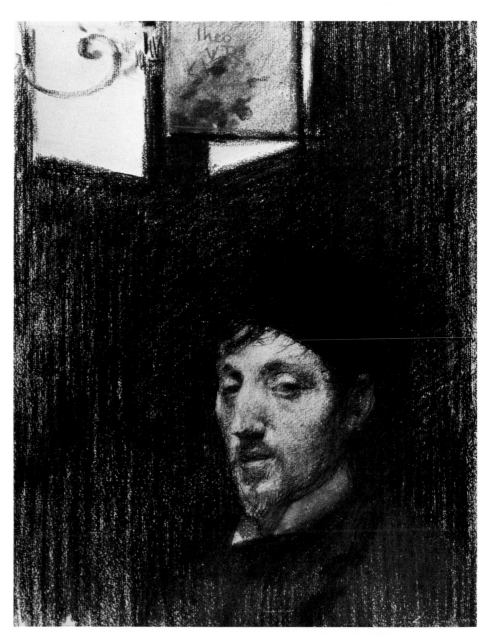

183. (*Right*) Théo van Rysselberghe, *Self-portrait*, c. 1888–9. Pastel, 13⅜ × 10⅛ in (33.9 × 25.7 cm). New York, Museum of Modern Art (Gift of Mr and Mrs Hugo Perls).

184. (*Opposite above*) Henry van de Velde, *Blankenberghe*, 1888. Oil on canvas, 27¾ × 39¼ in (71 × 100 cm). Zurich, Kunsthaus.

185. (*Opposite below*) Georges Lemmen, *View of the Thames*, c. 1890. Oil on canvas, 24 × 33½ in (61 × 86.7 cm). Providence, Rhode Island School of Design, Museum of Art.

pines and sun-dappled bathers, comes very close to Cross in subject and treatment. In 1894 he was a welcoming and energetic host to Pissarro and his family, the French painter having thought it prudent to leave France during a period of reprisals against leading anarchists, some of whom were his friends. Pissarro admired van Rysselberghe's innate talent as a painter and draftsman, but deplored his slavish commitment to the dot.

Another painter who was sympathetic to Pissarro's work and social idealism was Henry van de Velde, one of the most influential designers at the turn of the century and a key figure in the Art Nouveau movement. His Neo-Impressionist phase was short-lived but of a very high quality. In 1888 and 1889 he worked on the coast at Blankenberghe (plate 184), using a very delicate evenly applied Pointillist technique, saved by his sensitivity from being merely mechanical. His compositions are often decentralized, containing large areas of unfigured space – the pale sands of the Belgian coast – reminiscent of Signac's Portrieux

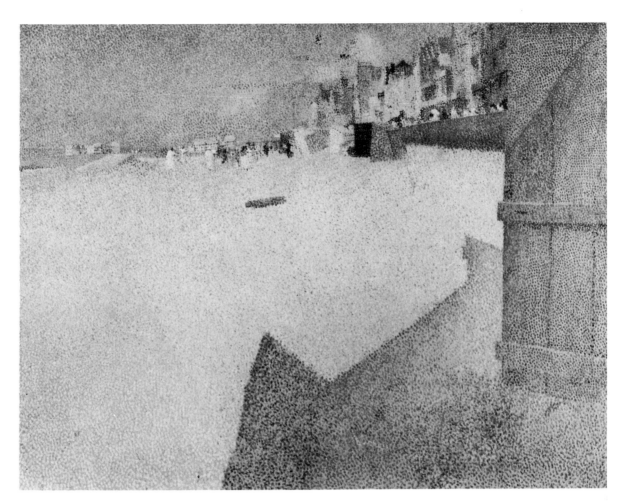

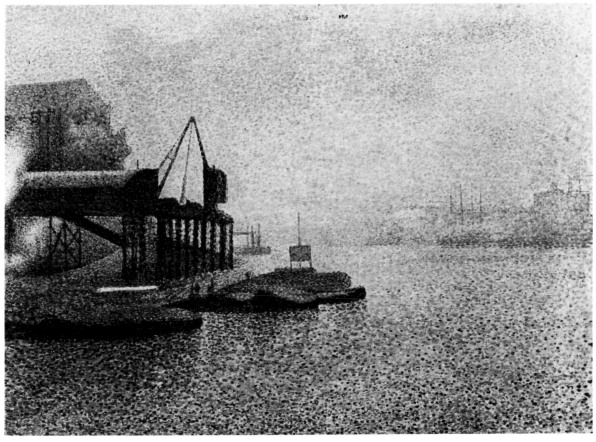

160

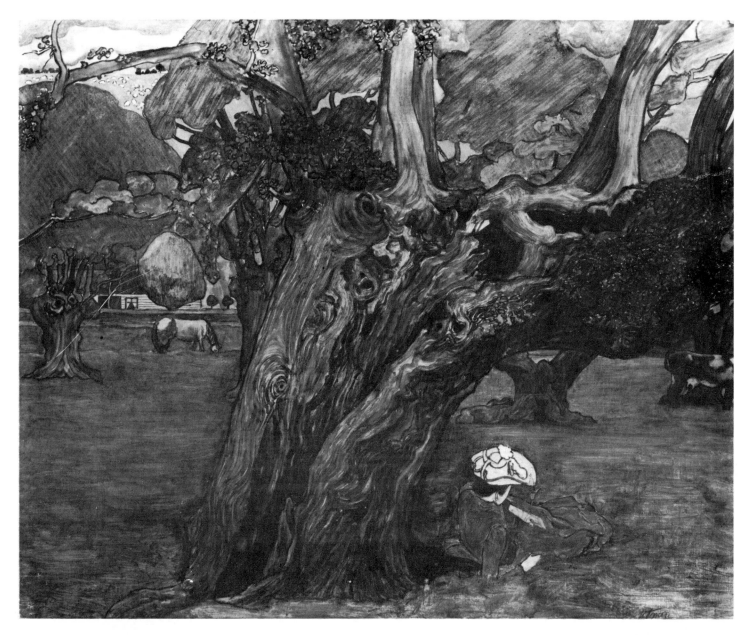

seascapes and Seurat's work at Port-en-Bessin, all of 1888. A little later he was influenced by van Gogh's undulating rhythms and coiling brush-strokes developed at St Rémy.

Van Gogh's work caused a sensation when six paintings were exhibited with Les Vingt in 1890. One, *The Red Vineyard* (now in the Pushkin Museum, Moscow), was sold to Anna Boch, a member of the society and sister of Eugène Boch, whose portrait van Gogh had painted in Arles (now in the Louvre). Van Gogh's work influenced several of the Belgians, particularly in their decorative work; van de Velde's pastel *The Garden* is virtually a pastiche of some of the St Rémy landscapes. Van de Velde's radical ideas and restless creativity soon led him to abandon painting as his predominant activity for design and architecture. In this he was closely associated with Georges Lemmen, a devout Pointillist whose work (plate 185), for the most part, shares the hamfisted sincerity of that of Maximilien Luce. His designs for books and for the catalogues of Les Vingt exhibitions are altogether

187. (*Above*) Jan Toroop, *Under the Willow*, c. 1892. Oil on canvas, 25¼ × 30¼ in (64 × 76.5 cm). Amsterdam, National Museum Vincent van Gogh.

186. (*Opposite*) Henri Matisse, *Nude in the Studio*, c. 1898–9. Oil on canvas, 26 × 10 in (66 × 25.5 cm). Tokyo, Ishibashi Collection.

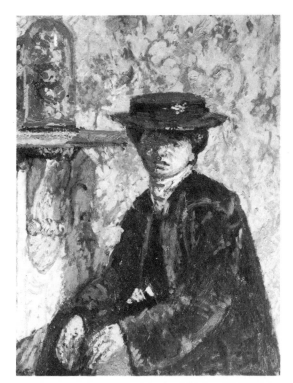

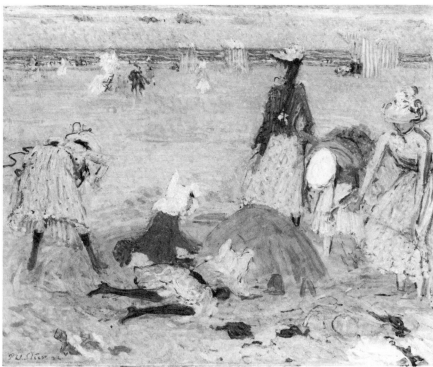

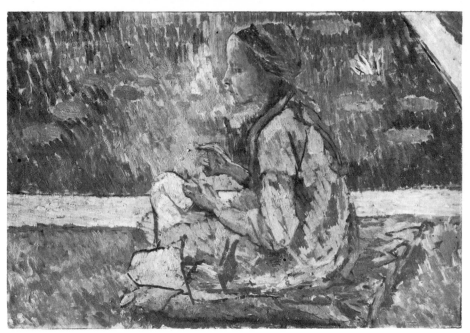

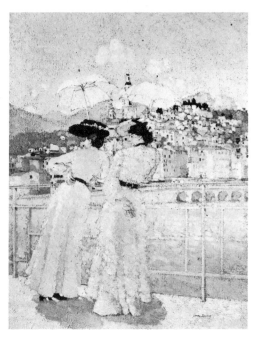

188. Walter Richard Sickert, *The New Home,* 1908. Oil on canvas, 20 × 16 in (50.8 × 40.64 cm). London, The Fine Art Society. Although this painting belongs to Sickert's residence in London he was often in Paris and early on had come into contact with the work of Bonnard and Vuillard. Bonnard certainly influenced Sickert's series of nudes in interiors painted in Paris in 1905 and he was later to write of Vuillard with particular insight and sympathy.

190. Duncan Grant, *Portrait of Pamela Fry,* 1911. Oil on canvas, 20 × 29¾ in (50.8 × 75.57 cm). London, Collection of Mrs Pamela Diamond. A portrait of the daughter of Roger Fry, the critic and writer responsible for organizing the two revealing Post-Impressionist

Exhibitions in London in 1910 and 1912. The present work was one of Grant's exhibits in the second show.

189. Philip Wilson Steer, *Boulogne Sands,* c. 1888–92. Oil on canvas, 24 × 30⅛ in (60.9 × 76.5 cm). London, Tate Gallery.

191. Simon Bussy, *Promenade.* Oil on canvas. London, Private Collection.
Bussy had been a fellow-student of Matisse and Rouault when they studied under Gustave Moreau. He was greatly influenced by Whistler and Japanese art but for a brief period, as this painting shows, something of the Nabi spirit (and texture of paint) entered his work.

more original and are conspicuous in the development of Art Nouveau.

One of the strangest figures associated with Les Vingt was Jan Toorop, a Dutchman born in Java whose Neo-Impressionist contribution, of a high standard, has been overshadowed by his fantastic Symbolist paintings and designs, a grotesque confection of Pre-Raphaelism, Art Nouveau and the nightmare world of his master and friend Ensor. At the same time he continued to paint poetic seascapes and harbour scenes, the early delicacy being replaced by a broader handling of the medium. Like Finch, he visited England and was an admirer of William Morris and the Arts and Crafts movement which was represented at several Les Vingt exhibitions and at those of La Libre Esthétique, the society that replaced Les Vingt in 1894.

By the turn of the century some of the Post-Impressionists were becoming known abroad – in Holland, Belgium, Scandinavia and Germany. Americans working in France were propagandists on their return home. In England, however, 'Impressionist' was still a dirty word though Impressionism had been influential since the 1880s in the progressive New English Art Club. But germination was slow. English students returned from Paris with little understanding of what was afoot in the capital; after brief 'experimental' periods they tended to settle down into a quasi-Impressionist style or revert to academicism. Talented native artists were often very much against what they knew of French painting. But in Wilson Steer and Walter Sickert England had two painters who had some first-hand knowledge of its recent developments and put it to constructive use. Steer in his luminous and energetically painted beach scenes (plate 189) was the first English painter to absorb something of Neo-Impressionist theory and handling (although he was never a Pointillist). Sickert brought an individual Northern Expressionism to his Degas-inspired theatre scenes and interiors; in 1905 he was considerably influenced by Bonnard in a series of nudes painted in a Paris hotel bedroom.

Both painters were sufficiently known to be invited to exhibit with Les Vingt, Sickert in 1887 (through Finch) and Steer in 1889. In painting figures on a beach (Boulogne and Walberswick), Steer was adopting subject matter common to the Impressionists – one thinks of Manet's *On the Beach at Boulogne* (1869), of Monet and Degas, of a world of bourgeois summer pleasures far from the anonymous figures or deathly silences of Signac's and van de Velde's Pointillist sands. Steer's *A Summer's Evening* (1886–7), exhibited in Brussels (and generally well received), shows something of Renoir's handling in its three female nudes by the sea; slightly later works with their broken and spotted colour have definite affinities with Pointillism. But neither Steer nor Sickert appears to have grasped the underlying motivation of Post-Impressionism at this time. And how could they, since Impressionism itself was still relatively new to them?

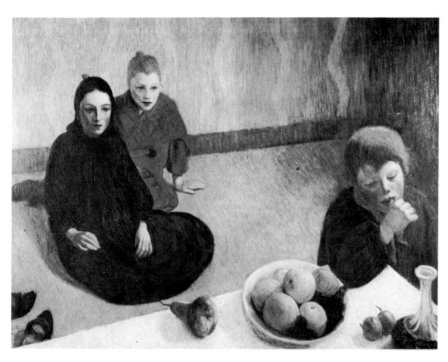

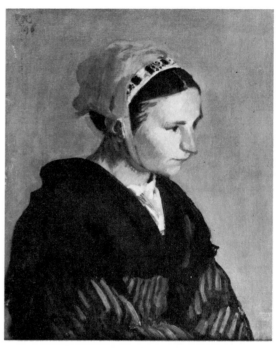

192. (*Above*) Eric Forbes-Robertson, *Great Expectations*, 1894. Oil on canvas, 29¼ × 39¼ in (74.4 × 100 cm). Northampton Museum and Art Gallery.

193. (*Above right*) Roderic O'Conor, *Portrait of a Breton Girl*, 1896. Oil on canvas, 21 × 17½ in (53.3 × 44.4 cm). London, Courtesy of Sotheby Parke Bernet.
In the later years of the last century and early in this, several British painters worked for long periods in France. The Irishman O'Conor came to Paris in 1883 and remained in France to his death in 1940. He was a particular friend of Gauguin and Sérusier but his work in the Pont-Aven period seems to show a knowledge of van Gogh.

There was, however, one painter from Britain who was well-known among the Pont-Aven school, an exhibitor with the Indépendants and a familiar figure in Paris. This was Roderic O'Conor, an Irishman who spent the rest of his life in France. He seems to have gone to Pont-Aven in 1892 and to have become friendly with Gauguin two years later. He was never a *Cloisonniste* but preferred to develop a personal style of brilliant colour and curving striated brushwork; he comes nearer to van Gogh in some Breton landscapes which show a forceful personality at work. Such works as *Landscape at Pont-Aven* (plate 181) and *Field of Corn, Pont-Aven* (plate 194) are outstanding for their audacious treatment and vehement use of primary colour; they form a welcome contrast to the work of painters to whom Gauguin was irresistible. Two other Englishmen, Eric Forbes-Robertson (plate 192) and Robert Bevan (plates 195 and 196) were also briefly at Pont-Aven. Bevan's drawings of Breton peasant life are interesting records of the world transformed in Gauguin's work and occasionally their sinuous lines remind us that we are not just looking at one more illustrator in the English genre tradition. Bevan, in fact, became a leading figure in London some years later as a member of the Camden Town Group, in which Gauguin and van Gogh were predominant influences.

The English public, as mentioned in the first chapter, was stunned by the two Post-Impressionist exhibitions of 1910 and 1912. But for several young painters they were a revelation. It is true that Gauguin and Cézanne had been shown in London over the previous few years but never in such numbers and with so many consummate masterpieces grouped together. The work of such painters as Spencer Gore, Duncan

Grant (plate 190), Harold Gilman and Stanley Spencer reflected the Post-Impressionist impact in a new-found brilliance of colour, simplification of design and an increased variety in their subject matter. Spencer, who owed much to Gauguin, painted biblical scenes taking place in the English countryside. Others preferred to take as their subject the London suburbs and the raw brick of the new Garden Cities. Duncan Grant ranged from footballers and bathers to an allusive Queen of Sheba, reminiscent of Maurice Denis, who held a one-man show in London in 1912.

Lucien Pissarro, by this time resident in England and a member of the Camden Town Group (founded 1911), supplied a valuable link with France through his direct knowledge of Neo-Impressionism. His own work was gradually modified in favour of a quiet, essentially Impressionist approach to landscape, although he retained the small dabs and criss-cross strokes characteristic of the Pointillist technique. Gilman, a more robust painter, was influenced above all by van Gogh in the rich impasto and iridescent colour of his portraits and nudes. By 1912 the influence of Matisse and Picasso is most apparent in the work of Duncan Grant and Vanessa Bell; the former, however, had already produced paintings in which a Pointillist technique was freely used without being tied to a systematic division of tones. For Roger Fry, Cézanne remained the chief inspiration (and the subject of his greatest critical work). Although these English painters produced much that was ill-considered and flimsy, we cannot deny them a sense of adventurous gaiety and release from the stuffy conventions of the prevailing art world in which Sargent was still regarded, as Sickert wrote in 1910, as 'the *ne plus ultra* and high-water mark of modernity'.

Norway's greatest painter, Edvard Munch, came to Paris in 1889. Although he seems to have made little personal contact with the Post-Impressionists during the two and a half years that he stayed, his work was strongly influenced by them. As a young artist in Norway, he did emphatically emotive paintings – sick-room interiors, for example – not far removed in sentiment from Luke Filde's celebrated *The Doctor* (1891) or Frank Bramley's *A Hopeless Dawn,* painted just a year before Munch's *Spring.* They have much in common with the sort of genre pictures that van Gogh so admired. In Paris there is a break with such overt narrative and Munch turned to street-scenes reminiscent of Manet's rue de Berne pictures and of early Signac. Munch responded briefly to Neo-Impressionism, but his ardent temperament forbade any strict adherence to scientific method. Pointillism hardly lent itself to the swiftly emerging themes that became his constant preoccupations – love, death, sexual jealousy and loneliness. He shares with several French painters of his time – particularly van Gogh and Lautrec – a concern for the humanity of his figures, their inner life and the importance of dreams. Windows, bridges, seashores and groves of trees are all potent

194. Roderic O'Conor, *Field of corn, Pont-Aven,* 1892. Oil on canvas, 15 × 15 in (38 × 38 cm). Belfast, Ulster Museum.

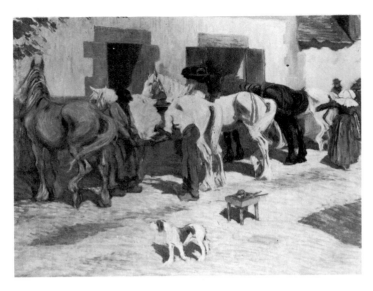

195. (*Above*) Robert Bevan, *A Breton yard*, c. 1894. Oil on canvas, 25 × 36 in (63.5 × 91.44 cm). London, Courtesy of Christie's.

196. (*Above right*) Robert Bevan, *Ploughing in Brittany*, c. 1893–4. Crayon and watercolour, 10 × 13¾ in (25.4 × 34.93 cm). London, Tate Gallery.

symbols which increased in their autobiographical significance. Women beneath trees is a motif shared with several Post-Impressionist painters, and seen most notably in *The Voice* (plate 145). Its image of erotic menace is altogether more powerful, however, than the dreamy sensuousness of Bernard's *Madeleine au Bois d'Amour* (plate 83). The emphatic sexual imagery of Munch's painting has no parallel among the French Post-Impressionists, although, of course, it is not wholly absent in Gauguin. Some of the Belgian and Dutch Art Nouveau artists are closer in this to Munch than to the generally more decorous and understated allusions of the French. The vehement colour and serpentine rhythms of Munch's great period in the 1890s show marked affinities with van Gogh's last pictures, which Munch may well have seen in Paris. There are also superficial similarities, particularly in his extensive graphic work, with stylistic features found in the Pont-Aven painters, in Redon and Max Klinger. Waves of female hair, whirling tresses and insidious strands occupy a similarly fetishistic role in his work as in Symbolist painting throughout Europe – from Rossetti and Burne-Jones to Klimt, Mucha, Lévy-Dhurmer and Segantini in Italy.

Munch cannot be classed as a participant in the Post-Impressionist movement as it developed in France. But the strong impact that it had on his work at a formative period changed him into a painter of European importance. We see this clearly when he writes: 'I painted the lines and colours that impinged on my inner eye. I painted from memory, adding nothing and omitting the details that I no longer had before my eyes. Hence the simplicity of these paintings, their apparent emptiness.' *(St Cloud Manifesto, 1890)*.

One other painter should be mentioned in this survey of some of those artists who came to France from abroad and were directly affected by the Post-Impressionists. This was Picasso, who visited Paris from Barcelona for a short time at the end of 1900 aged nineteen, and who came again for a longer period in 1901. Although at that time he mixed mainly with fellow Spanish painters and writers, he quickly found his way to the various dealers where he could study recent French art. Within the

following two or three years he assimilated all kinds of influences – a tremendous cross-country run over the styles and subject matter of the previous twenty years. It is an astonishing and exhilarating performance as we watch his sharp eye reviewing, pastiching and re-constructing the world of Lautrec (and Renoir) in *The Moulin de la Galette* (plate 176), and of the Nabis in *The Races* (1901); in pictures from the 'blue' and 'rose' periods we see him paying profound respects to Puvis de Chavannes. The back of a crouching nude, firmly enclosed in a simple dark line, reminds us of his admiration for Gauguin, and Bonnard is evoked in *The Flower Seller* of 1901.

It is easy to overstress these borrowings and similarities. When, for instance, we actually look into Picasso's *Moulin de la Galette*, there are overwhelming differences in colour and structure from Lautrec's paintings of the same dance hall. And the Spaniard's explosive use of broken colour applied in jabs and strips in such pictures as *The Dwarf Dancer* (plate 199) or *Old Woman* (plate 200) bears little relation to Pointillism in either its physical application or purpose. Picasso was still very much a foreigner in the Paris world of bars, cabarets and the demi-monde, for his experience of such places and people in Barcelona was essentially different. Many of these early pictures are almost self-consciously brilliant and at the same time strangely detached; they have little of Lautrec's knowing cynicism or bleak appraisal (as, for example, in his almost contemporary *Au 'Rat Mort'* [plate 182]) and nothing of Nabi intimacy. In the 'blue' period he is more obviously personal and, paradoxically, further away from what was going on about him in Paris. At the moment when Fauvism was gathering force with Matisse and Derain, Vlaminck and Dufy, Picasso turned to the sombre use of monochromatic blue and subjects of distilled hopelessness and gloom. We can view it almost as a cleansing of his palette and emotional reactions. In the following 'rose' period (a pale chalky pink, nothing to do with Renoir's opulent flesh or Monet's golden tonalities) Picasso examines an older tradition of classical-pastoral painting, inspired at the same time by Assyrian and Egyptian art which he studied in the Louvre. Hieratic and silent figures (as in Puvis) are posed against unspecified backgrounds and nameless shores. With the increasing influence of Cézanne we approach the Cubist period and the emergence of Picasso as the great animator and leader of the modern movement in France. But through all these early stages we witness a dynamic movement towards a new conception of reality – aggressively announced in *Les Demoiselles d'Avignon* – which mirrors, builds upon and extends the achievements of the major Post-Impressionists.

The Russian and German painters who formed Die Brücke (The Bridge) in Dresden in 1905 and later Der Blaue Reiter (The Blue Rider) in Munich in 1911 were all indebted to the example of van Gogh, Gauguin and Seurat. Although they had no personal contacts with these

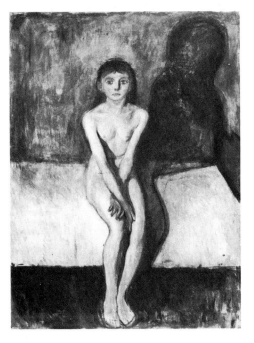

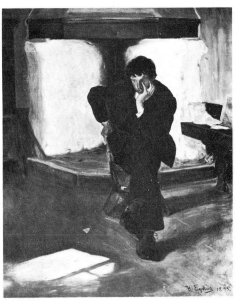

197. (*Top*) Edvard Munch, *Puberty*, c. 1893. Oil on canvas, 59 × 44⅛ in (150 × 112 cm). Oslo, Munch Museum.

198. Halfdan Egedius, *The Dreamer*, 1895. Oil on canvas, 39¼ × 32 in (100 × 81.5 cm). Oslo, National Gallery.
This painting by a little-known Norwegian artist who died very young reflects the Northern Symbolist spirit found in the work of his compatriot Munch.

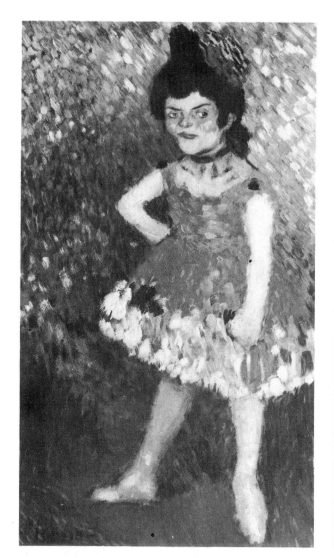

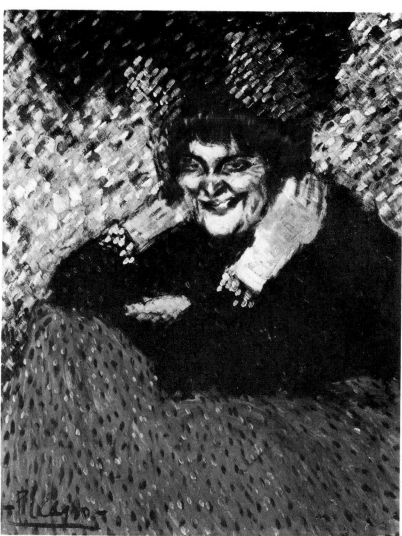

199. (*Above*) Pablo Picasso, *Dwarf dancer,* 1901. Oil on card, 41⅛ × 24 in (104.5 × 61 cm). Barcelona, Museo Picasso.

200. (*Above right*) Pablo Picasso, *Old woman,* 1901. Oil on cardboard, 26½ × 20½ in (67.4 × 52 cm). Philadelphia Museum of Art (Louise and Walter Arensberg Collection).

201. (*Opposite*) Pablo Picasso, *Boy with pipe,* 1905. Oil on canvas, 39⅜ × 32 in (100 × 81.3 cm). New York, Collection Mr and Mrs John Hay Whitney.
A mysterious, evocative painting from the end of Picasso's rose period. It is related to the many paintings of circus performers but the strange juxtaposition of pipe and crown of flowers and the youth's withdrawn look prevent any specific interpretation of the figure's significance.
In this we see the young Picasso's debt to Puvis and Gauguin.

painters, several of them visited Paris in the early years of this century. The Russian Alexej von Jawlensky worked there in 1903 and his compatriot Kandinsky exhibited at the Salon d'Automne from 1904 (and was elected to its jury). Both painters showed alongside the Fauves in the historic 1905 exhibition. In Germany the Post-Impressionists were eagerly exhibited and bought; a large van Gogh exhibition in Dresden (1905) greatly influenced some of the Brücke painters such as Erich Heckel and Ludwig Kirchner. Jawlensky and Kandinsky, both older men, had a more detailed knowledge of Post-Impressionism and both were affected by Pointillism at crucial moments in their development. But all these artists are very much part of twentieth-century painting; a reaction away from Impressionism was not a lasting element in the formation of their mature style. Although there are strong affinities with Fauvism, the Russians and Germans belonged to very different cultural and aesthetic traditions. The development of their work after the First World War and the development of French art in the same period emphasizes such differences. It also demonstrates the rich possibilities and the vitality of visual ideas that all of them found in the work of the leading figures of the Post-Impressionist epoch.

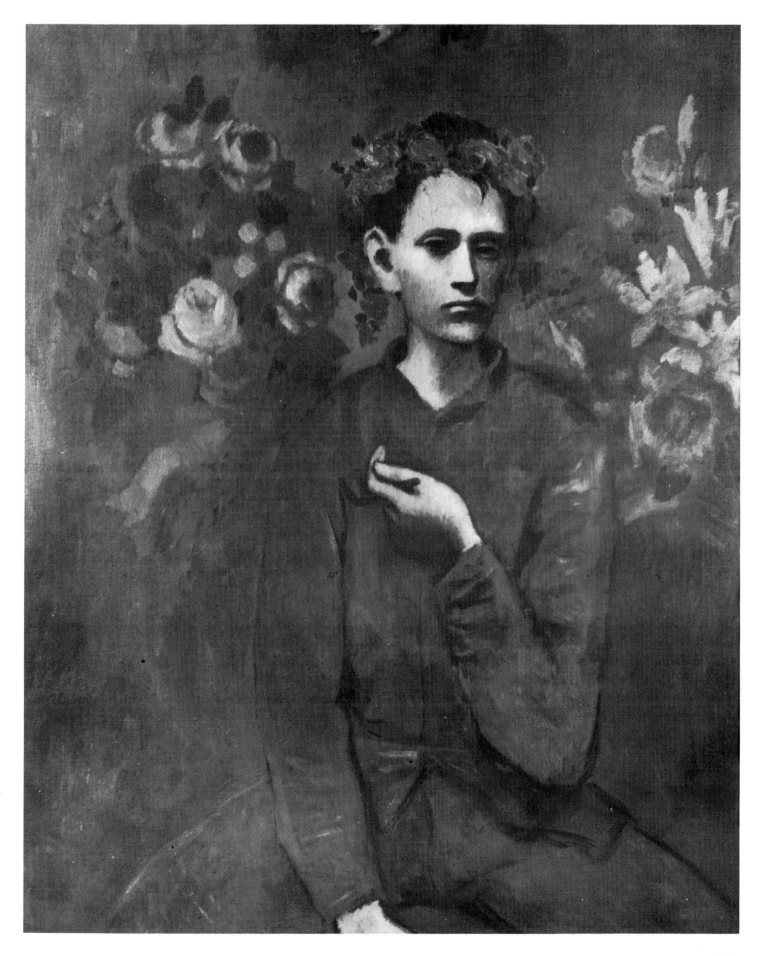

Artists' Biographies

Aman-Jean, Edmond (1859–1936)
Studied at the Ecole des Beaux-Arts in Paris where he met Seurat who remained a friend. A leading representative of the French Symbolist movement.

Angrand, Charles (1854–1926)
Painter and draughtsman influenced by his friend Seurat. Founder member of the Société des Artistes Indépendants. Later retired to his native Normandy.

Anquetin, Louis (1861–1932)
French painter important in the formation of *Cloisonnisme* with Emile Bernard. Took part in the Synthetist exhibition, Café Volpini, 1889. Friend of Toulouse-Lautrec and van Gogh.

Bell, Vanessa (1879–1961)
English painter and decorative artist. Influenced by Cézanne and Matisse, she exhibited at the Second Post-Impressionist Exhibition in London (1912).

Bernard, Emile (1868–1941)
French painter and writer closely connected with many of the Post-Impressionist painters. Met Gauguin in 1888 at Pont-Aven in Brittany and worked with him there in the following year. He was a friend of van Gogh who addressed a series of important letters to him from Provence. Exhibited with the Synthetists at the Café Volpini, 1889. Gradually moved away from the Synthetist circle and was greatly influenced by early Renaissance painting and travelled abroad, particularly in Egypt and Spain. He published his recollections of Cézanne and several letters from him in *Souvenirs sur Paul Cézanne et lettres* in 1912.

Bevan, Robert Polhill (1865–1925)
English painter who worked in Brittany 1890–91 and again in 1893–94 when he met Gauguin. Painted frequently in Poland. Became a member of the Camden Town Group in 1911.

Bonnard, Pierre (1867–1947)
French painter and leading member with Vuillard and Roussel of the Nabis. Lithographer and poster designer, associated with the founding of *La Revue Blanche*. Exhibited at the Nabis exhibitions and at the first Salon d'Automne, 1903. Later moved to the South of France and established a world-wide reputation as one of the leading European painters of the first half of the twentieth century.

Cézanne, Paul (1839–1906)
As a student in Paris he came to know several painters of the future Impressionist circle with whom he exhibited in 1874. Worked with Pissarro at Auvers and Pontoise. Gradually retired to his native Aix-en-Provence. In the later eighteen-nineties his work was exhibited by Ambroise Vollard and he attracted the admiration of a variety of younger painters. The revolutionary impact of his work was most strongly felt among the Cubist generation of painters in the years immediately following his death.

Cross, Henri-Edmond (1856–1910)
Exhibited with Seurat in 1884 at the Salon des Artistes Indépendants, where he continued to exhibit until his death. In 1891 he moved permanently to Saint-Clair, near the Mediterranean coast. Painted in Venice 1903 and Umbria and Tuscany in 1908. Cross's work had a considerable influence on the Fauvist painters, especially Matisse and Marquet.

Denis, Maurice (1870–1943)
French painter, decorator and illustrator; member of the Nabis and founder of the Ateliers d'Art Sacré (1919). A prolific writer on art, he published *Théories 1890–1910* (1912), *Nouvelles Théories* (1922) and

Aristide Maillol (1925). His revealing *Journal 1884–1943* (3 vols.) was published in 1957. He painted small scale, *intimiste* paintings alongside large religious and symbolist works including church frescoes and decorations such as those for the Théâtre des Champs-Elysées, 1912.

Dubois-Pillet, Albert (1845–1890)
Neo-Impressionist follower of Seurat and Signac and important founder member of the Société des Artistes Indépendants, exhibiting at its annual Salons. He had followed a military career from his youth, serving in the Republican Guard. At the time of his death he was head of the Gendarmerie, Haute-Loire. Exhibited at Les Vingt, Brussels in 1888 and 1890.

Egedius, Halfdan (1877–1899)
Norwegian painter of landscapes and portraits; influenced by the Symbolists. Some of his works share similarities with early Munch.

Finch, Willy (Alfred William) (1854–1930)
Belgian painter of British descent. Founder member of Les Vingt. His Neo-Impressionist period began in 1887. Virtually abandoned painting in the mid-1890s in favour of ceramics. Went to Finland in 1897 and managed a pottery there. Played an important role in introducing recent French and Belgian art and design to Finland. Resumed painting in a more Impressionist manner c.1900.

Forbes-Robertson, Eric (1865–1935)
English painter who first went to Pont-Aven in 1890. Exhibited with the Impressionist and Symbolist Group in Paris, 1895. He knew Gauguin in Brittany in 1894–95.

Gauguin, Paul (1848–1903)
Of French and Peruvian descent, Gauguin's childhood was partly spent in Peru. He was first a sailor and then stockbroker, eventually abandoning commerce for full-time painting in 1883. By then he had already exhibited with the Impressionists and come under the influence of Pissarro, Cézanne and Degas. First stayed in Pont-Aven, Brittany in 1886. Became the major figure of the Pont-Aven group which included Bernard, Sérusier, Meyer de Haan, etc. Stayed with van Gogh in Arles in 1888, before visiting Martinique with Laval. Exhibited with the Synthetists, Café Volpini, 1889. First Tahitian visit 1891–93. In Paris and Brittany, closely involved in the Symbolist movement. Second Tahitian visit 1895–1901; then he moved to the Marquesas Islands where he died on Hiva-Hoa in 1903. Gauguin's work exerted a strong influence during his life-time – at Pont-Aven and among the Nabis. After his death, his influence was felt throughout Europe, particularly among the German Expressionist painters and the Fauves. He was also a ceramicist, sculptor and writer.

Gogh, Vincent van (1853–1890)
Born in Holland, son of a pastor. Entered the picture dealing business in Brussels, London and Paris. Became a schoolmaster and then an evangelist in the Belgian mining district of the Borinage. Decided to devote himself to painting in 1880, working in Holland and Belgium. Studied in Antwerp 1885–6. Joined his brother Theo in Paris and came to know Pissarro, Signac, Bernard and Gauguin. Moved to Arles in Provence in spring 1888. Joined there by Gauguin and suffered the first of a series of mental crises at the end of that year which resulted in his seclusion in the asylum of St Paul at nearby St Rémy. Moved North to Auvers-sur-Oise under the care of Dr Paul Gachet. Committed suicide in July 1890. In January that year his work was included in the Les Vingt exhibition, Brussels and in May at the Salon des Indépendants. Van Gogh's letters to his brother and smaller collections to van Rappard, Bernard, John Peter Russell were collected into four volumes 1952–54 and published in English edition (3 vols.) in 1958.

Gore, Frederick Spencer (1878–1914)
English painter, member of the Camden Town Group (1911) and

exhibitor at the Second Post-Impressionist Exhibition (1912). Influenced at first by the Impressionists and later by Cézanne and Matisse.

Grant, Duncan (1885–1978)
English painter, decorator and stage designer. Studied in Paris under Blanche and was influenced by Post-Impressionism from 1910, particularly Gauguin and Cézanne. Exhibited at the Second Post-Impressionist Exhibition in London (1912).

Hayet, Louis (1864–1940)
Neo-Impressionist painter born in Pontoise where later he encountered and was encouraged by Camille and Lucien Pissarro. Exhibited at the Salon des Artistes Indépendants and with Les Vingt in Brussels. Hayet, who died in complete obscurity (while still alive he was catalogued as *'peintre inconnu'* in Neo-Impressionist retrospectives), was a tireless experimenter in his methods and the mediums he used, often painting in encaustic and watercolour on cotton and matt board. His subjects were mainly of Parisian life and of landscapes produced on varied travels throughout France.

Ibels, Henri-Gabriel (1867–1936)
French painter and graphic artist who studied at the Académie Julian. An original member of the Nabis and participant in various Symbolist and Nabi exhibitions at Le Barc de Boutteville and Vollard's.

Laugé, Achille (1861–1944)
Studied at the Ecole des Beaux-Arts, Paris and adopted Neo-Impressionist technique in 1888. Lived in Carcassonne and remained in the district for the rest of his life. Exhibited at the Salon des Artistes Indépendants in 1894 and at numerous one-man exhibitions in Paris and the French provinces. From c.1905 his style became increasingly free and Impressionist.

Laval, Charles (1862–1894)
French painter of the Pont-Aven group; greatly influenced by Gauguin whom he accompanied to Martinique in 1888. Exchanged self-portraits with van Gogh. Laval, who left little work behind, died of tuberculosis in Egypt, having recently married Madeleine Bernard, sister of the painter.

Lemmen, Georges (1865–1916)
Belgian painter and decorative artist and designer, Lemmen worked in the Neo-Impressionist style from c.1890–95. Exhibited with Les Vingt and at the Salon des Artistes Indépendants. Designed bookbindings, posters etc. in which activities he was closely associated with van de Velde.

Luce, Maximilien (1858–1941)
Leading Neo-Impressionist painter from 1887 much influenced by his friend Camille Pissarro. He was tried for his anarchist activities in 1894 following the assassination of President Carnot. Later Luce reverted to a more Impressionist style in landscapes, urban views, building sites and dockyards. He was a prolific draughtsman and lithographer.

Matisse, Henri (1869–1954)
Studied under Moreau in Paris with Marquet and Rouault as fellow students. After his early Impressionist phase he was greatly influenced by Neo-Impressionism (through Signac and Cross) and by Cézanne. He emerged as leader of the Fauves in 1905 at the Salon d'Automne.

Meyer de Haan, Jacob (1852–1895)
Dutch painter who went to Paris in 1888 where he was befriended by Theo van Gogh. Met Gauguin in the following year and went with him to Brittany working at Le Pouldu.

Munch, Edvard (1863–1944)
Norwegian painter and graphic artist, foremost representative of the Northern Expressionist movement. He was in Paris from 1889 to 1892 and again in 1895–96 where he became a friend of Mallarmé. He had been considerably influenced by the Post-Impressionists particularly Gauguin. The impact of both his painting and large output of en-

gravings and lithographs was most strongly felt among the German Expressionists.

O'Conor, Roderic (1860–1940)
Irish painter who from 1883 spent most of the rest of his life in France. He was in contact with the Pont-Aven school in 1892 and became a friend of Gauguin in the following year, later lending Gauguin his Paris studio.

Petitjean, Hippolyte (1854–1929)
Neo-Impressionist painter who first exhibited with the Société des Artistes Indépendants in 1891 and with Les Vingt, Brussels, in 1893. Greatly influenced by Puvis de Chavannes in his paintings of bathers and pastoral groups. Petitjean remained faithful to Neo-Impressionist theories throughout his career, especially in his drawings and water-colours.

Picasso, Pablo (1881–1973)
Picasso came to Paris in 1900 from Barcelona and visited again in 1901–2; he settled permanently in Paris in 1904. He was at first much influenced by Toulouse-Lautrec and van Gogh before beginning his Blue period. Cézanne's work had a decisive impact on his own painting and the development of Cubism after *Les Demoiselles d'Avignon* of 1907.

Puvis de Chavannes, Pierre (1824–1898)
French painter of large decorative schemes much admired by many of the Post-Impressionists including Seurat and Gauguin. His compositions of women and children under trees and by sea shores clearly influenced the decorative work of the Nabis, of Hippolyte Petitjean and more strictly Symbolist painters such as Grasset and Maurin.

Roussel, Ker-Xavier (1867–1944)
Closely associated with Vuillard (who became his brother-in-law in 1893) and Bonnard in the Nabi group. His earlier work has affinities with theirs and with French Symbolist painting, particularly in his large decorative works. His later paintings were chiefly mythological and bucolic in inspiration.

Rysselberghe, Théo van (1862–1926)
Belgian Neo-Impressionist and friend and recorder of many Belgian and French painters and writers (including Pissarro, Gide and Fénéon). A leading member of Les Vingt, he spent much of his life in Paris and in the South of France as a neighbour of Signac and Cross.

Schuffenecker, Emile (1851–1934)
French painter who met Gauguin at the stock exchange and, like him, abandoned a business career for painting. Of modest gifts, he is best known as Gauguin's devoted friend and supporter. He was largely responsible for organizing the Synthetist exhibition at the Café Volpini in 1889.

Sérusier, Paul (1864–1927)
Painter and theorist originally associated with Gauguin in Pont-Aven (1888) and Le Pouldu (1889–90); later with Denis, Bonnard, Vuillard and others of the Nabis. Like Denis and some of the Pont-Aven painters he was a devout Roman Catholic, developing his theories of sacred art in his *ABC de la peinture* (1921).

Seurat, Georges (1859–1891)
Founder of the Neo-Impressionist movement. Studied at the Ecole des Beaux-Arts and exhibited a portrait drawing of Aman-Jean at the official Salon (1883). Founder member of the Société des Artistes Indépendants where he met Signac, Cross and Angrand. Painted in Paris and on the Normandy coast. Exhibited with Les Vingt, Brussels and at the last Impressionist Exhibition (1886 *La Grande Jatte*). *Le Cirque* was left unfinished at his death in Paris at the age of thirty-one.

Sickert, Walter Richard (1860–1942)
English painter of Danish descent. Pupil of Whistler and later friend

and admirer of Degas from 1883. Associated briefly with the Nabis painters and worked in Venice, Dieppe and Paris before settling more permanently in London in 1905. Leading figure of the Camden Town Group, 1911. Exhibited with Les Vingt, Brussels in 1887.

Signac, Paul (1863–1935)
After Seurat, the most important of the Neo-Impressionists as painter and theorist; published numerous articles on modern painting and his classic *D'Eugène Delacroix au Néo-Impressionnisme* (1899). A friend of van Gogh, the Pissarros and Henri Matisse. Much of his work inspired by the harbours and coastline of the South of France, Venice and La Rochelle. President of the Société des Artistes Indépendants from 1908 to 1934.

Steer, Philip Wilson (1860–1942)
English painter, primarily of landscapes. Studied in Paris 1882–4. Early on influenced by Manet and Whistler and later by Neo-Impressionism for a brief period, particularly in paintings of Boulogne beach and Walberswick, England. Exhibited with Les Vingt, Brussels in 1889 and 1891.

Toorop, Jan (1858–1928)
Dutch painter born in Java; contributed to the Dutch Symbolist movement but painted also in the Neo-Impressionist style, his knowledge of which was gained mainly through Les Vingt exhibitions where he regularly showed work from 1885.

Toulouse-Lautrec, Henri de (1864–1901)
French painter and lithographer belonging to the old French nobility, Toulouse-Lautrec remained a dwarf after two accidents in childhood to his legs which thereafter refused to grow. Studied under Princeteau and later at the Atelier Cormon where he came to know Bernard and van Gogh. Greatly influenced by Manet, Degas and Japanese art. He remained an independent artist though was much associated with the Nabis and the circle around the Natanson brothers of La Revue Blanche. His posters were widely influential and he counted for much in the early development of Picasso, Rouault and other painters of the younger generation.

Vallotton, Félix-Edmond (1865–1925)
Swiss painter and notable etcher and engraver. A member of the Nabis and particular friend of Vuillard. He was later influenced by Ingres and early Flemish painting and returned to a more finished, academic style. He also wrote plays, poems and novels.

Valtat, Louis
French painter early associated with the Nabis though never a member of the group; his scenes of Parisian life were influenced by Toulouse-Lautrec.

Velde, Henry van de (1863–1957)
Belgian artist and designer of great influence on the decorative arts in Holland and Belgium at the turn of the century. His Neo-Impressionist period was brief, from about 1887 (when he saw Seurat's *La Grande Jatte*) to about 1894. An exhibitor with Les Vingt, he was much influenced by Millet and Pissarro in his choice of peasant subject matter and landscape, as well as by painters of the Belgian school. He designed the Folkwang Museum, Essen among many other architectural and decorative schemes.

Verkade, Jan (1868–1946)
Dutch painter who came to Paris in 1891; through his compatriot Meyer de Haan he came to know Sérusier and Gauguin. He worked in Brittany, was converted to Catholicism and ordained; he became a monk at Beuron in the Black Forest where he died. Verkade continued to paint at Beuron where there was a community of religious painters. He was in close touch with Denis and Sérusier, the latter painting his portrait at Beuron in 1906. He also wrote two invaluable volumes of autobiography giving many details of the Pont-Aven painters and the Nabis.

Vuillard, Edouard (1868–1940)
French painter, lithographer and decorative artist, Vuillard studied at the Académie Julian and became a leading figure of the Nabis, particularly associated with Bonnard and Roussel. His work is mainly of figures in interiors (especially his mother and family friends in their Paris flat), portraits, still-lifes and a series of large decorations. Later he had considerable success as a fashionable portrait painter.

List of Major Collections of Post-Impressionist Works

Australia
Melbourne: National Gallery of Victoria

Finland
Helsinki: Ateneum

France
Paris: Musée Carnavalet
　Musée du Louvre
　Musée National d'Art Moderne
St-Tropez: Musée de l'Annonciade

Germany
Berlin: Staatliche Museen
Essen: Folkwang Museum
Otterlo: Rijksmuseum Kröller-Müller

Holland
Amsterdam: National Museum of Vincent
　van Gogh
　Stedelijk Museum
The Hague: Gemeentemuseum

Norway
Oslo: Munch Museum
　National Gallery

Poland
Warsaw: National Gallery

Spain
Barcelona: Picasso Museum

Sweden
Stockholm: National Gallery

Switzerland
Bern: Musée des Beaux-Arts
Geneva: Petit Palais
Lausanne: S. Josefowitz Collection
Winterthur: Oscar Reinhart Collection
Zurich: Bührle Foundation

Kunstmuseum

United Kingdom
Cardiff: National Museum of Wales
Cambridge: Fitzwilliam Museum
Edinburgh: National Gallery of Scotland
Glasgow: Museum and Art Gallery
London: Courtauld Institute Galleries
　National Gallery
　Tate Gallery
Manchester: Whitworth Art Gallery
Northampton: Museum and Art Gallery
Oxford: Ashmolean Museum

United States of America
Baltimore: Museum of Art
Boston: Museum of Fine Arts
Buffalo: Albright-Knox Art Gallery
Cambridge, Mass.: Fogg Museum of Art
Chicago: Art Institute
Cleveland: Museum and Art Gallery
Hartford, Conn.: Wadsworth Atheneum
Los Angeles: County Museum
Merion, Penn.: Barnes Foundation
Minneapolis: Institute of Arts

New Haven: Yale University Art Gallery
New York: Arthur G. Altschul Collection
 Metropolitan Museum of Art
 Mr and Mrs John Hay Whitney Collection
 Museum of Modern Art
 Solomon Guggenheim Museum

Northampton, Mass.: Smith College
 Museum
Oberlin: Dudley Peter Allen Memorial Fund
Philadelphia: Museum of Art
Providence: Museum of Art, Rhode Island
 School of Design

Upperville, Virginia: Mr and Mrs Paul
 Mellon Collection
Washington D.C.: National Gallery of Art

U.S.S.R.
Moscow: Pushkin State Museum

Bibliography

The literature on the movements and painters included in this volume is vast and continually growing. The following bibliography lists a fraction of some of the books and catalogues consulted during the writing of *The Post-Impressionists*. It will be noted that there is only one entry under a similar title – John Rewald's *History of Post-Impressionism* which, recently republished in a new edition, contains a comprehensive and up to date bibliography. In a short survey such as this book it would be pretentious to list the periodical literature consulted but it should be said that much of it is to be found in *The Burlington Magazine*, *Apollo*, *La Gazette des Beaux-Arts* and *La Revue du Louvre*. Published writings by some of the artists themselves precede the bibliography.

Cézanne, Paul: *Letters* (ed. J. Rewald), Oxford, 1976.
Denis, Maurice: *Théories (1890–1910)*, Paris, 1912.
Gauguin, Paul: *Avant et Après*, Paris, 1923 (English trans. as *The Intimate Journals of Paul Gauguin*, London, 1930).
 Lettres à Daniel de Monfried, Paris, 1919.
Gogh, Vincent van: *Letters* (3 vols.), London, 1958.
Pissarro, Camille: *Letters to his son Lucien* (ed. J. Rewald), London, 1943.
Sérusier, Paul: *ABC de la Peinture*, Paris, 1950.
Signac, Paul: *D'Eugène Delacroix au Néo-Impressionnisme* (ed. F. Cachin), Paris, 1964.

Adler, K.: *Camille Pissarro, a biography*, London, 1978.
Alley, R.: *Gauguin*, London, 1961.
Barr, A. H.: *Matisse: His Art and His Public*, New York, 1951.
Cachin, F.: *Paul Signac*, Paris, 1971.
Chassé, C.: *Gauguin et son temps*, Paris, 1955.
Cooper, D.: *Une Baignade, Asnières*, London, 1946.
 Toulouse-Lautrec, London, 1955.
Courthion, P.: *Seurat*, Paris, 1969.
Delevoy, R.: *Symbolists and Symbolism*, London, 1978.
Maurice Denis: Exhibition Catalogue, Orangerie des Tuileries, Paris, 1970.
Dorra, H. and Rewald, J.: *Seurat*, Paris, 1959.
Eeckhout, P. and Chabot, G.: *Retrospective Theo van Rysselberghe*, *Exhibition Catalogue*, Musée des Beaux-Arts, Ghent, 1962.

Elgar, F.: *Van Gogh*, Paris, 1958.
 Cézanne, Paris, 1968.
Faille, H. B. de la: *The Works of Vincent van Gogh*, Amsterdam, 1970 (a new edition of de la Faille's 1928 catalogue raisonné).
Fry, R.: *Transformations*, London, 1926.
 Cézanne: A Study of His Development, London, 1927.
Guicheteau, M.: *Paul Sérusier*, Paris, 1976.
Herbert, R. L.: *Neo-Impressionists and Nabis in the collection of Arthur G. Altschul*, Yale, 1965.
Hilton, T.: *Picasso*, London, 1975.
Humbert, A.: *Les Nabis et leur époque. 1888–1890*, Geneva, 1954.
Jaworska, W.: *Gauguin and the Pont-Aven School*, London, 1972.
Lemoyne de Forges, M.-T.: *Signac*, Exhibition Catalogue, Musée du Louvre, 1963.
Meadmore, W. S.: *Lucien Pissarro*, London, 1962.
Natanson, T.: *Peints à leur tour*, Paris, 1948.
Pool, P.: *Impressionism*, London, 1967.
Reff, T. (and others): *Cézanne. The Late Work*, Museum of Modern Art, New York, 1977.
Rewald, J.: *The History of Impressionism*, New York, 1961; new ed. 1973.
 The History of Post-Impressionism from van Gogh to Gauguin, New York, 1965; new ed. 1978.
Rookmaaker, H. R.: *Gauguin and Nineteenth Century Art Theory*, Amsterdam, 1972.
Roskill, M.: *Van Gogh, Gauguin and the Impressionist Circle*, London, 1970.
Russell, J.: *Seurat*, London, 1970.
Sutter, J. (ed.): *The Neo-Impressionists*, London, 1970.
Sutton, D.: *Derain*, London, 1959.
 Bonnard, catalogue introduction, Royal Academy, London, 1967.
 Gauguin and the School of Pont-Aven, catalogue introduction, Tate Gallery, London, 1966.
Taylor, B.: *Cézanne*, London, 1961.
Terrasse, A.: *Maurice Denis. Intimités*, Paris, 1970.
Vollard, A.: *Recollections of a Picture Dealer*, London, 1936.
Vuillard, Roussel: Exhibition Catalogue, Orangerie des Tuileries, Paris, 1968.
Welsh-Ovcharov, B.: *Van Gogh in Perspective*, New Jersey, 1974.
Wildenstein, G. and Cogniat, R.: *Paul Gauguin, Catalogue*, Paris, 1964.

Acknowledgements and List of Illustrations

The author and John Calmann & Cooper would like to thank the museums, galleries and private collectors who allowed works in their collections to be reproduced in this book.

Unless otherwise stated, they provided the photographs used. The author and John Calmann & Cooper would also like to thank the photographers and photographic agencies who provided photographs.

1. Paul Gauguin, *Woman with Mango*, Baltimore Museum of Art, Baltimore
2. Paul Signac, *Gas tanks at Clichy*, National Gallery of Victoria, Melbourne
3. Georges Seurat, *Le Cirque*, Louvre, Paris. Photo Réunion des Musées Nationaux, Paris
4. Maximilien Luce, *Portrait of Georges Seurat*, Collection Arthur G. Altschul, New York
5. Spencer Gore, *Gauguins and connoisseurs at the Stafford Gallery*, Collection Sir William Keswick, Theydon Bois
6. Vanessa Bell, *Room at the Second Post-Impressionist Exhibition*, Musée d'Art Moderne, Paris
7. Paul Gauguin, *Self-portrait with Yellow Christ*,

Museum, Essen. Photo Regine Zweig
103. Paul Gauguin, *Self-portrait for van Gogh*, National Museum of Vincent van Gogh, Amsterdam
104. Emile Bernard, *Self-portrait for van Gogh*, National Museum of Vincent van Gogh, Amsterdam
105. Charles Laval, *Self-portrait for van Gogh*, National Museum of Vincent van Gogh, Amsterdam
106. Paul Gauguin, *Portrait of van Gogh painting sunflowers*, National Museum of Vincent van Gogh, Amsterdam
107. Paul Gauguin, *Night Café at Arles*, Hermitage Museum, Leningrad. Photo Cooper-Bridgeman Library
108. Vincent van Gogh, *Dance Hall*, Louvre, Paris. Photo Réunion des Musées Nationaux, Paris
109. Emile Bernard, *Brothel scene*, National Museum of Vincent van Gogh, Amsterdam
110. Paul Cézanne, *The Cardplayers*, Courtauld Institute Galleries, London
111. Paul Cézanne, *Large Bathers*, Museum of Art, Philadelphia. Photo Cooper-Bridgeman Library
112. Vincent van Gogh, *Les Alyscamps, Falling leaves*, Rijksmuseum Kröller-Müller, Otterlo
113. Paul Gauguin, *Old women of Arles*, Art Institute of Chicago, Chicago
114. Vincent van Gogh, *The Sower*, National Museum of Vincent van Gogh, Amsterdam
115. Paul Gauguin, *Dramas of the sea*. Photo courtesy of Christie, Manson and Wood, London
116. Paul Cézanne, *Still-life with apples, pears and pot*, Cabinet des Dessins, Louvre, Paris
117. Paul Gauguin, *Tahitian Woman*, Art Institute of Chicago, Chicago
118. Paul Gauguin, *Head of a Breton Peasant Girl*, Fogg Art Museum (Meta and Paul J. Sachs Bequest), Harvard University, Cambridge, Massachusetts
119. Paul Gauguin, *Head of a Tahitian Man*, Art Institute of Chicago, Chicago
120. Paul Gauguin, *Head of a Tahitian woman*, Cleveland Museum of Art (Mr and Mrs Lewis B. Williams Collection), Ohio
121. Paul Gauguin, *Auti Te Pape (les femmes à la rivière)*, Private Collection
122. Paul Cézanne, *Self-portrait with beret*, Museum of Fine Arts (Charles H. Bayley Fund), Boston
123. Paul Cézanne, *Harlequin*, Private Collection, London
124. Paul Cézanne, *View of the Château Noir at Aix*, Oscar Reinhart Collection, Winterthur
125. Paul Cézanne, *The lake of Annecy*, Courtauld Institute Galleries, London
126. Paul Cézanne, *Still-life with plaster Cupid*, Courtauld Institute Galleries, London
127. Paul Cézanne, *Three skulls*, Art Institute of Chicago (Mr and Mrs Lewis L. Coburn Memorial Collection), Chicago
128. Paul Cézanne, *Gustave Geffroy*, Louvre, Paris
129. Paul Cézanne, *Still-life: Apples and a pot of flowers*, Metropolitan Museum (Bequest of Samuel A. Lewisohn), New York
130. Paul Cézanne, *Madame Cézanne*, Metropolitan Museum (Mr and Mrs Henry Ittleson Jr Fund), New York
131. Paul Cézanne, *Pot of Flowers*, Cabinet des Dessins, Louvre, Paris. Photo Réunion des Musées Nationaux, Paris
132. Paul Cézanne, *The Aqueduct*, Pushkin Museum, Moscow
133. Paul Cézanne, *La Montagne Ste Victoire*, Courtauld Institute Galleries, London
134. Paul Cézanne, *La Montagne Ste Victoire*, Mary Atkins Museum of Fine Arts, Kansas
135. Paul Cézanne, *The Gardener*, Bührle Founda-

tion, Zurich
136. Paul Cézanne, *Bethshabee*, Private Collection
137. Paul Cézanne, *Portrait of a peasant*, Collection Oscar Reinhart, Winterthur
138. Paul Cézanne, *Still-life with apples*, Museum of Modern Art, New York
139. Paul Cézanne, *Les Grandes Baigneuses*, National Gallery, London
140. Paul Cézanne, *Bathers*, Museum of Art (Cone Collection), Baltimore
141. Paul Cézanne, *Mountains see from L'Estaque*, National Museum of Wales, Cardiff. Photo Cooper-Bridgeman Library
142. Edouard Vuillard, *Yellow Interior*, Louvre, Paris. Photo Giraudon
143. Edouard Vuillard, *Lunch at Villeneuve-sur-Yonne*, National Gallery, London
144. Maurice Denis, *The Muses*, Musée d'Art Moderne, Paris
145. Edvard Munch, *The Voice*, Museum of Fine Arts, Boston
146. Félix Vallotton, *Gossip*, Collection Arthur G. Altschul, New York
147. Paul Sérusier, *Breton Landscape*, National Museum, Warsaw
148. Maurice Denis, *Maternité à la fenêtre*, Musée d'Art Moderne, Paris. Photo Réunion des Musées Nationaux, Paris
149. Pierre Bonnard, *Man and woman*, Musée d'Art Moderne, Paris. Photo Réunion des Musées Nationaux, Paris
150. Edouard Vuillard, *Two women by lamplight*, Musée de l'Annonciade, St Tropez
151. Claude Monet, *The Sisley family at table*, Collection E. G. Bührle, Zurich
152. Georges Seurat, *Family scene, evening*, Allen Memorial Art Museum (R. T. Miller Jr. Fund), Oberlin College
153. Félix Vallotton, *Dinner by lamplight*, Musée d'Art Moderne, Paris. Photo Réunion des Musées Nationaux, Paris
154. Edouard Vuillard, *Portrait of Félix Vallotton*, Louvre, Paris
155. Henri de Toulouse-Lautrec, *At the Cirque Fernando*, Art Institute of Chicago, Chicago. Photo Giraudon
156. Pierre Bonnard, *Madame Sert*, Private Collection. Photo Mansell Collection
157. Edouard Vuillard, *Monsieur et Madame Feydeau on a sofa*, Galerie Schmidt, Paris
158. Edouard Vuillard, *Le Sommeil*, Musée d'Art Moderne, Paris. Photo Réunion des Musées Nationaux, Paris
159. Achille Laugé, *Marie Laugé and the laundress*, Galerie Marcel Flayian, Paris
160. Maximilien Luce, *Sewing*, Private Collection
161. Ker-Xavier Roussel, *The Seamstresses*, Collection Arthur G. Altschul, New York
162. Pierre Bonnard, *At the embroideress's*. Photo courtesy Sotheby Parke Bernet, London
163. Edouard Vuillard, *Personnages dans des Intérieurs: La Musique*, Petit Palais, Paris. Photo Réunion des Musées Nationaux, Paris
164. Edouard Vuillard, *Personnages dan des Intérieurs: La Bibliothèque*, Petit Palais, Paris. Photo Réunion des Musées Nationaux, Paris
165. Henri-Gabriel Ibels, *Travelling show*. Photo courtesy of Sotheby Parke Bernet, London
166. Louis Valtat, *Au Bal*. Photo courtesy of Sotheby Parke Bernet, London
167. Ker-Xavier Roussel, *The fountain of youth*. Photo courtesy of Christie, Manson and Woods, London
168. Pierre Puvis de Chavannes, *Oil sketch for Summer*, National Gallery, London
169. Maurice Denis, *Hommage à Cézanne*, Musée d'Art Moderne, Paris. Photo Réunion des Musées Nationaux, Paris

170. Maurice Denis, *Portrait of Mme Ranson*, Collection the Denis family, France
171. Maurice Denis, *Breton Pardon*, Private Collection
172. Edouard Vuillard, *Luncheon at Villeneure*, National Gallery, London
173. Félix Vallotton, *The Third Gallery at the Theatre du Châtelet*, Musée d'Art Moderne, Paris. Photo Réunion des Musées Nationaux, Paris
174. Henri de Toulouse-Lautrec, *Le Divan Japonais*, Victoria and Albert Museum, London
175. Pablo Picasso, *Lola: Portrait of the artist's sister*, Museo Picasso, Barcelona
176. Pablo Picasso, *Moulin de la Galette*, Solomon R. Guggenheim Museum (Thannhauser Foundation), New York
177. Theo van Rysselberghe, *Portrait of Irma Sethe*. Photo courtesy Sotheby Parke Bernet, London
178. A. W. Finch, *Orchard at Louviere*, Ateneum Museum, Helsinki
179. Theo van Rysselberghe, *Sailboat on the Escaut*, Collection Arthur G. Altschul, New York
180. Vincent van Gogh, *Landscape with Olive Trees, St Remy*, Collection Mr and Mrs John Hay Whitney, New York
181. Roderick O'Conor, *Yellow landscape at Pont-Aven*, Tate Gallery, London
182. Henri de Toulouse-Lautrec, *Au 'Rat Mort'*, Courtauld Institute Galleries, London
183. Theo van Rysselberghe, *Self-portrait*, Museum of Modern Art (Gift of Mr and Mrs Hugo Perls), New York
184. Jenry van de Velde, *Blankenberghe*, Kunsthaus, Zurich
185. Georges Lemmen, *View of the Thames*, Museum of Art, Rhode Island School of Design, Providence
186. Henri Matisse, *Nude in the Studio*, Collection Ishibashi, Tokyo. Photo Giraudon
187. Jan Toroop, *Under the willow*, National Museum of Vincent van Gogh, Amsterdam
188. Walter Richard Sickert, *The New Home*, The Fine Art Society, London
189. Philip Wilson Steer, *Boulogne Sands*, Tate Gallery, London
190. Duncan Grant, *Portrait of Pamela Fry*, Collection Mrs Pamela Diamand, London
191. Simon Bussy, *Promenade*, Private Collection, London
192. Eric Forbes-Robertson, *Great Expectations*, Northampton Museum and Art Gallery, Northampton
193. Roderic O'Conor, *Portrait of a Breton Girl*. Photo courtesy of Sotheby Parke Bernet, London
194. Roderic O'Conor, *Field of corn, Pont-Aven*, Ulster Museum, Belfast
195. Robert Bevan, *A Breton Yard*. Photo courtesy of Christie Manson and Woods, London
196. Robert Bevan, *Ploughing in Brittany*, Tate Gallery, London
197. Edvard Munch, *Puberty*, Munch Museum, Oslo
198. Halfdan Egedius, *The Dreamer*, National Gallery, Oslo
199. Pablo Picasso, *Dwarf Dancer*, Museo Picasso, Barcelona. Photo Giraudon
200. Pablo Picasso, *Old Woman*, Museum of Art (Louise and Walter Arensburg Collection), Philadelphia
201. Pablo Picasso, *Boy with pipe*, Collection Mr and Mrs John Hay Whitney, New York

Index

Page numbers in *italic* refer to the illustrations